PAINTED PRAYERS

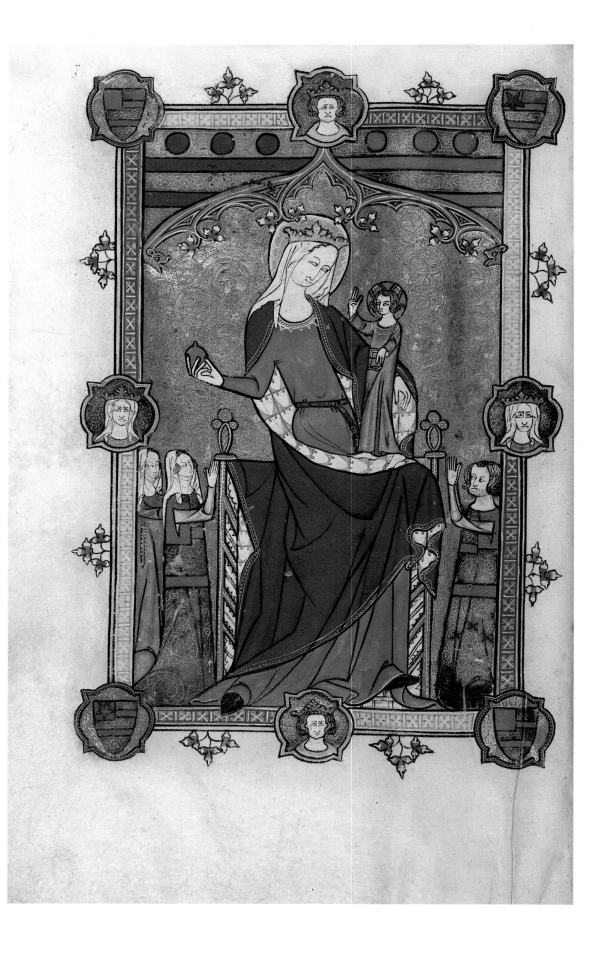

PAINTED PRAYERS

The Book of Hours in
Medieval and Renaissance Art

ROGER S. WIECK

GEORGE BRAZILLER, INC.
in association with The Pierpont Morgan Library
NEW YORK

First published on the occasion of the exhibition
"Medieval Bestseller: The Book of Hours" at The Pierpont Morgan Library
from 17 September 1997 to 4 January 1998

For information please address the publisher:
George Braziller, Inc., 171 Madison Avenue, New York, NY 10016

Frontispiece: see no. 5

Library of Congress Cataloging-in-Publication Data:

Wieck, Roger S.
 Painted prayers: the book of hours in medieval and Renaissance art / Roger S.
Wieck.
 p. cm.
 Includes bibliographical references and indexes.
 ISBN 0-8076-1418-1 (cloth). — ISBN 0-8076-1419-X (pbk.)
 1. Books of hours—Texts. 2. Books of hours—Illustrations. 3. Illumination
of books and manuscripts, Medieval. 4. Illumination of books and manuscripts,
Renaissance. I. Title.
ND3363.AIW54 1997
242'.094'0902—dc21 96-36927
 CIP

Photography by David A. Loggie, The Pierpont Morgan Library

Designed by Philip Grushkin

Printed and bound in China

First edition

CONTENTS

PREFACE

Books of Hours constitute one of the most significant groups of cultural artifacts from the late Middle Ages and Renaissance. Indeed, from the mid-thirteenth to the mid-sixteenth century, more Books of Hours were produced, both by hand and by press, than any other type of book. They were the bestsellers of an era that lasted 300 years. By reading these texts and looking at their pictures, we can learn a great deal about this period. The prayers, centered around the Mother of God, are the great literary expression of the cult of the Virgin Mary. From the frequent appearance of invocations to Sts. Sebastian, Apollonia, and Margaret, for example, we learn something of the chronic problem of plague, the annoyance of toothache, and the dangers of childbirth. In an era when some of the most important painting was in books, the illuminated miniatures in manuscript Books of Hours are the picture galleries of the Middle Ages. And straddling the revolution of manuscript to print, Books of Hours are the great constant in a sea of changing readership and competing markets.

With about 130 printed copies and nearly 240 manuscripts, the collection of Books of Hours at The Pierpont Morgan Library is the best in this country and one of the best in the world. Reproducing folios from the 100 finest or most interesting examples in the collection, this publication aims to introduce the genre to the public and to serve as an advertisement of these riches to the specialist.

Most of the manuscripts and printed books included here were bought by Pierpont Morgan and his son, J. P. Morgan, Jr., or subsequent directors and curators of the Library. Over the years, however, the holdings have been enriched by generous gifts, and I would particularly like to record the following donations or bequests: Dr. Beatrice Bishop Berle (nos. 21, 38, 50, and 66); William S. Glazier (nos. 6, 19, 55, and 71); The Heineman Foundation (nos. 39, 63, 70, 76, and 97); Tessie Jones (no. 47); Mr. and Mrs. H. P. Kraus (no. 72, partial gift); Mrs. Roy O'Connor (no. 106); Mr. and Mrs. Alexandre P. Rosenberg (no. 20); E. Clark Stillman (no. 53); Mr. and Mrs. Landon K. Thorne, Jr. (no. 33); and an anonymous benefactor (no. 65).

The escalating prices of truly stellar illuminated manuscripts have necessitated, at times, group efforts for important acquisitions. Mrs. Vincent Astor, Mrs. Charles W. Engelhard, Haliburton Fales, 2d, Alice Tully, and Julia P. Wightman joined resources to buy the Hours of Charlotte of Savoy (no. 56). The Honorable Robert Woods Bliss, Mrs. W. Murray Crane, Childs Frick, William S. Glazier, Matilda Geddings Gray, Arthur A. Houghton, Jr., Mr. and Mrs. Donald F. Hyde, Milton McGreevy, Colonel David McC. McKell, Joseph V. Reed, Mrs. Landon K. Thorne, Ralph Walker, and Christian A. Zabriskie together presented the Library with the Warwick Psalter-Hours (no. 98). Finally, a truly Olympian assembly enabled the Library to secure the second half of the Hours of Catherine of Cleves: Mrs. Frederick B. Adams, Sr., Mrs. Robert Horne Charles, Laurens M. Hamilton, The Heineman Foundation, Mrs. Donald F. Hyde, Mrs. Jacob M. Kaplan, Mrs. John Kean, Paul Mellon, Mr. and Mrs. Charles F. Morgan, Lessing J. Rosenwald, Mr. and Mrs. August H. Schilling, Mrs. Herbert N. Straus, Mrs. Landon K. Thorne, Mrs. Alan Valentine, Mr. and Mrs. Arnold Whitridge, and Julia P. Wightman (no. 107).

Without the support of these individuals and foundations, The Pierpont Morgan Library's collection of Books of Hours would not be as rich as it is today.

CHARLES E. PIERCE, JR.
Director
The Pierpont Morgan Library

For Fafa

ACKNOWLEDGMENTS

The Pierpont Morgan Library gratefully acknowledges the Lila Wallace-Reader's Digest Fund for its sponsorship of the exhibition "Medieval Bestseller: The Book of Hours," the accompanying public programs, and this publication.

The idea to discuss the actual texts found in Books of Hours stems from a conversation I had with Bruce Ferrini; my thanks to him. Susan L'Engle, while an intern at the Morgan Library, helped me enormously with research on and translations of the Latin prayers. Also helpful on the prayer front were Sister Regina Melican of St. Joseph's Seminary in Yonkers, New York, and Ancil George of the Van Pelt-Dietrich Library Center at the University of Pennsylvania, Philadelphia. My colleagues at the Library, George Fletcher, John Plummer, William Voelkle, and Julianne Griffin, were most generous with their time and expertise; Cathy Darrup, an intern, helped me read proof. Thanks also to Lilian Randall, curator emerita at the Walters Art Gallery, Baltimore; Paul Needham, director of the department of books and manuscripts at Sotheby's in New York; and François Avril, chief curator of the department of manuscripts at the Bibliothèque Nationale de France, Paris.

R. S. W.

INTRODUCTION

For three hundred years the Book of Hours was the bestseller of the late Middle Ages and the Renaissance. From the mid-thirteenth to the mid-sixteenth century, more Books of Hours were commissioned and produced, bought and sold, bequeathed and inherited, printed and reprinted than any other text, including the Bible. They exist in vast quantities. The Pierpont Morgan Library owns more than 370 manuscript and printed Books of Hours. The other great collection of illuminated manuscripts in this country, the Walters Art Gallery in Baltimore, has nearly the same number. The collections of the British Library in London, the Bibliothèque Nationale de France in Paris, and the Biblioteca Apostolica Vaticana in Rome are easily as rich in this genre. And this is not to mention the large number of Books of Hours to be found in the major university libraries here and abroad. To this day, the Book of Hours is the most frequent type of book to appear in antiquarian booksellers' catalogues and at the auction houses. The many single leaves circulating in private collections are, more often than not, from Books of Hours.

One of the reasons for this popularity lies in the book's contents. The Book of Hours is a prayer book that contains, at its heart, the Little Office of the Blessed Virgin Mary, that is, the Hours of the Virgin. For this reason the Latin term for the book is *Horae* (Hours). The Hours of the Virgin are a sequence of prayers to the Mother of God that, ideally, were recited throughout the course of the entire day, sanctifying it through her to God, Hour by Hour. Other prayers usually found in *Horae* helped round out the spiritual needs of late medieval and Renaissance men and women. The Penitential Psalms, for example, were recited to help one resist temptation to commit any of the Seven Deadly Sins (which could land one in hell). The Office of the Dead was prayed to reduce the time spent by one's friends and relatives in the fires of purgatory.

The Book of Hours played a key role in the late medieval and Renaissance cult of the Virgin. Marian devotion placed the Mother of God in the pivotal role as intercessor between man and God. As our spiritual mother, Mary would hear our petitions, take mercy on our plight. She would plead our case to her Son who, surely, could not deny his own mother anything for which she asked. In a Europe dominated by cathedrals dedicated to Nôtre Dame, the Hours of the Virgin were deemed Our Lady's favorite prayers, the quickest way to her heart.

The Hours of the Virgin are at least as old as the ninth century; it is thought that they were developed by Benedict of Aniane (c. 750–821) as part of a monastic movement that could not pray often enough. To the Divine Office, the daily (including nightly) round of prayers the medieval Church required of her ordained (priests, monks, and nuns), were added the Hours of the Virgin. By the mid-eleventh century, they were an established practice; the Hours would be chanted in church from large choir books called Antiphonaries. By the late twelfth century, the Hours were also found in Psalters, the prayer books containing all 150 Psalms, a Calendar, and among other prayers, usually the Litany and the Office of the Dead. By the early thirteenth century, an era of increased literacy, Psalters and combined Psalter-Hours were used by the laity as well as by the ordained. By the mid-thirteenth century, however, it became common for laypeople to ask for prayer books *not* containing the cumbersome Psalter section but with the Hours of the Virgin and other parts, such as the Calendar, the Litany, and the Office of the

Dead, intact. Thus, the Book of Hours as we know it was born. By the late fourteenth century, the typical Book of Hours consisted of a Calendar, Gospel Lessons, Hours of the Virgin, Hours of the Cross, Hours of the Holy Spirit, the two prayers to the Virgin called the "Obsecro te" and the "O intemerata," the Penitential Psalms and Litany, the Office of the Dead, and a group of about a dozen Suffrages; any number of accessory prayers complemented these essential texts.

Books of Hours were easy, even enjoyable, to use. The core text, the Hours of the Virgin, remained basically the same every day. The only variable was the three Psalms that constitute the nocturn of the first Hour, Matins (these Psalms changed depending on the day of the week; see appendix 1). The contents of the remaining Hours, Lauds through Compline, did not change (some *Horae*, but by no means all, contained a few textual variations for the Advent and Christmas seasons, but these were minor). The other parts of the typical Book of Hours were completely unchanging: the Gospel Lessons, the Hours of the Cross and of the Holy Spirit, the Penitential Psalms, the "Obsecro te" and "O intemerata," and the Office of the Dead. One was certainly encouraged to pray the Hours of the Virgin (and, time permitting, the Hours of the Cross and of the Holy Spirit) and the Office of the Dead on a daily basis. The other common texts offered plenty of variation, as did the numerous accessory prayers that owners freely included in their *Horae*.

Until around 1400, Books of Hours were entirely in Latin. Around this time, some French appeared in *Horae* made in France, but it was not a significant amount (Calendars, some rubrics, and a few accessory prayers might be in the vernacular). The same can be said about the extent of English in Books of Hours made in England or made for use there. The only major role played by a vernacular language in the history of Books of Hours is found in Dutch *Horae*. Geert Grote (d. 1384) translated the standard texts of the Book of Hours into Dutch as part of the *Devotio moderna*, the late medieval reforming movement that encouraged pious reading in the vernacular. This translation achieved great success, and throughout the course of the fifteenth and sixteenth centuries, Books of Hours produced in the northern Netherlands were almost always in Dutch. Disregarding this latter phenomenon, however, Books of Hours are books of Latin. How much did the lay reader understand? Probably more than we might initially think. Speakers of French and Italian, of course, had an easy ear for the language. Furthermore, the great armature for most prayers in the Book of Hours is Psalms. A total of thirty-seven Psalms form the Hours of the Virgin; these did not change. Nor did the seven of the Penitential Psalms or the twenty-two in the Office of the Dead. Other biblical excerpts—the four Gospel Lessons, the Passion according to

1. YOLANDE DE SOISSONS IN PRAYER (*opposite*)

Praying from her Psalter-Hours, Yolande, dame de Coeuvres and vicomtesse de Soissons, raises her eyes from her manuscript and, deep in meditation, gazes upon the statue of the Virgin and Child upon the altar. The sculpture seems to come to life—even her lapdog notices. This miniature, which faces the opening of the Hours of the Virgin, illustrates the goal of the prayers and the function of the book: to transport one from the distracting cares and temptations of this world to the divine pleasures of the next. Yolande's chapel is roofed with an elaborate array of Gothic pinnacles and gables. These details are more than mere architecture; they frame and crown the miniatures throughout the manuscript, making the events from the lives of Christ and the saints depicted beneath them appear timeless, eternal. Here, they reflect Yolande's aspiration to enter this heavenly domain upon her death where, in everlasting bliss, she will enjoy the presence of God and his mother.

"Psalter-Hours of Yolande de Soissons," for Amiens use. France, Amiens, c. 1280–90, for Yolande de Soissons (MS M.729, fol. 232v).

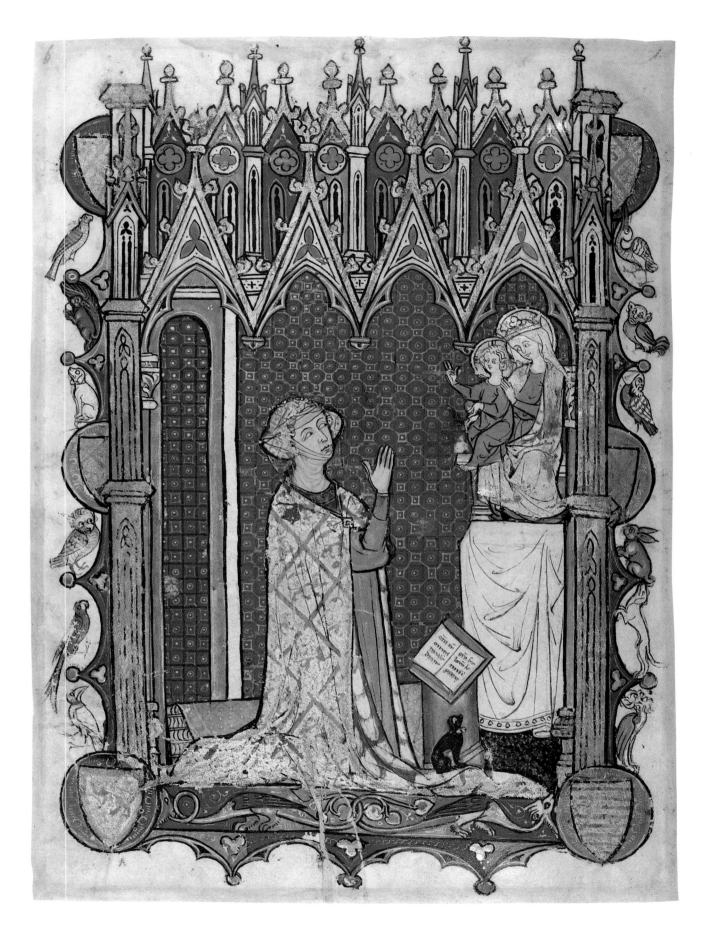

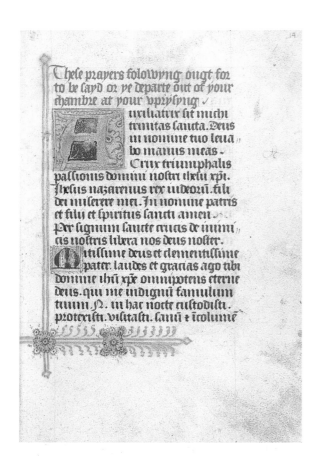

2. MORNING PRAYER

The revealing rubrics at the beginning of this manuscript show how a Book of Hours could be a constant companion, throughout the course of the day, at home and at church. Shown here is the prayer to be recited in the morning, "These prayers folowyng ougt for to be sayd or ye departe out of your chambre at your uprysyng." Following it are prayers to be said when leaving the house, upon entering church, when taking holy water, at night, plus a short series of preparatory prayers (against temptations of the flesh, for true contrition, and so forth) to be recited before praying the Hours of the Virgin themselves.

Hours for Sarum use. England, late fifteenth century (MS M.24, fol. 14r).

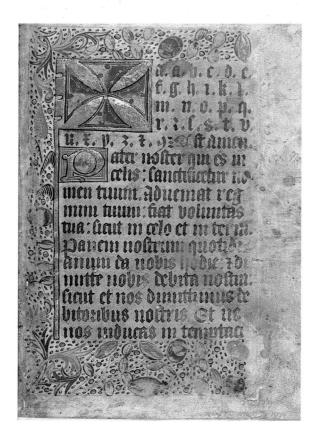

3. ABC, PATER NOSTER

This manuscript was made for a child. It begins with an ABC and proceeds with a series of the basic prayers all Christians were expected to know by heart, such as the Our Father, Hail Mary, Apostles' Creed, and "Confiteor." The soiled first folio reproduced here bears witness to the clumsy fingers of many a child's first encounter with the written word. The manuscript has miniatures, but their poor quality is an indication of the relatively little money spent for them—their crude style would not have offended young eyes.

Hours for Sarum use. England, Winchester? 1490s (MS M.487, fol. 1r).

John, and the readings from the Book of Job (in the Office of the Dead)—would become equally familiar over time. Much of the remaining Latin is in rhymed verse, such as the "Stabat Mater" and the "Salve sancta facies," or as with the Suffrages, it is rather simple "Church" Latin.

Most literate people had some working knowledge of Latin, and they knew certain basic prayers— "Ave Maria" (Hail Mary), "Pater noster" (Our Father), "Credo" (Apostles' Creed), and "Confiteor" (the prayer beginning, "I confess to Almighty God")—by heart. As children they learned to read from Books of Hours. In England, Books of Hours were called "primers," a word that eventually came to mean the book from which a child first learned to read and pray. The term derives from the Hour of Prime (recited early in the morning), the first of what are called the "little" Hours of the Hours of the Virgin (that is, Prime through None). Books of Hours made for young eyes were usually written in big letters or

4. PRAYER REBUS

As in the previous Book of Hours, a compilation of texts and prayers that were the foundation for the young medieval and Renaissance Christian mind is found at the beginning of the book. Entitled a "Livre de Jesus" (Book of Jesus), the collection consists of an alphabet ("a.b.c. pour les petiz enfans"—ABC for little children), the Our Father, Hail Mary, Apostles' Creed, "Confiteor," Ten Commandments, and so forth, all with explanatory notes in the side margins. While some of these prayers are in Latin, most are in French.

On the book's last folio is the rebus reproduced here, an edifying bonus for the quick learner. The French lines below the puzzle can be translated as "Let us salute Mary praying to Christ crucified. And our minds hope for his peace. I have given my heart to God. I hope for paradise. Let God be praised. Amen." The pictograms can be deciphered as: Salut [gold coin] os [bone] NS / Marie priant / Jesus en croix. N os [bone] / con [given in contraction] scie [saw] anse [handle] / éperons [spurs] / sac [purse] / paix [pax, the liturgical object]. "G" [the letter] / à / Dieu / mont [mount] / cuer [heart] / mi [musical note]. Geais [jays] / poire [pear] / parc [enclosure] a "X" [Roman numeral for ten]. Loup [wolf] ange [angel] / à / Dieu / ceps [stocks]. The system grasped, the young child was encouraged to decode the remaining four lines of the rebus by him- or herself.

Hours for Rome use. France, Paris, c. 1513 (almanac 1513–23), printed for Guillaume Godard (PML 18561, fol. O8v).

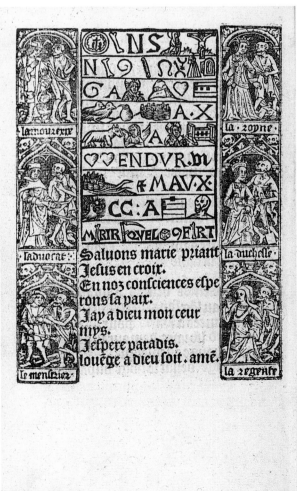

printed in large type; they also contain things like an ABC, Our Father, Hail Mary, Apostles' Creed, and the "Confiteor" on their first folios. Long ago memorized by every adult, these items, of course, are not found in a grown-up's Book of Hours.

Another reason Books of Hours were so popular was because of the people who used them. Although the Church's ordained occasionally owned them, it was the laity who formed the real audience for Books of Hours. In a kind of bibliophilic jealousy, laypeople during this period sought for themselves a book that paralleled the use and function of the Breviary, the book containing the Divine Office that the clergy prayed from daily. In an age when rood screens blocked all but the most fleeting views of the Mass, when squints were pierced into walls in an effort to offer some glimpse of the Elevation of the Eucharist, when, in other words, the laity's access to God was very much controlled and limited by others than themselves, Books of Hours bestowed direct, democratic, and potentially uninterrupted access to God, the Virgin Mary, and the saints.

How people felt about their Books of Hours is reflected in the varied marks of ownership—some-

5. VIRGIN AND CHILD ADORED BY HAWISIA DUBOIS AND HER FAMILY

This remarkable and remarkably large (12 1/2 x 8 1/2 inches) Book of Hours has two pairs of particularly telling miniatures at the beginning of the volume. In the first, members of the DuBois family kneel before facing miniatures of the archangels Gabriel and Michael. In the third miniature (reproduced here and in the frontispiece)

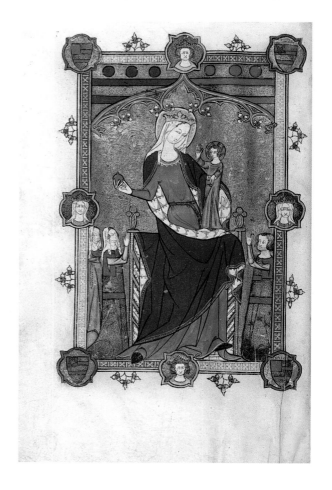

Hawisia DuBois, her husband, and a third family member kneel before the Virgin and Child; this picture faces a Last Judgment with the Resurrection of the Dead. These four images reveal the important role played by intercessors in medieval spiritual life. The two most important archangels—Gabriel, the angel of the Annunciation, and Michael, weigher of souls at the end of time—are asked to aid the DuBois family. The Virgin, in turn, is beseeched to intercede with her Son on behalf of the family. The purpose for the petitioning is made clear by the last miniature: the DuBois hope to be counted among the elect on the Day of Judgment.

Marks of ownership played a significant role in Books of Hours, even in the early stages of their development. Hawisia DuBois inserts her and her family's portraits right up front, before the Calendar, and she liberally sprinkles the folios with her family arms. Hawisia's name is inserted into prayers no fewer than four times.

"DuBois Hours," for Sarum use. England, London? c. 1325–30, for Hawisia DuBois (MS M.700, fol. 3v).

times proud, sometimes personal—that they had painted on their pages. Portraits abound. Simpler *Horae* of the thirteenth century, for example, include generic portraits that could stand in for whoever might have had the book in hand. By the fourteenth century, in contrast, recognizable portraits were an important element in specially commissioned Books of Hours. The outlandish number of miniatures and portraits in one Book of Hours in particular had an influence on the entire history of illumination. In the

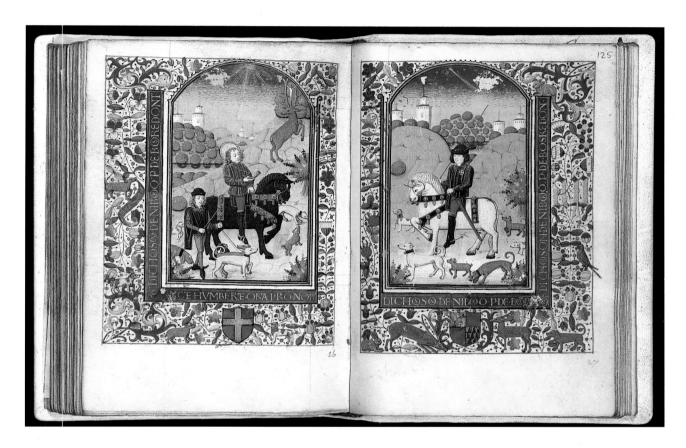

6. MIRACLE OF ST. HUBERT AND PIERRE DE BOSREDONT HUNTING

by Guillaume Hugueniot

Pierre de Bosredont, commander in the Champagne of the Order of the Hospital of St. John of Jerusalem and son of a royal counselor and chamberlain, commissioned this highly personal Book of Hours. His arms (which also appear full-page), name, and motto appear in many of the borders. A most unusual miniature depicts a battle between the Turks and the Knights of Rhodes under the command of Pierre's relative, George de Bosredont. Finally, Pierre himself is depicted three times, always wearing the Maltese cross of the Knights Hospitalers. In the portrait reproduced here he is shown hunting, facing a picture of St. Hubert, patron of hunters. According to legend, Hubert, an eighth-century nobleman, went hunting on a Good Friday, when everyone else was in church. The stag he pursued suddenly turned and revealed, between its antlers, a crucifix. The miracle converted Hubert. With a continuous landscape uniting the two miniatures, Pierre envisions himself as a latter-day Hubert, sharing the same worldly pastime and spiritual passion.

The artist Guillaume Hugueniot's name appears in an account of 1472, in which he is paid thirty-nine *livres* for 27 miniatures and 229 illuminated initials in a manuscript of Nicholas of Lyra's *Postillae* (Paris, Bibliothèque Nationale de France, MSS lat. 11972–73, 11978).

"Hours of Pierre de Bosredont," for Rome use. France, Langres, c. 1465, for Pierre de Bosredont (MS G.55, fols. 124v–125r).

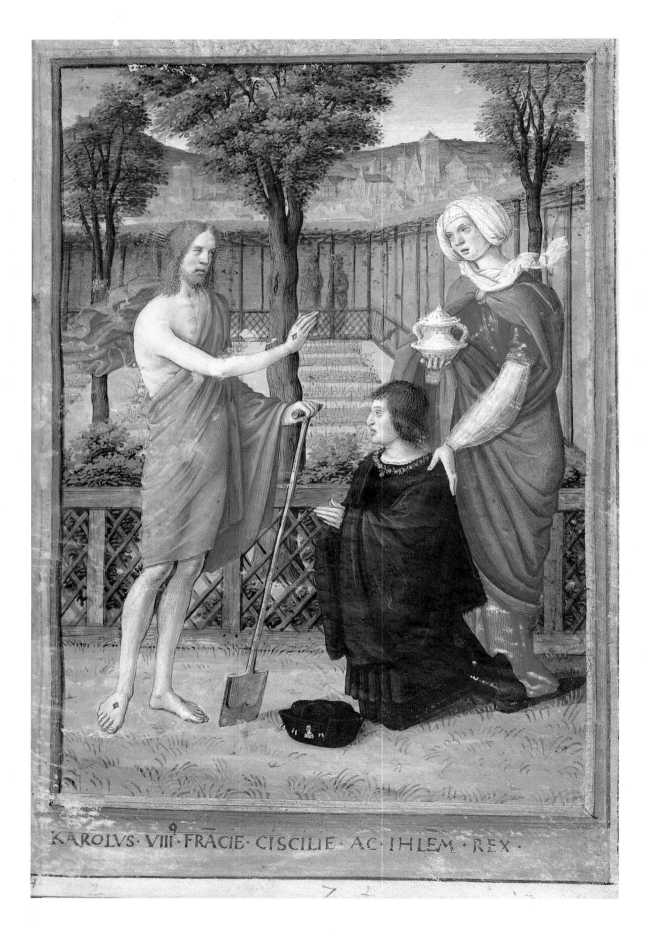

KAROLVS · VIII · FRACIE · CISCILIE · AC · IHLEM · REX ·

1330s, Blanche of Burgundy, countess of Savoy and granddaughter of King (later, Saint) Louis IX, commissioned an unprecedented Book of Hours. It had more than two hundred miniatures incorporating about eighty portraits of Blanche! King Charles V, who owned the Savoy Hours in the 1370s, himself added an extra sixty-eight miniatures, nearly half of which included portraits of him. Charles's brother Jean, duc de Berry, was so envious of his brother's Book of Hours that he commissioned his own, the so-called *Petites Heures*, whose texts, picture cycles, and use of portraiture closely mimic those of the book he was unable to possess. Thus began Jean's career for commissioning increasingly lavish Books of Hours, in all of which portraiture plays a key role. (The *Petites Heures* is today in Paris, Bibliothèque Nationale de France, MS lat. 18014. The Savoy Hours was destroyed in the 1904 fire at the Biblioteca Nazionale in Turin, MS E.V.49; however, twenty-six leaves, which had been detached from the book before the conflagration, are today in New Haven, Yale University, Beinecke MS 390.)

Marks of ownership in Books of Hours, however, are not restricted to portraits. Their range includes coats of arms, initials, monograms, mottoes, and personal emblems, which are used singly or in all combinations possible.

In the course of their three-hundred-year history, Books of Hours offer case studies that cover all the possibilities of how men and women of the late Middle Ages and Renaissance acquired their books. People commissioned them, received them as gifts (brides especially), inherited them, bought them new or secondhand from bookseller's stock, borrowed them, sometimes made them themselves, and indeed even stole them. The range in their quality—from a specially illuminated vellum manuscript with hundreds of pictures to a poor man's unillustrated *Horae* printed on paper—speaks not only of deep or shallow pockets but also of a vast audience with a shared mind-set. By the late fifteenth century, when printing made the Book of Hours available to a whole new category of customers, nearly any literate soul, even on the slimmest income, could buy one.

A great part—really the greater part—of this lay audience was female, and women played a key role in the patronage of Books of Hours throughout their entire history. In the first hundred and fifty years,

7. KING CHARLES VIII PRESENTED BY MARY MAGDALENE TO THE RESURRECTED CHRIST (*opposite*)

by Jean Poyet

On Easter morning, Mary Magdalene was the first to see the resurrected Christ. She mistook him, however, for a gardener (for which reason his attribute on this day is often a shovel). When Jesus said her name, the Magdalene recognized him, but was not permitted to touch his newly glorified body. It is at this singular moment in time that Charles VIII choses to insert himself. Mary Magdalene's duties include carrying the responsibility of being the first person to bear witness to the beginning of mankind's redemption and introducing Charles to the Savior. Justification for such hubris is offered, in a way, by the inscription at the bottom, where "Karolus" reminds us that he is king, not only of France and Sicily, but also of Jerusalem. Facing the miniature is a full-page representation of Charles's coat of arms.

These two miniatures did not originate with the manuscript in which they now find themselves. They were apparently executed for the king (who died in 1498), became detached from their original book (which may never have been completed), and were inserted in the present codex around 1510. (The other miniatures, of much inferior quality, also belie any royal provenance.) For the illuminator, Jean Poyet, see no. 39.

Hours for Rome use. France, Tours, c. 1495, for the two inserted miniatures, and Berry? c. 1510, for the codex itself (MS M.250, fol. 14r).

8. EMPEROR CHARLES V IN PRAYER

by the Master of Charles V

Considering the particularly turbulent times in which the emperor Charles V lived (1500–58) and reigned, it should not surprise us that the ruler had a penchant, in his manuscripts, to be portrayed invoking the aid of his guardian angel (the images illustrate a prayer to one's guardian angel). In addition to Charles's portrait reproduced here, the manuscript contains many marks of ownership. Other family portraits include a sister who was Queen Eleanor of France (wife of François I), another sister who was Queen Marie of Hungary, and his son, Philip II. A full-page miniature of the imperial arms forms the title page. Tradition has it that Charles took this Book of Hours with him when he retired to the monastery of Yuste, in Spain; Martin de Gaztelu, his secretary and one of the executors of his will, inherited the manuscript.

The Master of Charles V is named, not after this manuscript, but after one of his prayer books in Vienna (Österreichische Nationalbibliothek, Cod. 1859). That manuscript, datable between 1516 and 1519, is somewhat different in style, so it is possible that the "Master" of Charles V is more likely a workshop. The style of the Vienna manuscript is related to that of Simon Bening, whereas the artist of this codex is more cognizant of the achievements of major panel painters such as Quentin Metsys and Jan Gossaert.

"Hours of Charles V," for Rome use. Belgium, Brussels, c. 1540, for Emperor Charles V (MS M.696, fol. 56r).

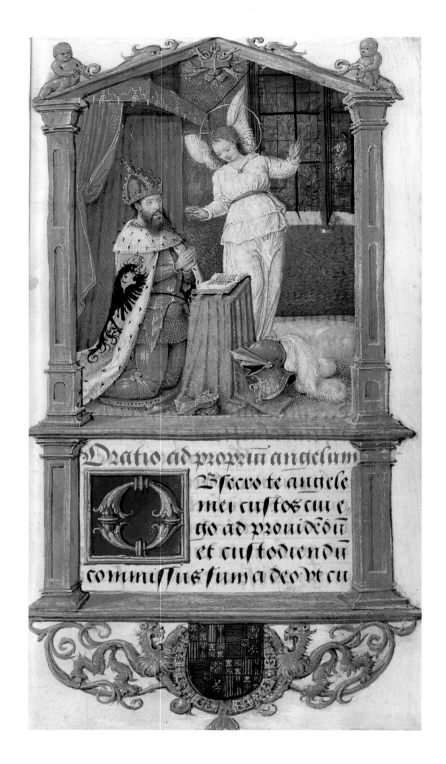

9. ARMS OF CLAUDE MOLÉ

by the Master of Petrarch's Triumphs

The manuscript commissioned by Claude Molé I, lord of Villy-le-Maréchal (near Troyes), contains the usual series of miniatures to be found in a late fifteenth-century French Book of Hours. At the end of the volume, however, are a number of unconventional pictures that put his personal stamp on the book. They include a pair of facing miniatures of Claude presented by St. Claudius to the Virgin, a stark image of Christ Crucified against a vermilion cloth background, and four pictures that relate to the late medieval theme for meditation called the

Four Last Things: Death (represented as a personification), Hell, the Last Judgment, and Heaven. A final miniature in the manuscript, reproduced here, acts as a kind of pictorial colophon: a proud full-page representation of two Moors supporting Molé's coat of arms, which is surmounted by a helmet and a wreath and mantling of his colors, and crested by a nude female with a scroll bearing his motto, "Cuider decoit" (Beware of deceit).

For the Master of Petrarch's Triumphs, see nos. 10 and 26.

"Hours of Claude Molé," for Rome use. France, Paris, c. 1500, for Claude Molé (MS M.356, fol. 66r).

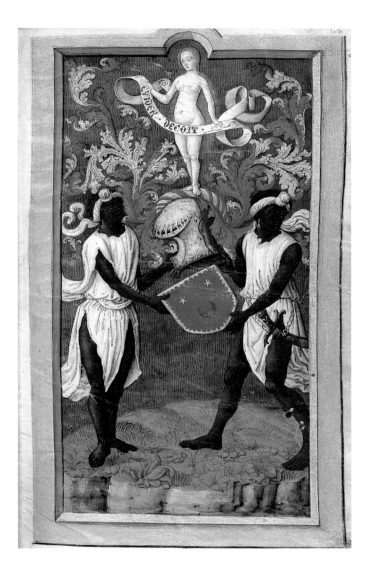

this patronage was essential, and it was due to women that the genre took off. Women, it was thought by their male clerical advisers, needed the pictures to help them in their piety. The images were, literally, visual aids.

This, finally, leads one to consider the pictures, for therein, too, lies much significance for the continual popularity and success of Books of Hours. As well liked now via Christmas cards as they were then, the pictures in any Book of Hours were often the only form of art owned by the middle class. Even to the wealthy, who could commission paintings and tapestries for their castle or chapel walls, miniatures

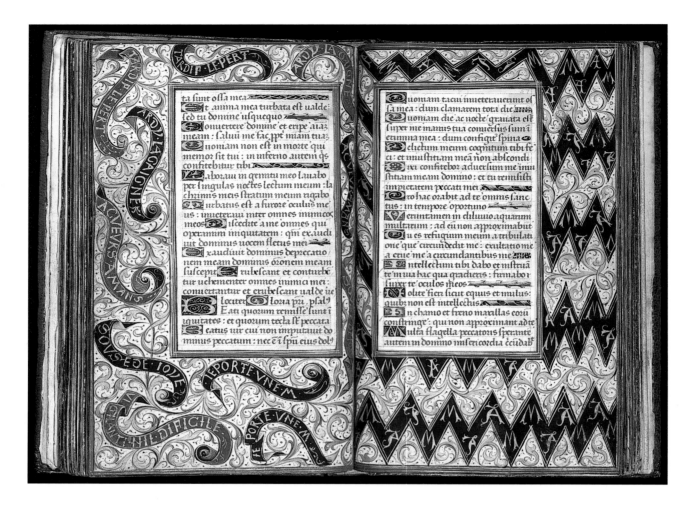

10. MONOGRAMS AND MOTTOES

by the Master of Petrarch's Triumphs

Although the miniatures in this manuscript are quite fine, one's attention is quickly distracted by the book's marvelous borders. All sorts of fanciful designs and inventive shapes—scrolls, zigzags, triangles, teardrops, to name just a few—dance before the eye. The palette, too, is quite unique, dominated by brown, white, black, and gold. (The miniatures, executed in limited colors, are predominantly gray.) That these colors were clearly chosen by the patron of the book is made clear in a poem, written on the last folio, that includes the line, "Gris et tanne enseront mes couleurs" (Gray and tan will be my colors). The patron's initials, "AM," appear in many of the borders, as do his various mottoes, "Tardif le pert" (Who is late loses), "Ardy la gaigne" (Who is bold wins), and especially "Je porte une M" (I bear an M). Ironically, considering the manuscript's numerous marks of ownership, the name of this idiosyncratic patron has thus far eluded identification.

For the Master of Petrarch's Triumphs, see nos. 9 and 26.

Hours for Rome use. France, Paris, c. 1505–10 (MS M.618, fols. 56v–57r).

in Books of Hours were a continuous source of aesthestic pleasure. One did not *need* more than one Book of Hours, but those who could afford to sometimes owned several; Jean, duc de Berry, owned about fifteen.

The pictures in Books of Hours, whether manuscript or printed, were, of course, versions of the subjects people saw at church. The main text, the Hours of the Virgin, was marked by a series of pictures

11. Nativity, Annunciation to the Shepherds, Adoration of the Magi, Flight into Egypt, and Massacre of the Innocents

This manuscript is the oldest Book of Hours in the Morgan Library. It was apparently commissioned by Margravine Kunegund of Moravia for Princess Agnes, daughter of Ottokar I of Bohemia (c. 1155–1230). For the young Agnes, educated in Cistercian and Premonstratensian convents, this Book of Hours clearly played a key role in her spiritual education. The manuscript contains a Calendar, the Hours of the Virgin (into which are mixed the Hours of the Trinity, of the Holy Spirit, of the Cross, and of All Saints), Office of the Dead, Litany, Suffrages, an abbreviated Psalter, plus a number of interesting miscellaneous prayers (for oneself, against evil-doers, for rain, and so forth).

While its Suffrages are given historiated initials (see no. 85), the principal pictorial component of the book is an expansive prefatory cycle of thirty-two miniatures depicting major events from the Old and New Testaments (reproduced here are scenes of the Infancy of Christ). Such cycles were a common feature in thirteenth-century Psalters, and they, not unex-

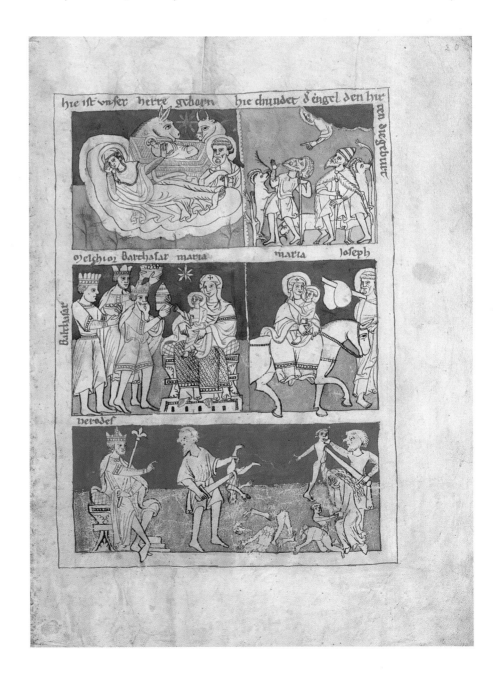

pectedly, also appear in early Books of Hours. Significantly, the pictures are given inscriptions in the vernacular (German, in this case: "Hie ist unser herre geboren"— Here Our Lord is born). The pictures and their titles were an educational device, offering for the young reader the main events from the Bible in a clearly understood and easily remembered form.

Hours for Premonstratensian use. Bohemia, probably the Monastery of Luka, near Znaim, c. 1215, probably for Princess Agnes of Bohemia (M.739, fol. 20r).

illustrating either Christ's Infancy or his Passion. The events relating Christ's birth or his death were the same to be seen depicted in the multiple panels of a medieval or Renaissance altarpiece. The Nativity of Christ was the central event in the Christmas season, which started with the First Sunday in Advent (in late November or early December) and ended with the Feast of the Purification of the Virgin (February 2). Christ's death and Resurrection were the key events in the next season, which began on Ash Wednesday, the first day of Lent, and concluded with Christ's Ascension and the Feast of Pentecost, the descent of the Holy Spirit. (Sundays after Pentecost fill out the rest of the year until one again returns to Advent.) Thus, in one's Book of Hours one had a mirror of the Church's entire liturgical year in pictorial form. Suffrages were illustrated by images of the saints who were the object of the petitions. These, of course, were the same saints who were also seen at church, at side altars or in stained glass.

These pictures had two main functions. On a practical level, they indicated where the major texts began; they were bookmarks (Books of Hours, manuscript or printed, were originally neither foliated nor paginated). Second, as they marked certain texts, they also embodied them. They provided the themes upon which to meditate; they were "painted prayers." The miniatures or prints depicting in one's book the mysteries of the Incarnation, the sorrows of the Passion, or the comfort of death could stir the same emotions as the images one saw at church.

The usual themes for the standard texts of the Book of Hours are summarized in the chart on the facing page.

Books of Hours linked church and home. The entire celestial court, God and his cosmos, could be held within the palms of one's hands and taken home. The Virgin, in the two popular prayers called the "Obsecro te" and "O intemerata," is addressed in the first person singular; one could insert one's name in the prayer. Used at home, the Book of Hours transformed one's chamber into a chapel. A Book of Hours printed in 1538 in Rouen for English export (use of Sarum) by Nicholas le Roux for François Regnault contains an introductory section called "The Preface and the Manner to Live Well" (spelling modernized). Its instructions reveal how a Book of Hours was actually used:

> First rise up at six of the clock in the morning in all seasons and in your rising do as follows. Thank Our Lord of rest that he gave you that night, commend you to God, Blessed Lady Saint Mary, and to that saint which is feasted that day. . . . When you have arrayed yourself in your chamber or lodging, [say] Matins, Prime, and Hours if you may. Then go to the church . . . , and abide in the church the space of a low mass, while there you shall think and thank God for his benefits. . . . When you are come from the church, take heed to your household or occupation till dinner time. . . . Then take your refection or meal reasonably, without excess or over much. . . . Rest you after dinner an hour or half an hour as you think best. . . . As touching your service, say unto Terce before dinner, and make an end of all before supper. And when you may, say Dirige [Office of the Dead] and Commendations for all Christian souls, at the least way on the Holy Days and, if you have leisure, say them on other days, at the least with three lessons. . . . (PML 19585, fols. C6r–C8r)

When Books of Hours came to be printed, in the late fifteenth and the sixteenth centuries, their pictures, made accessible to an even wider market, ensured their meteoric success. (Between 1480 and 1600 there were some 1,775 different *Horae* editions printed.) This success was initially due in part to the cycles of small border vignettes with which the printers of Books of Hours were able to embellish their prod-

Text	*Image*
CALENDAR	LABORS
	ZODIAC
GOSPEL LESSONS	JOHN ON PATMOS
	LUKE
	MATTHEW
	MARK
HOURS OF THE VIRGIN	
INFANCY CYCLE	
MATINS	ANNUNCIATION
LAUDS	VISITATION
PRIME	NATIVITY
TERCE	ANNUNCIATION TO THE SHEPHERDS
SEXT	ADORATION OF THE MAGI
NONE	PRESENTATION
VESPERS	FLIGHT INTO EGYPT
	or MASSACRE OF THE INNOCENTS
COMPLINE	CORONATION OF THE VIRGIN
	or FLIGHT INTO EGYPT
	or MASSACRE OF THE INNOCENTS
PASSION CYCLE	
MATINS	AGONY
LAUDS	BETRAYAL
PRIME	CHRIST BEFORE PILATE
TERCE	FLAGELLATION
SEXT	CHRIST CARRYING THE CROSS
NONE	CRUCIFIXION
VESPERS	DEPOSITION
COMPLINE	ENTOMBMENT
HOURS OF THE CROSS	CRUCIFIXION
HOURS OF THE HOLY SPIRIT	PENTECOST
"OBSECRO TE"	VIRGIN AND CHILD
"O INTEMERATA"	LAMENTATION *or* PIETÀ
PENITENTIAL PSALMS	DAVID IN PENANCE
	or DAVID AND BATHSHEBA
	or CHRIST ENTHRONED
	or LAST JUDGMENT
OFFICE OF THE DEAD	PRAYING THE OFFICE OF THE DEAD
	or BURIAL
	or LAST JUDGMENT
	or JOB ON THE DUNGHEAP
	or RAISING OF LAZARUS
	or LAZARUS AND DIVES
	or DEATH PERSONIFIED
	or THREE LIVING AND THREE DEAD

ucts. This was a selling point, and they knew it; printers often boasted about their pictures on their title pages. As the following selective list indicates, the cycles' range of subjects (in addition to the standard ones given in the chart on page 23) is quite extraordinary: lives of Christ and the Virgin, saints and evangelists, the Dance of Death, the trials of Job, children's games, heroines, sibyls, the Fifteen Signs of the Second Coming, the story of Joseph, the Seven Sacraments, the Seven Virtues, the Seven Vices, the Triumphs of Caesar, the story of Tobias, the Miracles of Our Lady, the story of Judith, the Destruction of Jerusalem, and, finally, the Apocalypse.

The Morgan Library's holdings are art historically blessed. Although the pictures in the following chapters are arranged according to the texts they illustrate, they could, if chronologically organized and geographically grouped, offer a survey of late medieval illumination and early printing (see appendix 2).

The *Horae* included here, for example, could easily chart the history of French fifteenth- and sixteenth-century illumination, beginning with the Boucicaut Master, one of the most important Parisian illuminators of the early fifteenth century. His style was spread by his younger collaborators and trainees, such as the Master of the Harvard Hannibal and the Master of Morgan 453. In the 1420s and '30s, Parisian illumination was dominated by the personality of the Bedford Master (named after Duke John of Bedford, regent for the English king Henry VI). The English occupation of the French capital in the 1420s, however, caused many artists to leave, and the best French illumination around the middle of the century must be located in the provinces. Barthélemy van Eyck (no relation to the famous Jan, although Barthélemy clearly knew his work) migrated from the southern Netherlands to the south of France in the 1440s. The great Jean Fouquet was based in Tours; his famous follower, Jean Colombe, in Bourges. Payment documents have recently yielded up a new name: Guillaume Hugueniot, a gifted if idiosyncratic illuminator working in Langres. By the 1460s and '70s, Paris again comes to the fore with the work of Maître François and his successor, nicknamed his Chief Associate. In the 1490s, the Master of Anne de Bretagne turned his hand to a variety of media (including illumination and prints), succeeding at all of them. Slightly later, Jean Pichore, who headed a vast workshop that included such personalities as the Master of Petrarch's Triumphs and the Master of Morgan 96, seems to have gotten burned at his one venture into printed Books of Hours; he returned to his specialty, illumination. Meanwhile, such court artists as Jean Poyet and his rival, Jean Bourdichon, both of whom worked for the highest aristocratic circles, painted some of the most stunning of all French illumination. A comparison between the work of the Master of the Getty Epistles and the Books of Hours of Geoffroy Tory reveals how artistic cross-pollination between illuminators and printers in the sixteenth century could produce dazzling results.

The Morgan's Books of Hours are almost equally revealing of the history of Flemish illumination. In the second quarter of the fifteenth century, the highest quality work was done by two closely related artists: the Master of Guillebert de Mets and the Master of the Ghent Privileges. The Masters of the Gold Scrolls, a group of artists all working in a similar style, supplied illumination for the mass market at the same time. The second half of the century witnessed the rise of more distinct artists, among whom Willem Vrelant, the Master of the Dresden Prayer Book, and especially Simon Marmion are noteworthy. Simon Bening can easily be considered the greatest Flemish illuminator of the sixteenth century. Following him, finally, the work of the Master of Charles V brings Flemish illumination to its close.

As high points in the history of art, two Books of Hours in the collection stand out. The Hours of Catherine of Cleves and the Hours of Cardinal Alessandro Farnese are members of that restricted club,

"the most important Books of Hours in the world." For its iconographic ingenuity and stylistic virtuosity, the illumination by the eponymous Master of Catherine of Cleves is for Dutch painting what the *Très Riches Heures* (Chantilly, Musée Condé, MS 65) is for French art. The nine years Giulio Clovio spent painting the Farnese Hours resulted in manuscript that so dazzled Vasari he felt compelled to describe all of its miniatures in the second edition of his *Lives of the Painters*; he called the manuscript one of the "marvels of Rome."

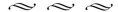

This publication has two goals. The first is to offer a selection of images from one hundred of the most significant manuscript and printed Books of Hours in The Pierpont Morgan Library. The accompanying captions briefly discuss the images' place in the Book of Hours, their iconography, and where known, something about the artist who painted or designed them. The second goal is to offer enough of the actual texts and prayers typically found in a Book of Hours—by way of paraphrase, description, translation, and the outlines provided in appendix 1—so the reader can learn something of their nature, their flavor, and their poetry. It is hoped that the conjoint treatment of pictures and textual discussions will conjure up something of the experience of what it was like to use a Book of Hours—where images and prayers operated on separate, though related, planes.

Recently I attended a Catholic Mass. No one prayed from his or her own prayer book; instead, the members of the parish used copies of Missals provided to them from the shelf attached to the pew in front. These books were truly sad affairs: skinny, printed on newsprint, unillustrated, and bound in flimsy paper, they were slipped into cheap plastic folders. Returning home, I opened the Missal I had used as a child, a First Communion gift from my parents. Hardbound in black and with red fore edges, it looked, to my young eyes at that time, like the prayer books used by the priests and nuns who taught me. Fat, it was filled with not only the very texts recited by the priest at Mass but also numerous special prayers; it also had pictures, both colored and black-and-white. As a child I stuffed it with holy cards containing my favorite images. Thirty-five years later, in my hands, this prayer book still spoke to me, the apostate adult. How much this book had meant to me as a believing child.

My Missal has long since lost its influence and power over me. But for a brief Proustian moment, I tasted again its effect. And I had a fleeting glimpse, I thought, into the kind of magic a Book of Hours must have had for its owner, years and years ago.

Nota bene

Biblical passages are quoted from the Rheims-Douai Bible (also called the Douay Version). Completed in 1610, it was the first complete English Bible produced for Catholics after the invention of printing. The Rheims-Douai Bible was translated from the Latin Vulgate, which itself is a translation, largely from Hebrew and Aramaic sources, that St. Jerome completed in 405. In the mid-eighteenth century, the Rheims-Douai Bible was revised by Bishop Challoner of London; his revised Bible became the standard for English-speaking Catholics and remained so until shortly after the Second Vatican Council (1962–65). The Rheims-Douai Bible (in Challoner's revision) is used here because, as a translation from the Vulgate, it is the most accurate reflection of the medieval Bible and thus also of the biblical passages that found their way into Books of Hours.

I. CALENDAR

CALENDARS, AT THE FRONT OF ALL BOOKS OF HOURS, had the same function in the Middle Ages as calendars do today: to tell you what day it is. They do this, however, not (as we now do) by enumerating the days of the month, but by citing the feast that was celebrated on that particular day. Today, when we speak of Christmas Eve, Christmas Day, St. Valentine's Day, St. Patrick's Day, and Halloween, we know we are referring to December 24 and 25, February 14, March 17, and October 31. This is the medieval way of telling time.

The feasts listed in medieval Calendars are mostly saints' days, that is, commemorations of those particular days on which, tradition has it, the saints were martyred (their "birthdays" into heaven). Other feasts commemorate important events in the lives of Christ and the Virgin. In addition to Christmas Eve and Christmas itself, Calendars celebrate Christ's Circumcision (January 1) and the Epiphany (January 6). The Virgin's feasts include her Conception (December 8) and Birth (September 8), the Annunciation (March 25) and Visitation (July 2), her Purification in the Temple (February 2), and her Assumption into Heaven (August 15). No Calendars include the events of Christ's Passion, his Resurrection, or his Ascension, nor the Descent of the Holy Spirit. That is because these were movable feasts whose dates depend upon that of Easter, the celebration of which changed from year to year (and more about which later in this chapter). Thus, Calendars in Books of Hours (as they are in all of the Church's liturgical service books) are, in a way, perpetual calendars since they can be used from one year to the next.

Some feasts, of course, are more important than others, and their relative importance, or grading, is indicated in the way Calendars are written. The majority of feasts are written in black (or dark brown) ink, whereas the more important feasts appear in red (hence, our term *red-letter day*, meaning a major event) or, sometimes, blue. Some Calendars have triple gradations, with the most important holy days in gold, the less solemn in red, and the least in black. These genuinely triple-graded Calendars are not to be confused with those from some deluxe French manuscripts of the late fourteenth and early fifteenth centuries whose highly decorative layouts alternate their feasts in red and blue but with the more important ones in burnished gold. Finally, a rare Calendar or two might be graded in gold and silver.

While most of the feasts mentioned so far have been universal, that is, celebrated by the medieval Catholic Church as a whole, Calendars also include feasts of a more local interest. These are the ones that help determine the Calendar's "use," that is, the place where the manuscript was intended to be used. (For other use indicators, see the discussions in reference to the Hours of the Virgin and the Office of the Dead in appendix 1.) Local festivals can indicate the country, region, city, parish, or in a few rare instances, the particular church in which a Book of Hours was to be used. Paris Calendars always highlight the feasts of St. Geneviève, patroness of the city (January 3), and St. Denis, patron saint of France, whose place of martyrdom, Montmartre, is named after that occurrence (September 9). Calendars for Rheims cite Sts. Gervasius (June 19), Martialis (July 3), and the sixth-century bishop of the city, Romanus (October 23), as red-letter days. The institution of a feast celebrating the transfer (or sometimes theft) of a saint's relics from one site to another, called a translation, is also a good indicator for local use. Rouen

celebrates the translations of St. Audoenus, to whom a magnificent fourteenth-century church is dedicated (May 5), St. Eligius (May 25), and a general feast of all the city's translations (December 3). Rouen Calendars sometimes include the dedication of their great cathedral (October 1). *Horae* made for Orléans use might include the celebration of Joan of Arc's deliverance of the city from the English after a seven-month siege in 1429 (May 8). In addition to geographic uses, some Books of Hours were made for particular religious orders, such as Franciscan or Dominican.

The use of a Calendar can be helpful (but one must be careful) in determining where the Book of Hours was actually made. Paris Calendars almost always mean "made in Paris," since with its productive workshops the French capital had no need to import manuscripts manufactured elsewhere. Most Dutch Books of Hours, too, were made locally. But many *Horae* with English Calendars were manufactured in Flanders or France, both of which exported many manuscripts to that country. Books of Hours with Spanish Calendars, too, were often made in Belgium. The situation continued with printed *Horae* but is less confusing, since their colophons or title pages often give, in addition to the manuscript's use, the name and city of the printer.

To the left of the list of saints' days are repeating series of letters running *A* through *G*. These are the Dominical Letters, so called because they help one find Sundays (and, of course, all the other days of the week) throughout the year. Each year this Sunday Letter changed, moving backward. In leap years it changed a second time (on February 25); thus, feasts that in a common year had been on the previous day, now "leaped" to two days apart. To find the Dominical Letter for any year from 1 to 1582 (end of the old calendar system), take the year and add to it a quarter of itself (ignoring the remainder); divide the sum by seven; subtract the remainder from three or, if that produces zero or a negative number, from ten; the resulting number corresponds to the Dominical Letter (1=*A*, 2=*B*, etc.). Here is the example for the year 1534:

$$1534 + (1534 / 4) = 1534 + 383 = 1917$$
$$1917 / 7 = 273, \text{ remainder } 6$$
$$10 - 6 = 4$$
$$4 = \text{Dominical Letter } D.$$

At the far left in most Calendars is an odd column of Roman numerals that run from *i* to *xix* (the series is not consecutive, however, and there are gaps). These are the Golden Numbers, which indicate the appearances of new moons and, counting ahead fourteen days, full moons throughout the year. To find any given year's Golden Number, take the year and add one; divide by nineteen; the remainder is the Golden Number (if the remainder is zero, the Golden Number is nineteen). Here is the example for the year 1534:

$$1534 + 1 = 1535$$
$$1535 / 19 = 80, \text{ remainder } 15$$
$$xv = \text{Golden Number for the year 1534.}$$

This dreadfully esoteric information was extremely important to the medieval Christian. With it he or she could determine the date of Easter, the Church's most important feast, in any given year. Easter was celebrated on the Sunday following the first full moon that falls on or after the vernal equinox (the

spring day when day and night are the same length); should the full moon occur on a Sunday, Easter is then pushed to the following Sunday. The varying occurrence, from one year to the next, of that first full moon and the occasional pushed Sunday account for the widely disparate dates for medieval (and modern) Easters.

Finally, many Calendars, especially those from the thirteenth to the mid-fifteenth century, include the ancient Roman calendrical system. In this most confusing of all systems, each month had but three fixed points: Kalends (always the first day of the month and from which we derive our term *calendar*), Ides (the middle of the month, either the thirteenth or fifteenth), and Nones (the ninth day before the Ides, counting inclusively; it fell on the fifth or seventh of the month). All the days in between were counted

12. AUGUST

This Calendar, from an early Book of Hours, includes all the usual contents (reading from the left): the Golden Numbers, Dominical Letters, Roman calendar, and list of feast days. The important holy days were written in red, such as the one on the first line, "Ad vincula sancti Petri" (Feast of St. Peter's Chains), and lesser ones in black, like the second line, "Stephani pape" (Feast of Pope Stephen I). This Calendar also contains the traditional pictorial vignettes, the labors of the months and the signs of the zodiac. Here, for August, the labor is threshing wheat, performed by a youth stripped down to his medieval underwear, and the astrological sign is Virgo, represented by a young woman proffering a flower.

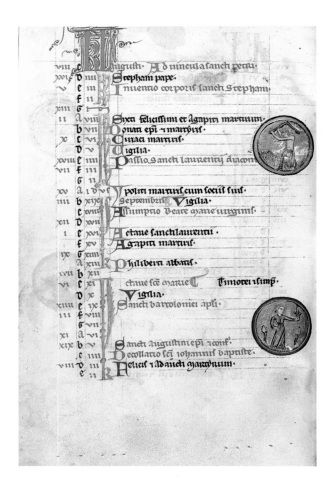

Under the patronage of King Philip Augustus (1165–1223), the regent Blanche of Castile (1188–1252), and her son Louis IX (1214–70), manuscript illumination flourished in thirteenth-century Paris. Many workshops grew out of the royal commissions of the massive Moralized Bibles whose illustrations for a single copy numbered in the thousands. This Book of Hours, from one of Paris's finer workshops, contains 14 large and 118 small miniatures.

The prickings clearly visible at the bottom of the leaf were used as guides to the scribe when laying out the multiple columns of text. The first group of five holes were for the verso, the second for the recto. The corresponding prickings at the top were cut off when the leaf was trimmed.

Hours for Soissons use. France, Paris, 1230s (MS M.92, fol. 18v).

backward from these three fixed points. Thus St. Valentine's Day was not February 14 according to Roman time, but *xvi Kalends Martii*, or the sixteenth day before the Kalends of March.

Medieval time was Roman time. It followed the reformed but still imperfect system instituted by Julius Caesar (100–44 B.C.). By the thirteenth century, it was noticeably out of sync with reality: by the late Middle Ages, full moons were not appearing until ten days after the Calendars said they were supposed to. Easter was moving on into summer. Pope Gregory XIII (papacy, 1572–85) reformed the Julian calendar and, adding ten days (October 4 in 1582 was followed by October 15) and other fine tunings, instituted in 1583 the Gregorian calendar we use today. And this is why, if I run the calendar in my computer backward, it stops in that year.

13. FEBRUARY

The major holy day in the first half of February occurs on the 2nd, the Purification of the Virgin, written here in red. This is followed by lesser feasts penned in black, including St. Blaise (February 3), who is still invoked today against throat ailments. St. Valentine's Day (February 14) appears near the bottom. This Calendar (as well as the one in the previous reproduction) includes a number of blank spaces; these are the ferial days, that is, weekdays on which the feast of a saint was not celebrated. Liturgically this meant that the Mass for that particular day related to the season (from January 2 to 5, for example, the Mass of the Circumcision was said on ferial days). Calendars in later Books of Hours, such as those in the following three reproductions, tend to be composites, with a saint's feast supplied for every day. Such Calendars—visually appealing to the medieval eye—were of little practical use.

While most of this Book of Hours is in Latin, the Calendar and some prayers, as was typical with *Horae* made in France, appear in the vernacular. At the bottom are the labor of the month, keeping warm (the Latin inscription reads, "I burn wood"), and the zodiacal sign of Pisces.

Hours for Rome use. Northern France, early fifteenth century (MS M.264, fol. 2r).

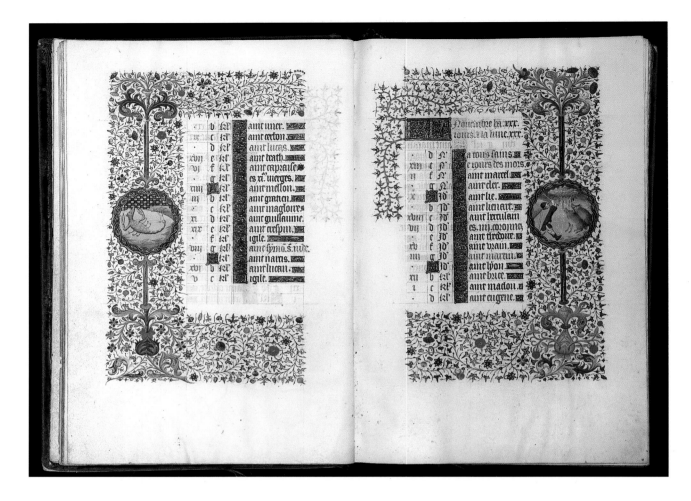

14. OCTOBER–NOVEMBER

by the Bedford Master and his workshop

The handsome layout of this Calendar is typical of deluxe French Books of Hours of the late fourteenth and early fifteenth centuries. The feasts alternate red and blue (note, however, the scribal error at November 10, where St. Vrain has mistakenly been written in blue) with the important days written in burnished gold: "La tous sains" (All Saints' Day) and "Le iours des mors" (All Souls' Day) on November 1 and 2. This Calendar reflects the Roman calendar's fading utility: "N," "Id," and "Kl," the abbreviations for Nones, Ides, and Kalends, are indicated, but without their accompanying Roman numerals (present, for example, in the two previous illustrations), the system is rendered useless.

The luxury of the layout continues in the borders, whose verdant foliage, strewn with burnished gilt ivy leaves, frames the text and sets off the vignettes of the labor and astrological sign like jewels among the decoration. The task for November is feeding to hogs acorns procured by shaking oak trees; the zodiacal sign, on the left, is October's Scorpio.

The manuscript was illuminated by the Bedford Master, named after the manuscripts he painted for Duke John of Bedford (1389–1435), regent in France for the young English King Henry VI (1421–71). One of the hallmarks of the Bedford Master's style was the use of multitudinous border vignettes; this Book of Hours contains 356 marginal medallions (see also no. 36).

Hours for Rome use. France, Paris, c. 1430–35 (MS M.359, fols. 10v–11r).

15. September

From the thirteenth to the early fifteenth century, Calendar illustrations were usually vignettes, small pictures no larger than modern (domestic) postage stamps. But throughout the course of the fifteenth century, artists and their patrons took an increasing interest in these secular elements, which begin to grow, both in size and importance. In this manuscript the illustrations of the labors break through the gold frame enclosing the Calendar and rise through the foliate border.

The miniatures throughout this Book of Hours are all housed within elaborate architectural structures, and so is the Calendar, where even the outdoor labors are performed "indoors." September's work is wine making; workers remove full baskets from their horse, carry them upstairs, and dump the grapes into a vat for stomping.

Hours for Rome use. Southeastern? France, c. 1430 (MS M.64, fol. 9r).

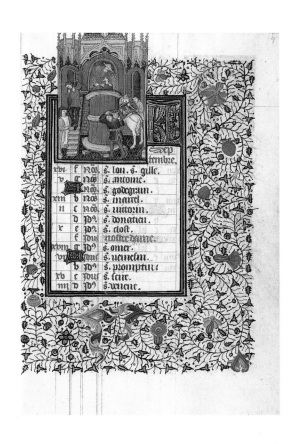

16. June

by the Master of Morgan 85

Whereas all the Books of Hours discussed thus far in this chapter can be called Gothic or late medieval in style, this manuscript is a product of the Renaissance. In the first two decades of the sixteenth century, a taste for things Italian swept the royal court and influential patrons such as Cardinal Georges d'Amboise, archbishop of Rouen. French manuscripts succumbed to the charisma of the Italian Renaissance. We detect this immediately in this manuscript's calligraphy, a clearly legible Italian humanist script (as opposed to Gothic script, at times difficult to read). Note, too, how, because of the Renaissance interest in clarity, the Golden Numbers, as well as the numbers of the Roman calendar, are written in arabic, not in Roman numerals. The influence of the Italian Renaissance is also evident in the depiction of June's labor, mowing and gathering hay. The artist emphasizes the grace and nobility of the workers, not the work performed.

The Master of Morgan 85 was a member of the prolific workshop of Jean Pichore, a Parisian artist who headed a commercial enterprise that included a vast atelier and even an excursion into printing (see no. 52). While Pichore himself executed the commissions with large and complex miniatures for his important clients, he relied upon his talented staff, including the Morgan 85 Master, to turn out the many Books of Hours that were his bread and butter.

Hours for Rome use. France, Paris, c. 1510–20 (MS M.85, fol. 6r).

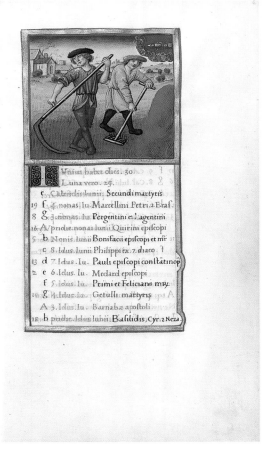

17. December

by Simon Bening

It was Simon Bening (1483/84–1561), the last great Flemish illuminator, who capitalized on the taste for large Calendar miniatures, taking them to their limit by making them full-page. The artist was stimulated by one of the most famous of all medieval Books of Hours, the *Très Riches Heures* of Jean, duc de Berry (Chantilly, Musée Condé, MS 65), which Bening saw when it was in the library of Margaret of Austria in Malines. Its large Calendar pictures, unique in the early fifteenth century, inspired Bening to create the miniatures in this manuscript, the first in a series of full-page Calendar cycles. The duc de Berry's manuscript also intensified Bening's interest in landscape. As seen in this December miniature depicting the butchering of a hog, the landscape—the wintery cold of snow-covered hills and bare trees—is the real subject of the picture.

Bening's fame was widespread in his lifetime, and his creations were much sought after, not only in Belgium, but also in Italy, Germany, and Portugal. This manuscript, for example, was made for a member of the Portuguese Sá family; it then passed to King Manuel's armorer, Alvaro da Costa, after whom it takes its name.

"Da Costa Hours," for Rome use (Office of the Dead). Belgium, Bruges, c. 1515, for a member of the Portuguese Sá family (MS M.399, fol. 13v).

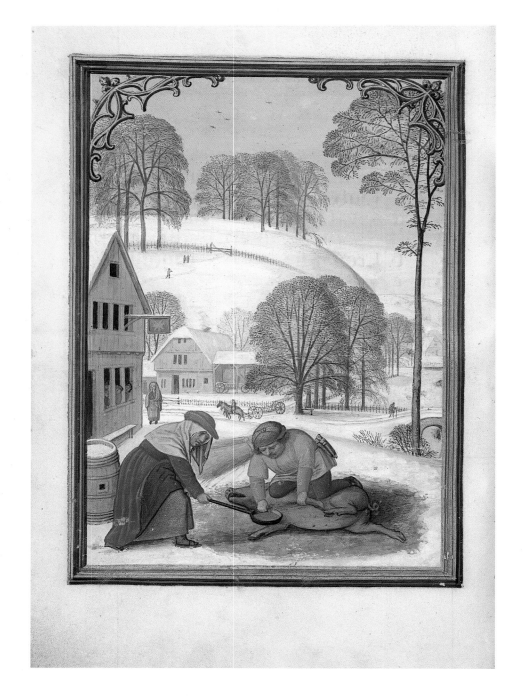

18. September–October
by the Master of Anne de Bretagne

The most striking feature of many of the early printed *Horae* is their multitudinous images. At a cost much lower than their manuscript competitors, printers were able to offer their customers more pictures per book. This richness is apparent even in Calendars. In addition to the expected labors and zodiacal signs (sowing winter wheat and Libra for September; wine making and Scorpio for October), this Calendar illustrates major feasts with border vignettes: Sts. Michael (September 29), Luke (October 18), and Dennis ("Dionysii": October 9) are all given small pictures in the margins. Amusing grotesques or putti fill the remaining border, while horizontal illustrations of children's games (blindman's buff) or seasonal activities (making barrels) fill the bottom.

The designer of these metalcuts is the Master of Anne de Bretagne, named after the very beautiful and very small (2 1/2 x 1 3/4 inches) Book of Hours he illuminated for Anne de Bretagne (1477–1514), queen to two kings of France, Charles VIII and Louis XII (Paris, Bibliothèque Nationale de France, MS nouv. acq. lat. 3120). Terrifically talented, the Anne Master was head of a shop that not only painted manuscripts, but also drew cartoons for stained glass and tapestries (including the Hunt of the Unicorn tapestry series, the Cloisters Collection, Metropolitan Museum of Art, New York), and designed images for printed books (see also nos. 23, 28, and 38).

Hours for Rome use. France, Paris, 20 March–17 April 1497, printed by Philippe Pigouchet for Simon Vostre (PML 572 [ChL 1481], fols. a6v–a7r).

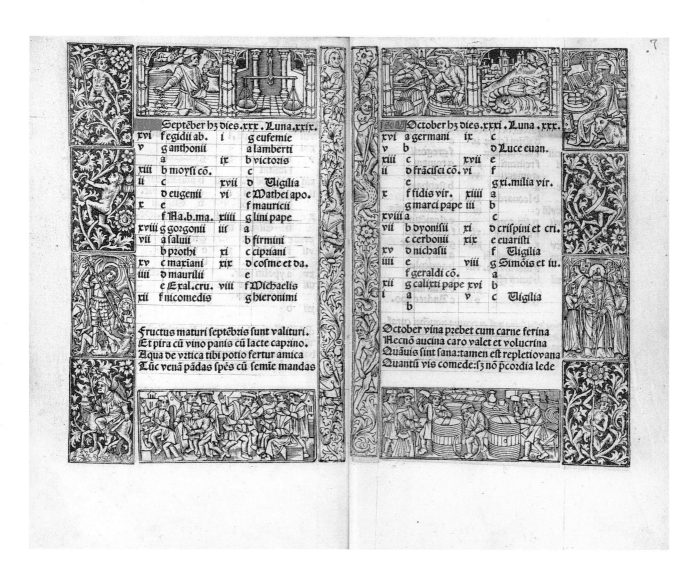

19. GEMINI

attributed to Venturino Mercati

The picture cycles in this Book of Hours are quite idiosyncratic and were certainly commissioned by someone who had very individual iconographic preferences. The Virgin Mary, for example, barely makes an appearance within her own Hours, which have been taken over by miniatures and historiated initials depicting other saints. The Calendar is equally eccentric. Gone are any references to the labors of the month; instead, there are unusual full-page illustrations of the signs of the zodiac in which the figures suggested by the stars have been fleshed out. The minor element has become the major theme.

The illumination is attributed to Venturino Mercati, a Milanese artist who worked on the choir books at Siena Cathedral from 1466 to 1475 and at Monte Oliveto Maggiore, near nearby Pienza, between 1472 and 1480.

Hours for Rome use. Italy, probably Milan, c. 1470 (MS G.14, fol. 7v).

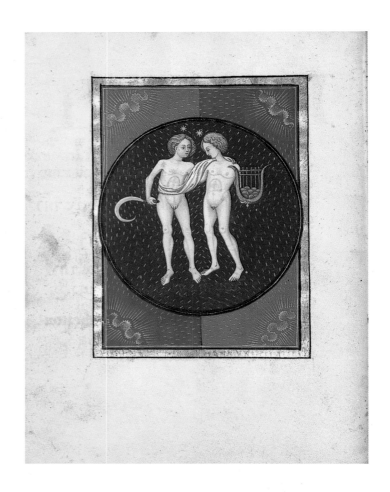

20. VIRGO

attributed to Agostino Decio

Like the previous manuscript, this minuscule (2 3/4 x 1 7/8 inches) Book of Hours eschews the labors of the month and devotes its Calendar illustrations solely to the signs of the zodiac. Painted on golden skies, the signs appear to us as if through a momentary parting of the clouds. Here, Virgo holds lilies, Marian symbols of virginity.

The illumination is attributed to Agostino Decio, a member of the sixteenth-century Milanese family of artists. A Missal in the Morgan Library (MS M.377) signed "Decius" and dated 1534 is also generally thought to be painted by Agostino. The pastel palette and elegant, attenuated figures are typical of the Mannerist style. As indicated by its calligraphy, this Book of Hours was written in France, possibly Tours. Although Decio is said to have worked for Emperor Rudolf II (1552–1612) and the dukes of Savoy, there is no evidence, other than this manuscript, that he ever worked in France.

Hours for Rome use. France, Tours? c. 1530–40 (MS M.1030, fol. 8r).

21. SECOND AGE OF MAN

Although there are a few manuscripts with this theme, the Ages of Man (as opposed to the labors or zodiac) were apparently only used as Calendar illustrations in sixteenth-century printed *Horae*. Traceable to a fourteenth-century French poem, the Twelve Ages divide man's life span into periods of six years each and draw parallels between the seasonal changes and man's growth, maturity, and decline. January (the first six years) symbolizes infancy; February (ages seven to twelve) denotes childhood; March (thirteen to eighteen) represents adolescence; and so forth, until December when (at seventy-two) man succumbs to senility and death.

Shown here is the woodcut illustrating the month of February, where children learn or are punished for not doing so. The sign of Pisces can be seen through the window. The cut shows the influence of both the Italian Renaissance, as exemplified in the antique pilasters and garlands that frame the page, and German printmaking, as in the drapery of the clothing worn by the teachers and students. The French quatrain below the picture was translated in contemporaneous English editions as, "The other vi yeres is lyke February, In the ende ther of begynneth the sprynge, That tyme chyldren is moost apt and redy, To receyve chastysement, nurture, and lernynge."

Hours for Paris use. France, Paris, 19 June 1525, printed by the widow of Thielman Kerver (PML 125446, fol. A3v).

22. PLANETARY MAN (*right*)

Among the extra images often found in the Calendars of printed *Horae* are those illustrating the effects of the planets on different parts of the human body, shown here as an eviscerated corpse. Starting at the top and proceeding clockwise, this diagram reveals that the sun (considered, like the moon, a planet) rules the stomach; Venus, the kidneys; the moon, the head (the crouching jester alludes to lunar madness); Mars, the gallbladder; Jupiter, the liver; and Saturn, the spleen. In the corners are personifications of the four temperaments. The choleric, whose symbol is the lion, angrily stabs himself; he is associated with the element of fire. The sanguine calmly holds his hawk, accompanied by a monkey; his element is air. The melancholic leads a pig; his element is earth. The phlegmatic's animal is the lamb and his element water.

One of the most productive printers of *Horae* in the late fifteenth century, Philippe Pigouchet produced editions for himself, Simon Vostre, and the de Marnef brothers. This is possibly his earliest Book of Hours.

Hours for Rome use. France, Paris, c. 1488–91 (almanac 1488–1508), printed by Philippe Pigouchet for Enguilbert, Jean, and Geoffroy de Marnef (PML 127562 [ChL 1475X], fol. a2v).

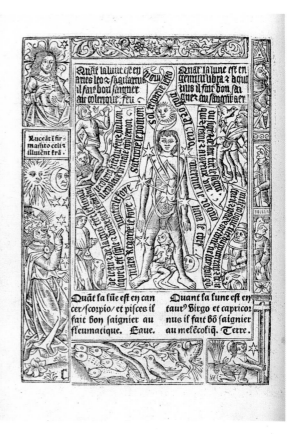

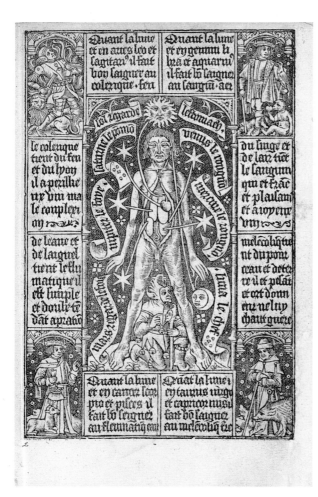

23. PLANETARY MAN (*left*)

by the Master of Anne de Bretagne

The information contained in this and the previous Planetary Man was especially pertinent to the foremost medical practice of the Middle Ages (and later): bleeding, to rid the body of bad blood and harmful fluids. The instructions here and on the previous cut relate the best zodiacal times for this medical procedure. The upper left text, for example, tells us, "When the moon is in Aries, Leo, and Sagittarius, it is good to bleed the choleric."

Hours for Rome use. France, Paris, 28 June 1500, printed by Philippe Pigouchet for Simon Vostre (PML 580 [ChL 1487], fol. a2r).

24. ZODIACAL MAN

In addition to Planetary Man, many printed *Horae* included cuts illustrating the influence of the zodiac over different parts of the body. As seen here, Aries governs the head and face; Gemini, the shoulders, arms, and hands; Leo, the stomach, heart, and back; Libra, the navel, groin, and buttocks; Sagittarius, the thighs; Aquarius, the legs from the knees to the heels and ankles; Pisces, the feet; Capricorn, the knees; Scorpio, the genitals; Virgo, the belly and entrails; Cancer, the breast, sides, and spleen; and Taurus, the neck and throat. This information, used in conjunction with that provided with charts of Planetary Man, was especially useful in times of disease or injury.

Marcus Reinhard's establishment in Kirchheim was his second press. Earlier he had been a printer in Lyon but had closed shop around 1482. Success seems to have eluded him in Alsace, however. He began around 1489–90, apparently with this *Horae*, but his presses stopped by the mid-1490s.

Hours for Rome use. France, Kirchheim (Alsace), c. 1490 (almanac 1490–1508), printed by Marcus Reinhard (PML 32528.1 [ChL 578], fol. π2r).

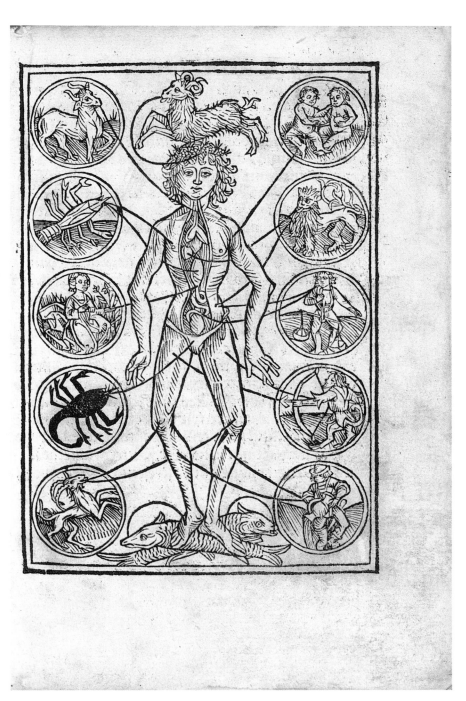

25. ANNUNCIATION AND GREEK ALPHABET

This abbreviated Book of Hours printed in Greek, whose core texts include only the Hours of the Virgin, Penitential Psalms, and Litany, is an instructional volume. As a group of prayers with which all literate Italians would have been familiar, its texts, when translated, offered an ideal means for learning a new language. As an aid, the Greek text is preceded by a grammar, which Aldus Manutius (1449–1515) himself wrote for the volume. It consists of an alphabet (the beginning of which is shown here), a pronunciation guide, a table of abbreviations and ligatures, and a list of accents. As an introduction to the language, there follows a series of prayers, printed in alternating lines of Latin and Greek, that all Christians knew by heart: the Our Father, Hail Mary, Apostles' Creed, the beginning of John's Gospel (the "In principio"), "Salve Regina," and so forth.

Hours for Rome use. Italy, Venice, 5 December 1497, printed by Aldus Manutius (PML 21863 [ChL 1005 & 1002], fols. a1v–a2r).

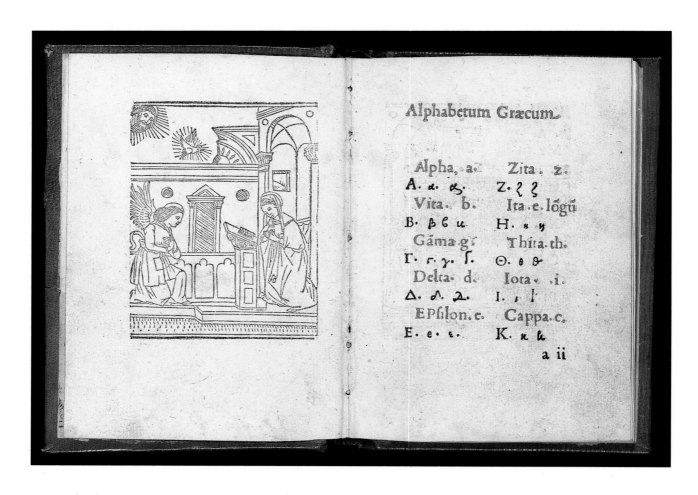

II. GOSPEL LESSONS

FOLLOWING THE CALENDAR, which one did not read so much as consult, the first text proper in a Book of Hours is a series of Gospel Lessons by the four evangelists. Although not always found in *Horae* of the thirteenth and fourteenth centuries, by the fifteenth these Lessons had become a regular feature.

The first reading, from John (1:1–14), is a kind of preamble for the entire Book of Hours. "In principio erat Verbum. . ." (In the beginning was the Word, and the Word was with God, and the Word was God. The same was in the beginning with God. . .). The Word of God, existing from eternity, becomes the revealer of the Father and the light of men. The text thus emphasizes the eternal generation of the Word, who is Jesus Christ, mankind's need of redemption, and God's willingness to provide it. The passage continues, alluding to the witness of John the Baptist, mankind's rejection of Christ, and the theme of Christians as the new children of God, and it ends with the Incarnation.

Luke's Lesson (1:26–38) describes the Annunciation: "Missus est Angelus Gabriel a Deo in civitatem Galilaeae, cui nomen Nazareth, ad virginem desponsatam viro, cui nomen erat Joseph, de domo David, et nomen virginis Maria. . ." (The angel Gabriel was sent from God into a city of Galilee, called Nazareth, to a virgin espoused to a man whose name was Joseph, of the house of David; and the Virgin's name was Mary. . .). Gabriel addresses the Virgin, "Ave gratia plena. . ." (Hail, full of grace, the Lord is with thee: blessed art thou amongst women), the famous salutation that would become the first part of the Hail Mary, the prayer to the Virgin that all medieval Christians knew by heart. Luke's account ends with the Virgin's acceptance of God's will: "Be it done to me according to thy word."

The reading from Matthew (2:1–12), after mentioning the birth of Christ, launches into the story of the Three Magi: "Cum natus esset Jesus in Bethleem in diebus Herodis regis, ecce Magi ab Oriente venerunt Hierosolimam. . ." (When Jesus was born in Bethlehem in the days of King Herod, behold, there came wise men from the East to Jerusalem. . .). The passage relates the Magi's interview before Herod (and his concern over the prophecy of the Messiah), their worship of Christ, their gifts, and, finally, their return home.

Mark's Lesson (16:14–20), "Recumbentibus undecim discipulis, apparuit illis Jesus. . ." (Jesus appeared to the eleven as they were at table. . .), relates Christ's appearance to the eleven apostles after the Resurrection, his command to preach salvation throughout the world, his granting miraculous powers to them (including exorcism), and, finally, his Ascension.

Except for Christ's Passion (which is discussed later in this chapter), these excerpts from the New Testament touch on the major events from the life of the Savior. Two of them, indeed, dwell especially on the Christmas story, those events from Christ's Infancy that were so dear to medieval people. These readings, however, were not arbitrarily chosen from the Bible for insertion into the Book of Hours. They are actually the Gospel Lessons that were read on four of the Church's major feasts: Christmas Day, December 25 (John's reading is from the main Mass of the day); the Feast of the Annunciation on March 25 (Luke); Epiphany, January 6 (Matthew); and the Feast of the Ascension, a movable feast whose date

depended upon that of Easter (Mark). Each Book of Hours thus contained, in a way, the essence of the Church's liturgical year, encapsulated in these four readings. In the introduction, I mentioned how the Book of Hours was a kind of lay Breviary, created by a jealousy on the part of the laity to own their own prayer book. Containing these four Gospel Lessons, the Book of Hours thus also steals a small but important group of texts from the Missal, the service book used at the altar when the priest celebrated Mass. The Lessons in a Book of Hours, however, are not arranged in *liturgical* order (the Feast of the Annunciation on March 25 is, of course, always celebrated after that of the Epiphany on January 6). The sequence of these four readings has been altered so that their composite narrative relates the events in their proper *chronological* order: God's divine plan (John); the Annunciation and Incarnation (Luke); Christ's Nativity and his manifestation to the world (Matthew); Christ's sending his apostles on their missionary way and his Ascension (Mark).

By the late Middle Ages, these particular passages had acquired a special, almost magical position in the lay mind. As Eamon Duffy has related, priests could be hired to recite them specially, as a protection against harm to oneself or against damage to one's house. They appear together in some English processionals and were read aloud during annual processions that blessed the parish in the hope of scattering demons and ensuring the fertility of the fields. John's Lesson, the "In principio," was one of the most numinous texts of this period. It was used at the blessing of bread at Sunday Mass and was the final Gospel recited by the priest at the end of each Mass. Pope Clement V (papacy, 1305–14) issued an indulgence of one year and forty days to those who, while listening to the last Gospel, kissed something—a book, a sacred object, or even their thumbnail—at the words, "Verbum caro factum est" (The Word was made flesh). Inscribed on a strip of vellum and hung around the neck, this sacred text was thought to ward off evil; ailing cattle could be cured by this charm if dangled from their horns.

As mentioned earlier in this chapter, Christ's Passion was the one important part of the Savior's life not covered by the four Gospel Lessons. This lacuna was clearly felt by the owners of Books of Hours, with the result that the story of the Passion was often included in *Horae* in the form of an extra reading taken from John (18:1–19:42). This is the haunting eyewitness account by the one apostle who remained at the foot of the cross, along with Mary, during the entire Crucifixion. It was John's version of the Passion with which medieval men and women would have been most familiar, as it was this account that was read or chanted on Good Friday. On this day, medieval Christians imitated John's devotion in a service where they would join in procession, kneel, and kiss a statue of Christ crucified (called "creeping to the cross" in England). John's Passion, something of an optional text in manuscript *Horae*, became standard in printed Books of Hours. In the latter, the Passion of Our Lord Jesus Christ according to John is almost always found immediately after the traditional four Lessons.

These Lessons operated on many levels for the owners of the books that contained them. As extracts from the Bible, they offered one of the very few ways that late medieval Christians could actually possess the New Testament word of God (households did not own Bibles). As texts by the evangelists, the Lessons contained these authors' direct accounts of the life of Christ. As Gospel readings taken from the Missal, they formed a microcosm of the liturgical year. Appearing at the front of the Book of Hours, they form its foundation, the legitimizing structure upon which the rest of the prayers that follow are built. They helped, too, transform for its possessor the Book of Hours from a collection of texts into a sacred object.

26. JOHN ON PATMOS

by a follower of the Master of Petrarch's Triumphs

Immediately following the Calendar are the Gospel Lessons. In a tradition that can be traced back to classical antiquity via Carolingian Gospel Books, each of these readings usually had an author portrait as a frontispiece. That for John, whose text appears first, customarily depicts the evangelist on the isle of Patmos, where he had been exiled by the Roman emperor Domitian (ruled 81–96). It was there that John received his vision of the Apocalypse and wrote the Book of Revelation. As shown here, the clouds open to reveal the Virgin of the

Apocalypse: Mary, holding Christ, trampling the evil seven-headed beast. Down on the earth, John's symbol, an eagle, offering him ink, tries to get the evangelist's attention.

The illuminator's style is close to that of an artist nicknamed the Master of Petrarch's Triumphs after a glorious copy of *Les triomphes* by Petrarch (Paris, Bibliothèque Nationale de France, MS fr. 594) that was illuminated for King Louis XII of France (ruled 1499–1515). Both the Triumphs Master (see also nos. 9, 10) and this follower were members of the Parisian atelier of Jean Pichore (see no. 52). Pichore's workshop produced manuscripts and at least one printed book in the Italianate style, a taste for which emerged in France at the end of the fifteenth century and continued into the sixteenth. Dramatic in this Book of Hours is the severe but handsome palette limited to black, white, shades of gray, and gold. Renaissance pilasters and garlands frame the miniature.

Hours for Rome use. France, Paris, c. 1520 (MS M.632, fol. 13v).

27. JOHN BOILED IN OIL

by the Master of Morgan 96

While the Gospel Lessons in most Books of Hours have the traditional author portraits showing the evangelists busy writing their texts, some miniatures depicted scenes from their lives as well. In this miniature, while John is shown writing on the isle of Patmos in the bottom border, above, in the main image, he is boiled in oil.

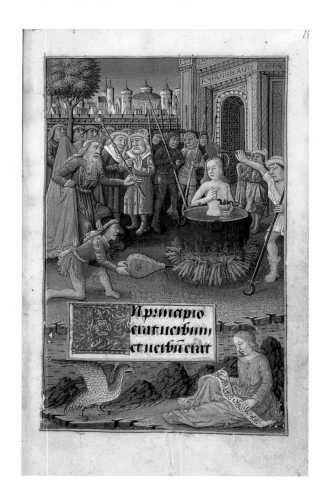

Emperor Domitian directs the torment while one torturer ladles the saint with the scalding liquid—miraculously, the evangelist survives the experience. (John Boiled as an illustration for the first Gospel Lesson became very popular in printed *Horae*; see next reproduction.) The cup filled with serpents in John's hand alludes to another unsuccessful attempt on his life. Offered poison by the high priest Aristodemus and challenged to drink it without ill effect, John did so (the miracle converted the priest, the local proconsul, and the latter's entire family).

The Master of Morgan 96, named after this manuscript, was a follower of Jean Fouquet, the great Tours painter of both panels and miniatures (see no. 29). The Morgan 96 Master's charming style, less refined than that of his great mentor, is characterized by big heads with large noses and heavy jaws.

Hours for Tours use. France, Tours, c. 1480 (MS M.96, fol. 11r).

28. JOHN BOILED IN OIL (*opposite*)

by the Master of Anne de Bretagne

This extremely rare printed Book of Hours was produced to teach children to read. It is a practical, not a luxurious, volume. It is printed on paper, instead of more expensive vellum, and the type font is unusually large, clear, and legible. Secondary texts (antiphons, versicles, responses) are made slightly smaller, as if to emphasize, in a didactic manner, their subordinate role. Decorative line fillers have been done away with. At the beginning of the book, right after the Calendar, is a series of prayers—the Our Father, Hail Mary, Apostles' Creed, and so forth—that medieval children were taught to memorize (there was no need for these in Books of Hours used by adults). Although the publisher, Simon Vostre, uses cuts from his contemporaneous editions (see, for example, no. 38), a greater contrast could not be found between this simple *Horae* and his deluxe editions. The bare cuts here are askew on the page and have no framing border vignettes.

Hours for Paris use. France, Paris, 8 September 1498, printed by Ulrich Gering and Berthold Rembolt for Simon Vostre (PML 19604 [ChL 1504], fol. b2v).

Initiū sancti euāgelij Secundū Johannem. Gloria tibi domine.

N principio erat verbū ⁊ verbū erat apud deū: et deus erat verbū Hoc erat in principio apud deū. Omīa per ipsuz facta sunt ⁊ sine ipo factū est nichil. Qd̄ factū ē in ipso vita erat: et vita erat lux hominum: ⁊ lux in tenebris lucet: et tenebre eam non comprehenderunt. Fuit homo missus a deo cui nomen erat iohānes. Hic venit in testimoniū vt testimoniū perhiberet de lumine: vt omnes crederent per illum. Non erat ille lux sed vt testimoniuz

29. LUKE

by Jean Fouquet

This miniature by Jean Fouquet (c. 1420–c. 1480), considered the greatest French painter of the fifteenth century, alludes to Luke's three traditional professions. As evangelist, he is shown writing his Gospel, while the picture of the Virgin on his workbench refers to Luke as a painter (tradition has it that he executed a portrait of Mary from life), and, finally, the glass bottles on the shelf (shaped like those for urine specimens) symbolize his role as physician. The evangelist's symbol, an ox, is seen in a pen through the open door. As the artist did in the famous Hours illuminated for Etienne Chevalier (most of the manuscript, which was cut up in the eighteenth century, is in Chantilly, Musée Condé, no number), Fouquet paints the miniature as if it were a scene from a medieval drama, a kind of *tableau vivant* on a raised stage.

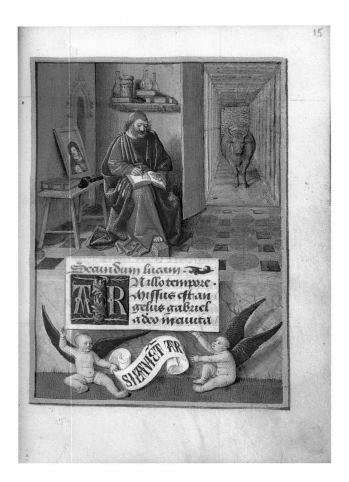

The manuscript was apparently commissioned by Antoine Raguier, who had his initials and motto, "S'il avient" (Behold, he arrives), incorporated into the decorative scheme. Raguier's death in 1468 interrupted the work; Fouquet was responsible for only the first nine miniatures. The remaining sixteen are among the earliest works by Jean Colombe (see nos. 30, 81, 94), who completed the book for Jean Robertet and his wife, Louise Chauvet. Their initials, "RL," and motto, "Chaste vie loue" (Chaste life praises, an anagram of the wife's name), appear in Colombe's section of the book.

"Hours of Jean Robertet," for use of Rome and the Abbey of Marmoutier (near Tours). France, Tours, c. 1465–68, for Antoine Raguier, and Bourges, c. 1470, for Jean Robertet and Louise Chauvet (MS M.834, fol. 15r).

30. LUKE PAINTING THE VIRGIN (*opposite*)

by Jean Colombe and his workshop

When the miniature marking Luke's lesson is not a portrait of the evangelist writing, it sometimes shows him as artist. According to medieval legend, Luke executed a portrait of the Virgin from life. Depicted on the wall of Luke's studio is a painting or relief depicting the Annunciation, the subject of the reading.

Native of Bourges, Jean Colombe established a most prolific atelier there, illuminating a multitude of manuscripts from the 1460s to the '80s. Jean came from a family of artists: his brother Michel was a sculptor, his son Philibert took over Jean's atelier upon his death, and Philibert's son François was also an illuminator. Although influenced by both Jean Fouquet (previous illustration) and Barthélemy van Eyck (next illustration), Jean's style is distinctively his own. His finer works, such as the Hours of Anne of France (see no. 81), exhibit a delicate, engagingly fastidious brushwork. In his more modest productions, such as this *Horae*, the painting is less fussy and forms are more abstract.

Hours for Rome use. France, Bourges, c. 1480 (MS M.330, fol. 9v).

45

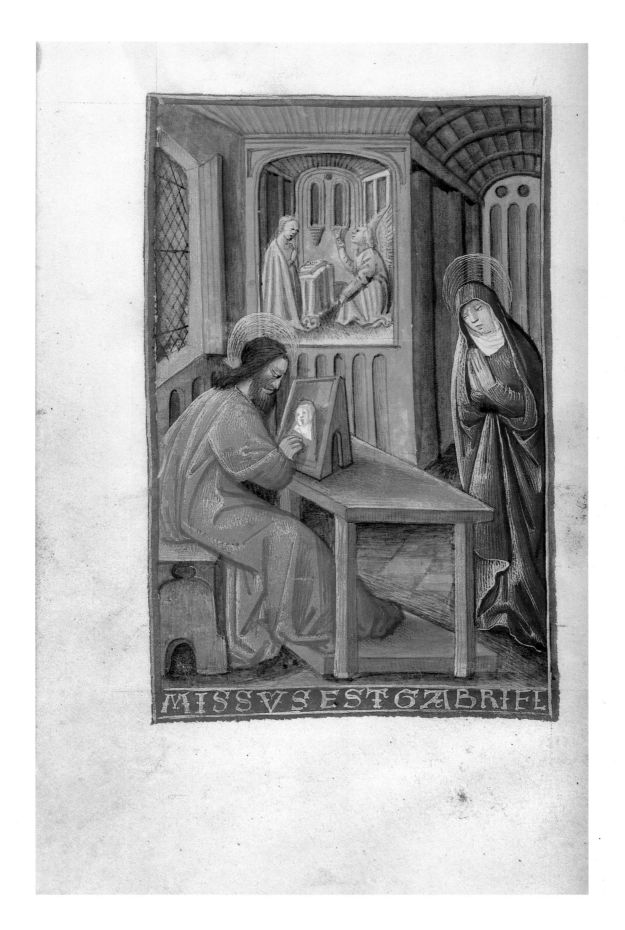

45

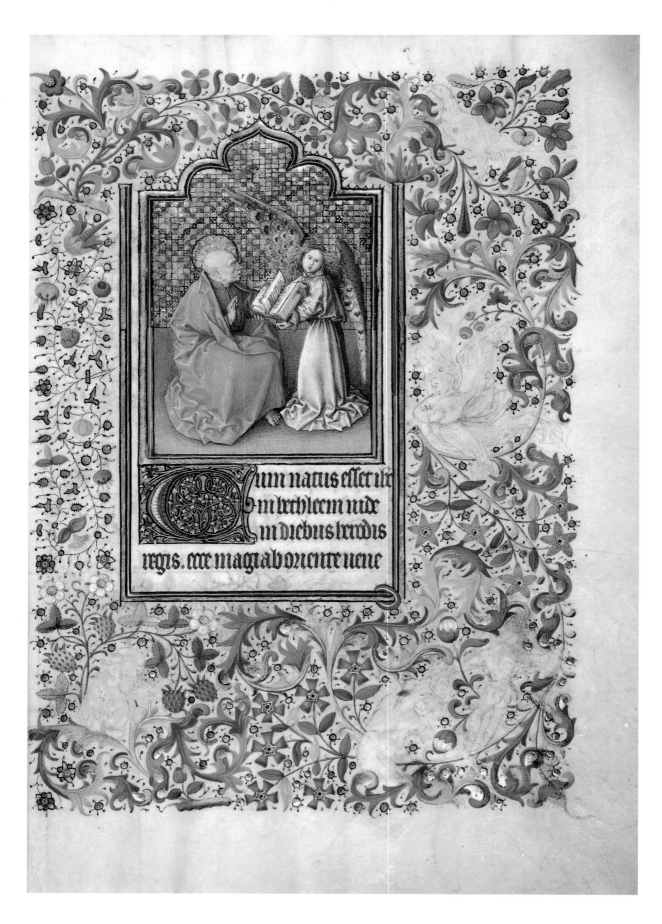

31. Matthew (*opposite*)

by Barthélemy van Eyck

With some urgency and a little surprise the seated Matthew consults the open book held by his symbol, an angel. This miniature is meticulously painted, no doubt with the aid of magnification—the evangelist himself is shown wearing glasses. The crinkled folds of the evangelist's orange robe darken to amber in their shadows but glow lemon-yellow where they catch the light. The angel's wings are made of peacock feathers. And both figures are set before a gilt diaper pattern whose surface shimmers like painted enamel.

Barthélemy van Eyck was both an illuminator and panel painter. His most famous large-scale work is the Annunciation panel in the Church of the Madeleine in Aix-en-Provence. From the eastern Netherlands, where he knew and was influenced by the work of Jan van Eyck (no relation), he migrated to France and worked in Provence for King René I from about 1440 to 1470. On this Book of Hours he collaborated with another artist, the Frenchman Enguerrand Quarton, also a painter of both manuscripts and large-scale panels.

As is evident here, the manuscript is unfinished. On this folio, van Eyck, working from the inside out, completed the central miniature, but the border figures—a bird, musical angel, man fighting a bear, and another animal—while sketched in, were never painted.

"Unfinished Hours," for Rome use. France, Provence, 1440–50 (MS M.358, fol. 17r).

32. Matthew

by the Master of the Ango Hours

This rather dour Matthew seems distracted by the party of peppy putti who have invaded his study. They play with garlands, pretend to be Venus, and pass water. The putti are part of the Italianate vocabulary that infuses the manuscript. The large miniatures are all framed by elaborate architectural structures whose elements directly imitate those found in Italian manuscripts and hand-painted incunables. The use of a kind of gathering shadow behind the frame (green here, on other folios blue or gray) is also an Italian device used to enhance the frame's three-dimensionality. In addition, the manuscript is written in a self-consciously exacting Italianate script. Both manuscripts and printed *Horae* utilize these Renaissance elements to appeal to the early sixteenth-century French taste for things Southern.

The Master of the Ango Hours (the eponymous manuscript is in Paris, Bibliothèque Nationale de France, MS nouv. acq. lat. 392) was active in Rouen in the 1520s and early '30s. Distinctive are his facial types, fussy drapery, and a fascination with fanciful perspectival constructions.

Hours for Orléans use. France, Rouen, datable to 1525 (MS M.61, fol. 17r).

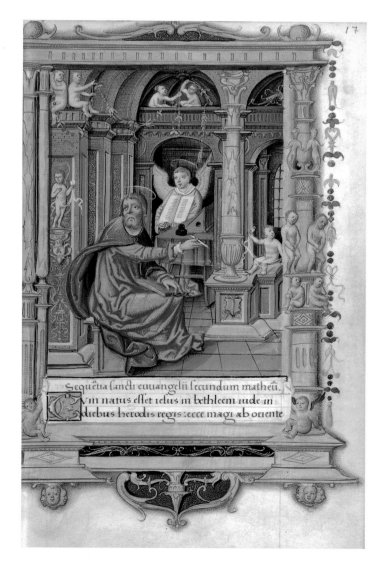

33. Ascension

by the Master of Jacques de Luxembourg

In addition to evangelist portraits and scenes from their lives, miniatures for the Gospel Lessons sometimes (albeit rarely) depict events described in the Lessons themselves. Mark's reading speaks of Christ's appearance and exhortations to his apostles following his Resurrection, and his Ascension. The latter—the concluding event in the Savior's terrestrial life—is illustrated here (appropriate, too, when one remembers that Mark's Lesson was the Gospel reading for Mass on Ascension Day). While the Virgin and a group of disciples kneel and look up, the blue clouds part and admit Christ into the golden glow of heaven. Below sits the evangelist Mark with, however, the wrong symbol; Matthew's angel instead of Mark's lion accompanies him (artists, like scribes, sometimes made mistakes). The other miniatures for the Gospel Lessons in this manuscript depict the Last Supper for John, the Journey of the Magi for Matthew, and God Sending forth the Christ Child to the Virgin Annunciate for Luke (the whereabouts of this miniature, extracted from the codex before it came to the Morgan Library, are unknown; it was last sighted in a German auction catalogue of 1930).

The Master of Jacques de Luxembourg is named after the much less elaborate Book of Hours he painted for that patron, which is now in Los Angeles (J. Paul Getty Museum, Ludwig MS IX.11). The illuminator's work has an earthy quality and a strong narrative component that point to his familiarity with Flemish art. Indeed, his work has sometimes been confused with that of Simon Marmion (see no. 58).

Hours for Paris use. France, Paris, or eastern France? c. 1465 (MS M.1003, fol. 18v).

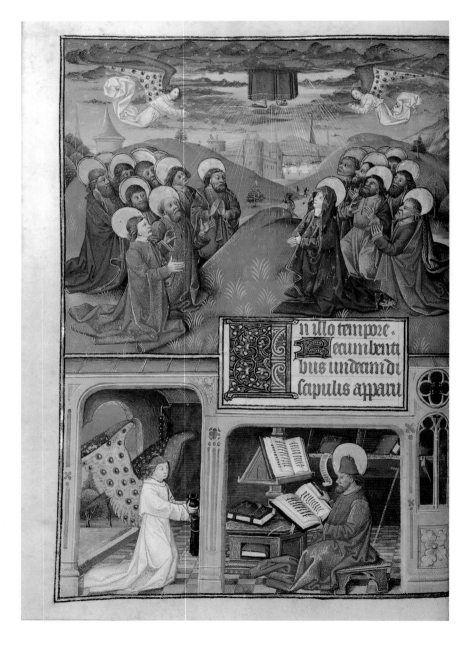

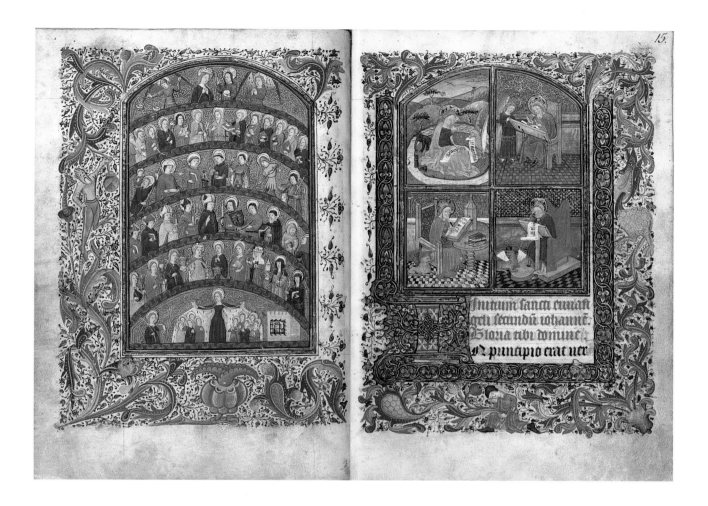

34. ALL SAINTS IN HEAVEN AND THE FOUR EVANGELISTS

As often happens in Flemish *Horae* of the fifteenth century, the Gospel Lessons in this manuscript are given a single quadripartite miniature including all the evangelists. They are shown composing at their desks, except John, who writes in exile on the isle of Patmos. Each author is accompanied by his symbol, and to John's distraction is added a mischievous devil who attempts to steal his ink.

Unusual in this book is the facing miniature depicting the court of heaven. The picture forms a kind of pictorial table of contents: it includes all the *dramatis personae* who will play important roles in the devotions to follow. In the bottom rung St. Ursula, with some of her 11,000 virgins sheltered beneath her cloak, can be recognized. Above are more female martyrs with their symbols: Apollonia holding her tooth, Agatha her breast, Barbara her tower, and so forth. The other rungs are inhabited by male confessors, male martyrs, the apostles with John the Baptist at their center, and, finally, Christ and the crowned Virgin Mary flanked by archangels Michael and Gabriel.

Hours for Rome use. Belgium, Tournai? c. 1440 (MS M.357, fols. 14v–15r).

35. AGONY IN THE GARDEN

The four Gospel Lessons are the same that were read at Mass on four of the Church's major feast days—Christmas (John), the Feast of the Annunciation (Luke), Epiphany (Matthew), and the Feast of the Ascension (Mark)—but they did not cover Christ's Passion. This absence was clearly felt, and the Passion according to John began to appear in manuscript *Horae* around the beginning of the fifteenth century. By the end of the century, it became a standard feature of printed editions, where it became a fifth reading following the other four. It was usually illustrated by one of the opening events of the Passion: Christ's Agony in the Garden (as here), the Betrayal, or the "Ego sum" (when Christ responded, "I am the one," to the soldiers who sought him and they fell to the ground in amazement).

For many reasons, this is a fascinating Book of Hours. It was printed in Paris for export to England just at the dawn of the Reformation there; it contains, for example, a number of indulgences the generous promises of which particularly offended the English reformers. While much of the book is still in Latin, rubrics (and, as here, the occasional verse) are mostly in English. The book, too, takes on modern features: it has a printed foliation (on the recto of each leaf) and a detailed table of contents.

The monogram in the lower left corner of the print, "PVL," is that of an unidentified woodcutter who worked for various Parisian printers: Regnault (as here), Pigouchet, and Vostre.

Hours for Sarum use. France, Paris, 1534, printed by François Regnault (PML 17604, fol. A3v).

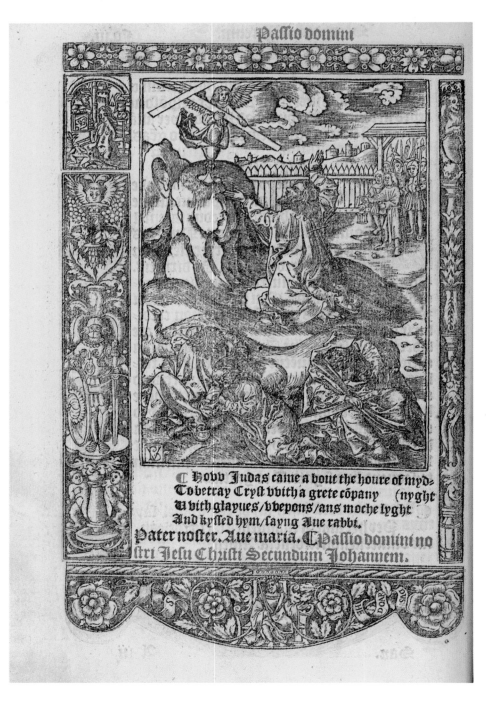

III. HOURS OF THE VIRGIN

AFTER THE GOSPEL LESSONS comes the heart of every Book of Hours, the series of prayers called the Little Office of the Blessed Virgin Mary or the Hours of the Virgin (hence the name Book of Hours or, in Latin, *Horae*). There are eight separate Hours: Matins, Lauds, Prime, Terce, Sext, None, Vespers, and Compline. Each Hour consists mostly of Psalms, plus varying combinations of hymns, prayers, and readings (lessons), to which innumerable short ejaculations (antiphons, versicles, and responses) are generously sprinkled. Ideally these eight Hours were prayed throughout the course of the day: Matins and Lauds were said together at night or upon rising, Prime (the first hour of the day according to ancient Roman, and thus medieval Church, time) around 6 A.M., Terce (the third hour) at 9 A.M., Sext (the sixth hour) around noon, None (the ninth hour) at 3 P.M., Vespers (evensong) in early evening, and Compline before retiring.

The Hours of the Virgin can be traced back at least to the ninth century; tradition holds that they were developed by Benedict of Aniane (c. 750–821). In any case, the Hours of the Virgin began to be added to the Divine Office, the daily round of prayers the medieval Church required of its ordained: priests, monks, and nuns. By the mid-eleventh century, they were an established practice. The Hours would be chanted, in choir, from Antiphonaries. By the late twelfth century, the Hours were also found in Psalters, the prayer books containing the Psalms used, in this era of emerging literacy, by both the ordained and the laity. By the mid-thirteenth century, these hybrid Psalter-Hours lost their Psalter sections and, retaining their Calendars and Offices of the Dead, became the core of the prayer book known as the Book of Hours.

Part of the attraction of the Hours of the Virgin for the laity is their simplicity. Although some Psalms for Matins change depending on the day of the week, and some *Horae* include some minor textual variations for Advent and Christmastide, the same basic Hours of the Virgin were prayed day in, day out. This constancy was clearly a comfort. Repeated on a daily basis from childhood to old age, the Hours of the Virgin became a familiar, steadfast friend. Variety could be achieved by adding, mixing, or substituting the Hours of the Cross and the Hours of the Holy Spirit, or, indeed, any of the multiple prayers contained within a typical Book of Hours.

By the mid-sixteenth century, we reach the end of the Hours of the Virgin's popularity with the laity: the manuscripts cease to be commissioned and the printed editions peter out. In 1568 Pope Pius V removed the general obligation on the part of the clergy to say the Hours as part of their Divine Office (Breviaries continued to contain the text up to the twentieth century, however, indicating the Hours' optional use). A certain portion of both the lay and clerical population continued to pray the Hours up to modern times—it enjoyed something of a revival at the French royal court of the seventeenth and eighteenth centuries whose members sometimes commissioned illuminated manuscript prayer books. In the 1960s, the Second Vatican Council revised the Breviary and even renamed the traditional canonical Hours (Matins, for example, became the optional "Office of Readings," Prime was suppressed, and Terce, Sext, and None became "Daytime Prayer"). Quashing a tradition extending back hundreds of years, the

Second Vatican Council entirely eliminated the Hours of the Virgin from the Church's new official prayer book, *The Liturgy of the Hours*. There is no edition of the Hours of the Virgin in print. The text that constituted the core of the medieval bestseller can be devilishly hard to find today (Latin-English editions, printed as late as the 1960s, can sometimes be had from secondhand bookshops).

Because of the scarcity of the Hours of the Virgin today, it seems appropriate here to offer a short portion of one of the Hours, Matins. This will allow the reader to experience something of the rich texture of the prayer, its flavor and rhythms, its poetry and layers of meaning.

Matins is preceded, as is each Hour, with the Hail Mary (although one rarely encounters the prayer itself in Books of Hours made for adults because its recitation was assumed). A most appropriate prelude, the prayer contains the words spoken by the archangel Gabriel to the Virgin when he announced that she had been chosen by God as the vehicle for the Incarnation. Its second half is a request for Mary's intercession, during the course of one's life and at the crucial moment of death:

> *Hail Mary, full of grace, the Lord is with thee: blessed art thou amongst women, and blessed is the fruit of thy womb, Jesus. Holy Mary, mother of God, pray for us sinners, now and at the hour of our death. Amen.*

Matins itself opens with a series of versicles (**V.**) and responses (**R.**):

> **V.** *Lord, Thou shalt open my lips.*
> **R.** *And my mouth shall sing thy praise.*
> **V.** *God, come to my assistance.*
> **R.** *Lord, hasten to help me.*

This plea, with its almost breathless cadence, sets the tone and states two themes that run throughout the Office, praise of God and a request for aid. The invocation (partially taken from Psalm 69) asks God to bless our thoughts during the recitation of the Hours. It is followed by a short prayer in praise of the three persons of the Trinity, the "Gloria Patri": "Glory be to the Father, to the Son, and to the Holy Spirit. As it was in the beginning, is now, and ever shall be, world without end. Amen."

The opening words of the Hail Mary are then repeated as the invitatory to Psalm 94. Psalms form the nucleus for the Hours, the core that the other prayers frame. Psalm 94 ("Come let us praise the Lord with joy. . .") has, from earliest times, been used by the Church as an invitatory Psalm; it invites us to praise God for his greatness and for creating us, and exhorts us to obey him or suffer the loss of paradise. That loss is couched in terms of a mystical interpretation of the Psalm—a second level of reading that runs throughout the Office. The Psalm refers to the Israelites who, in the Old Testament, remained in the desert for forty years, outside the Promised Land; mystically interpreted, these are Christians who, in the era of the New Testament, doubt God's word.

The ensuing prayer is an ancient hymn called the "Quem terra"; it is a key text to our understanding of the Hours of the Virgin:

> **Hymn** *The Lord, whom earth and sea and sky,*
> *Adore and laud and magnify,*
> *Who over their threefold fabric reigns,*
> *The Virgin's spotless womb contains. . . .*

It was through the Virgin that God effected mankind's salvation, and it is thus through the Virgin that salvation can most efficaciously be achieved. The late medieval cult of the Virgin placed Mary in the pivotal role of intercessor between man and God.

There then follows what is called a nocturn, a series of three Psalms, each framed by a beginning and ending antiphon, plus three lessons. In liturgical terms, nocturns were originally night prayers, recited by monks who rose in the darkness of the new day's early hours. Offices for major feast days consisted of three nocturns, but the Hours of the Virgin, as an ancillary "Little" Office, had but one. (The particular Psalms constituting this single nocturn, however, change according to the day of the week: Psalms 8, 18, and 23 are read on Sundays, Mondays, and Thursdays; Psalms 44, 45, and 86 on Tuesdays and Fridays; and Psalms 95, 96, and 97 on Wednesdays and Saturdays.)

The Psalms of the Old Testament do not, of course, make mention of the Virgin Mary. The theme of this Psalm (**Ps.**), 8, is the glory of God, as shown in nature and in man:

> **Ps.** *O Lord our Lord: how admirable is thy name in the whole earth! For thy magnificence is elevated above the heavens. Out of the mouths of infants and of sucklings thou hast perfected praise. . . . What is man that thou art mindful of him?. . . Thou hast made him a little less than the angels. . . .*

Part of the beauty of the Hours of the Virgin is how the themes celebrated in the Psalms are applied to the Mother of God. This is done through the antiphons that begin and end, as a kind of frame, each Psalm. "Blessed art thou" is said before the Psalm; like a musical motif whose opening notes are enough to recall its entirety, the opening antiphon was only a short phrase. "Blessed art thou amongst women, and blessed is the fruit of thy womb" is the closing antiphon, said at the completion of Psalm 8 (its source is obviously the Hail Mary). Thus, the theme of the Psalm, the glory of God made manifest in both nature and man, is expanded through the theme of the antiphons, the miracle of the Incarnation. Man is not only worthy of salvation, but this salvation is also brought about through the Virgin Mary, a member of the human race. The nocturn continues with Psalm 18:

> **Ps.** *The heavens show forth the glory of God: and the firmament declareth the work of his hands. . . . The justices of the Lord are right, rejoicing hearts: the commandment of the Lord is lightsome, enlightening the eyes. . . .*

The Psalm's theme is the splendor of the physical and moral orders of the universe. The short form of the antiphon recited at the beginning of the Psalm, "Even as choice myrrh," is expanded to its complete form at the end, "Even as choice myrrh, thou hast yielded an odor of sweetness, O holy Mother of God." The phrase, based on Ecclesiasticus 24:20, compares Divine Wisdom to the choicest myrrh and, by extension, to the Virgin Mary. Psalm 23 is the third and last Psalm of the nocturn:

> **Ps.** *Lift up your gates, O ye princes, and be ye lifted up, O eternal gates: and the King of Glory shall enter in. Who is this King of Glory? The Lord of hosts, he is the King of Glory.*

After the the conquest of the Promised Land, the Ark of the Covenant was kept in various places until the accession of David; it was he who transferred it to his capital, Jerusalem. Tradition has it that David wrote Psalm 23 to celebrate this joyous occasion; it praises the majesty of the Lord and his glorious entrance into his shrine. "Before the couch," the opening antiphon, is expanded to "Before the couch of this Virgin sing to us often sweet songs with solemnity," recited at the end. The antiphon exhorts us to

sing praises before the Virgin who, receiving Christ at the Incarnation, is the new Ark of the Covenant. After the three Psalms there follow the nocturn's three lessons whose teachings reiterate themes introduced by the Psalms and expanded by their antiphons. The three readings, all taken from Ecclesiasticus 24:11–20, speak of Eternal Wisdom and its dwelling place on earth. Mystically interpreted, Eternal Wisdom is taken to be the Incarnate Christ. The Hours of the Virgin also apply these Old Testament texts to the Virgin. The responses recited at the end of the first two lessons, for example, guide the reader in this interpretation:

> R. *O holy and immaculate Virgin, with what praises I shall extoll thee, I know not: for he whom the heavens could not contain rested in thy bosom.*

> R. *Blessed art thou, O Virgin Mary, who didst bear the Lord, the Creator of the world: thou hast brought forth him who made thee, and thou remainest a virgin for ever.*

The third lesson (Ecclesiasticus 24:17–20) is particularly poetic:

> Lesson *I was exalted like a cedar in Libanus, and as a cypress tree on Mount Sion. I was exalted like a palm tree in Cades, and as a rose plant in Jericho. As a fair olive tree in the plains, and as a plane tree by the water. . . .*

The response tells us:

> R. *Truly thou art happy, O holy Virgin Mary, and most worthy of all praise: for out of thee is risen the sun of justice, Christ our God.*

The concluding versicle asks the Virgin to pray for the clergy but also for "the devoted female sex," a phrase whose particular inclusion here toward the end of Matins would have meant much to the large female audience of Books of Hours.

Matins ends with the "Te Deum," the Canticle traditionally attributed to Sts. Ambrose and Augustine:

> Canticle *We praise thee, O God: we acknowledge thee to be the Lord. All the earth doth worship thee: the Father everlasting. To thee all angels cry aloud: the Heavens and all the powers therein. . . .*

The origins of this prayer go back to the fifth century. A special song of thanksgiving, it is used not only at the end of Matins but also at many other places in the Church's liturgy.

What this small sampling of excerpts from Matins demonstrates is the richness and variety the experience of praying the Hours of the Virgin offered its readers. The core of each Hour, a series of Psalms, offers some of the Bible's best poetry. Short antiphons vary the pace of the prayers and provide interpretive guideposts to the Old Testament words. Lessons, hymns, and Canticles further enrich the experience, acting as a kind of gloss.

For an outline of the entire Hours of the Virgin, see appendix 1.

36. ANNUNCIATION

by the Bedford Master and his workshop

The eight Hours of the Virgin in most Books of Hours are illustrated by the awe-inspiring events in the Virgin's life surrounding the Infancy of Christ. The pictures functioned as picture gallery, meditational aid, and bookmarks (most Books of Hours were originally neither foliated nor paginated). The first Hour, Matins, is traditionally marked by an Annunciation; the theme of Christ's Incarnation is echoed throughout Matins's invitatory, hymn, antiphons, Psalms, and lessons.

The Bedford Master was France's most influential illuminator in the second quarter of the fifteenth century (see also no. 14). While his style clearly stems from the elegant International Style of about 1400, the Bedford Master's manner is more worldly. His figures seem actually to live in (as opposed to be visiting) the world that surrounds them. He had a keen interest in storytelling. Related to the latter is his use of border vignettes. The 356 marginal medallions in this manuscript expand upon the major events illustrated in the large miniatures. Around the Annunciation, for example, are vignettes showing Joachim and Anne (Mary's parents) giving money to a beggar, Joachim with a lamb, Joachim offering the lamb to a priest, and the Annunciation to Joachim. The Office of the Dead is embellished with the earliest known cycle of the Dance of Death, in fifty-eight illustrations, plus fifteen scenes of the Fifteen Signs of the Second Coming, and a Job cycle of twenty-seven scenes. Such cycles, especially the Dance of Death, occur later in printed *Horae*.

Hours for Rome use. France, Paris, c. 1430–35 (MS M.359, fol. 21r).

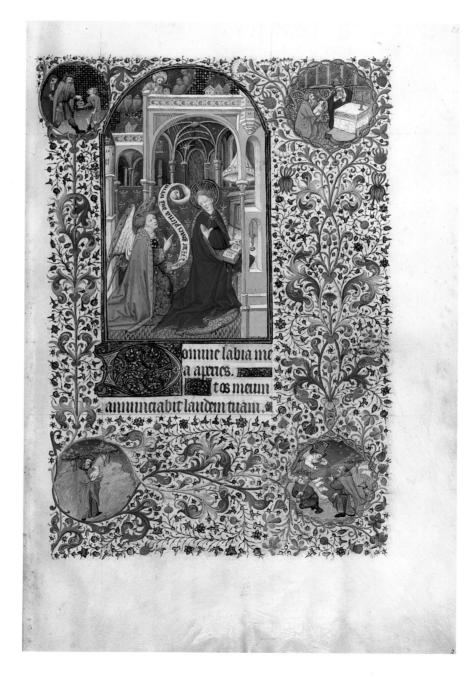

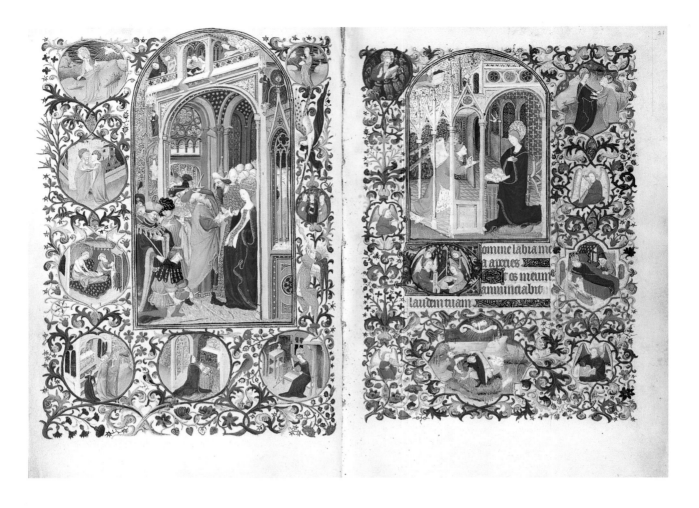

37. Marriage of the Virgin and Annunciation

by the Master of Morgan 453 and a follower of the Bedford Master

While the Hours of the Virgin usually open with a single picture of the Annunciation, some deluxe manuscripts (as well as printed books) treat their readers, as here, to double-page spreads. On the left is the Marriage of the Virgin surrounded by eight roundels that form an illustrated biography of Mary's early life: the Annunciations to Anne and to Joachim, their Meeting at the Golden Gate, the Birth of the Virgin, her Presentation, Praying, Weaving in the Temple, and Mary with two Maidens. The Annunciation is also complemented with ancillary scenes: God the Father, the Visitation, Nativity, and Annunciation to the Shepherds; musical angels appear in the border and in the initial "D."

Named after this manuscript, the Master of Morgan 453 was apparently a Flemish artist who emigrated from his native Low Countries and set up shop in Paris. Active in the 1420s in Paris, he left the French capital at the end of the decade (as did many illuminators when the English occupation killed much of their business) and moved to Amiens. Stylistically the Marriage of the Virgin is slightly different from his usual manner; it was drawn by a follower of the Limbourg brothers and then painted by the Morgan Master. The Annunciation is the work of yet another collaborator, a follower of the Bedford Master (see previous illustration).

Hours for Paris use. France, Paris, c. 1425–30 (MS M.453, fols. 30v–31r).

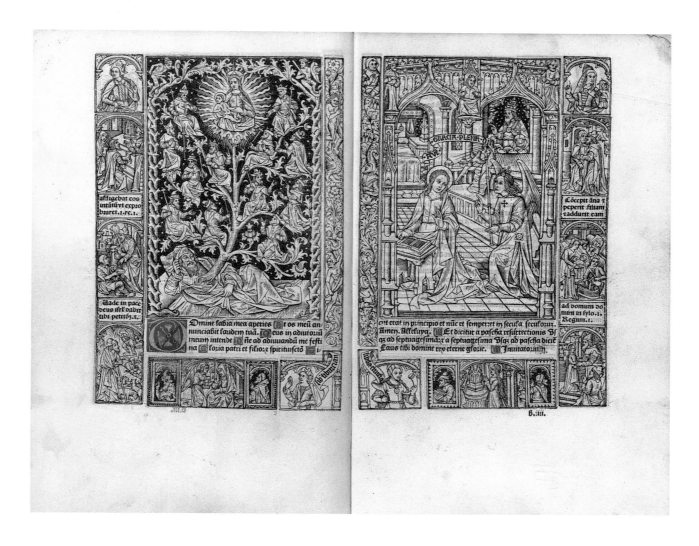

38. Tree of Jesse and Annunciation

by the Master of Anne de Bretagne

It is with the Books of Hours printed by Philippe Pigouchet for the publisher Simon Vostre that the art of the printed *Horae* achieved late Gothic perfection. The pages are harmoniously laid out, with small border images framing the large pictures like sculpture on a Gothic portal. The gracefully designed images are the work of the Master of Anne de Bretagne, whose work we have already encountered (see nos. 18, 23, 28). Using the fine lines and dots made possible by the metalcut technique, and contrasting dense areas with expanses of undisturbed white, the artist achieves a remarkably rich coloristic effect. Four major textual divisions are marked by majestic pairs of facing images. Matins's traditional Annunciation is juxtaposed with a Tree of Jesse, an illustration of the Savior's lineage.

While a few borders within the book illustrate genre scenes, most consist of narrative series that elaborate upon the themes of the prayers and the cycles of large images. Here, for example, next to the Tree of Jesse are three vignettes with Zachariah and Elizabeth, parents of John the Baptist. At the right, framing the Annunciation, are the Virgin's Conception, Birth, Presentation in the Temple, and, at bottom, Mary at Prayer. These extra images, plus their accompanying additional texts, greatly enriched the reader's experience and pleasure in using this Book of Hours.

Hours for Rome use. France, Paris, 22 August 1498, printed by Philippe Pigouchet for Simon Vostre (PML 125444 [ChL 1483], fols. b3v–b4r).

39. ANNUNCIATION

by Jean Poyet

Until recently any French illumination of high quality from around 1500 (including this manuscript) was attributed to Jean Bourdichon, an artist working in Tours for the French court (see no. 46). Working in Tours at the same time and often for the same patrons was another artist, Jean Poyet, who was even more famous in his own day (especially for his use of perspective) than Bourdichon; later he fell into obscurity. New scholarship has brought his career out of the closet. With its rich cycle of fifty-four miniatures—reproduced here is the Annunciation for the Hour of Matins—this Book of Hours may be regarded as Poyet's masterpiece.

According to a tradition that goes back to the eighteenth century, this book was given to King Henry VIII of England (1491–1547) by Emperor Charles V. While this provenance cannot be proven, the metal clasps of its eighteenth-century binding bear the name, arms, and motto of that English king.

"Hours of Henry VIII," for Rome use. France, Tours, c. 1500 (MS H.8, fol. 30v).

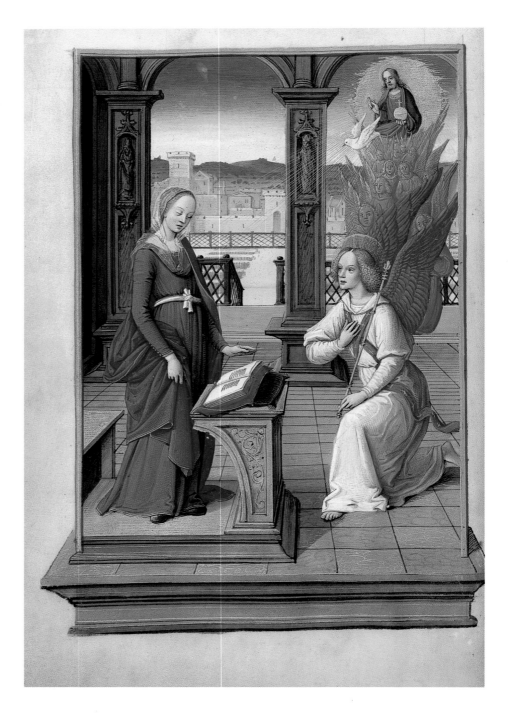

40. ANNUNCIATION

Geoffroy Tory (c. 1480–c. 1533) was truly a Renaissance man: an artist, a scholar who traveled widely in Italy, a poet, a translator of both Latin and Greek classics, a philologist who introduced the accent, the cedilla, and the apostrophe to the French language, a calligrapher and type designer, engraver, printer, and publisher. The Books of Hours he published—this double-page Annunciation for Matins is from his first—represent both a revolution and a triumph of the French Renaissance book. Tory eschews the clutter that characterizes most earlier printed *Horae*. A new lightness of touch and clarity of design reign. The woodcuts in this book result from a happy wedding of Italianate spatial concerns and the elegant figural style of early sixteenth-century French courtly illumination, as exemplified in the art of Jean Bourdichon and Jean Poyet (compare, for example, this Annunciation with the previous reproduction). Italianate borders are purposefully flat and not trompe-l'oeil. This new minimalist sensibility is effected, too, in the coloring, which is done in light shades and never obscures the underlying print.

Hours for Rome use. France, Paris, 17 January 1525, printed by Simon de Colines for Geoffroy Tory (PML 17588, fols. D3v–D4r).

41. VISITATION

by the Master of the Ghent Privileges

The traditional illustration for Lauds is the Visitation. The pregnant Virgin "went into the hill country" (as Luke tells us) to her cousin Elizabeth, herself pregnant with John the Baptist, of whom it was prophesized that he would prepare the way for the Lord. The older, slightly hunched Elizabeth, trekking with the skirts of her outer dress tucked inside her belt, extends one hand to Mary and the other toward the unborn Savior. The stately Virgin holds before her womb a cloth-enfolded prayer book; the motif is a visual pun: the words of God before the Word of God (that is, Christ).

Active in the 1440s and '50s, the Master of the Ghent Privileges is named after a manuscript of the legal privileges of Ghent and the county of Flanders commissioned by Duke Philip the Good of Burgundy (Vienna, Österreichische Nationalbibliothek, Cod. 2583). Like other Flemish illuminators painting in the second quarter of the fifteenth century, the artist employs a conservative style with doll-like figures set within stage-set landscapes. Stars, even in daytime, nearly always fill the sky. His customary palette juxtaposes intense royal blues and lime greens with salmon pinks and pale tans.

Hours for Rome use. Belgium, 1440s (MS M.82, fol. 43r).

42. VISITATION (*opposite*)

During the reign of Henri II (1547–59), manuscript illumination reached its final flowering in France. Among the many courtly patrons during this last phase of the handwritten and hand-painted book was Claude Gouffier, whose important governmental posts included First Gentleman of the Privy Chamber and Master of the Horse of France (*Grand Ecuyer de France*). He renovated his château d'Oiron (at Écouen) — adding a decorated gallery rivaling that at Fontainebleau — and collected paintings, sculpture, tapestries, and enamels.

Among Gouffier's manuscript commissions this large Book of Hours is considered the most striking. It is an example of the highly sophisticated taste of French courtly circles. The traditional theme for Lauds, the Visitation, is here peopled with figures whose gestures and drapery, typical of French Mannerist art, reveal the hothouse mixture of Italian, German, and Flemish influences. The elaborate gilt frame, composed of strapwork, swags, garlands, and caryatids, is inspired by the work Rosso Fiorentino did for François I at Fontainebleau in the 1530s. The bottom of the frame incorporates Gouffier's coat of arms, from which hangs the necklace of the prestigious order of St. Michael. Like other forms of art, Books of Hours in the sixteenth century are often awash in coats of arms, mottoes, monograms, or devices whose function was pure self-aggrandizement.

"Hours of Claude Gouffier," for Rome use. Northern France, c. 1555, for Claude Gouffier (MS M.538, fol. 25v).

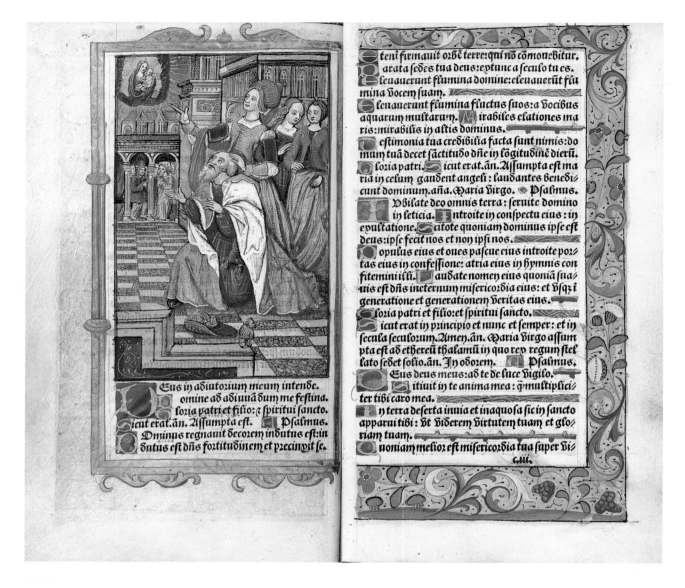

43. AUGUSTUS AND THE TIBURTINE SIBYL

Because of the late medieval penchant for iconographic complexity, fifteenth- and sixteenth-century Books of Hours, both manuscript and printed, at times employed typological illustrations. Typology was a system of interpreting events from the Old Testament or pagan antiquity as foreshadowing those of the New Testament. Here, instead of the the traditional Visitation for Lauds, is the Vision of the *Ara coeli* (Altar of Heaven), the Tiburtine Sibyl's interpretation of Emperor Augustus's heavenly vision of a mother and child as a reference to the forthcoming Savior (the Nativity, of course, is the subject of the next Hour, Prime). The event is used here to foreshadow Elizabeth's acknowledgment at the Visitation of Mary's Child as the Lord. The use of typology in Books of Hours reflects the influence of such treatises as the *Biblia pauperum* (Bible of the Poor) and *Speculum humanae salvationis* (Mirror of Human Salvation). Profusely illustrated, these texts (especially the latter) circulated widely in the fifteenth century and were available in manuscript, block-book, and incunabular editions.

This Book of Hours is typical of printed *Horae* that were hand-painted to make them look like manuscripts. Most areas of the metalcut are completely obscured by paint; a few others, more thinly colored, allow the underlying designs to show through. Also hand-painted are the gilt border, the initials and line endings, and the foliate border on the facing page.

Hours for Rome use. France, Paris, c. 1509 (almanac 1509–24), printed by Gillet and Germain Hardouyn (PML 593, fols. c2v–c3r)

44. Nativity

by the Master of the Morgan Infancy Cycle

The traditional subject of the miniature for Prime is the Nativity. As was typical with Dutch art, even at this early date, the scene is filled with narrative details of everyday life. A smiling Christ Child leans eagerly toward the cloth-covered hands of Mary's attendant. The shed is minutely described, down to the hole in the roof. Joseph, drying a diaper in the foreground, appears again in the initial on the facing leaf in his occupation as carpenter.

This Book of Hours—with its fifty-three full-page and seven half-page miniatures, ten historiated initials, and twenty-four Calendar vignettes—is one of the most richly illustrated Dutch manuscripts predating the Hours of Catherine of Cleves (see nos. 78, 107). The artist is named after his inventive series of miniatures for the Hours of the Virgin in this manuscript. They, like many of his narrative illustrations, are filled with anecdotal elements. In addition to inspired iconography, the artist was also gifted at working in more than one technique, sometimes within a single miniature. Thick and generous gold, heavy impasto, thin washes, and pen drawing were handled equally well in this manuscript, which is regarded as his finest work.

Hours for (mostly) Windesheim use. The Netherlands, Delft? c. 1415–20 (MS M.866, fols. 33v–34r).

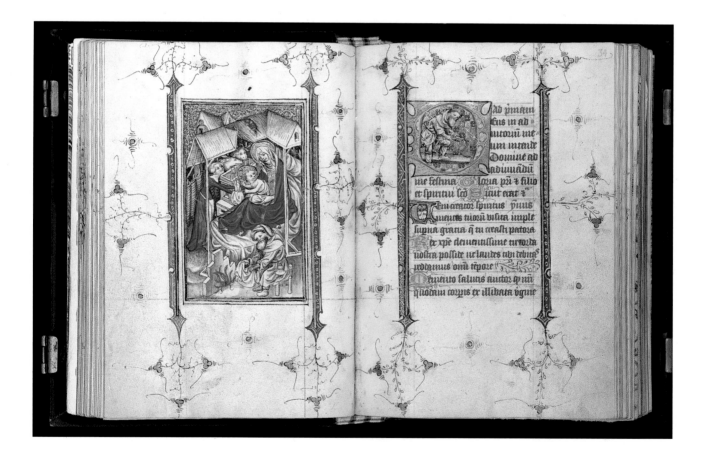

45. First Bath of Christ

Textually and pictorially, this is not a typical Book of Hours. It contains, for example, both the short and long Hours of the Cross and a rare litany of the Passion. The images, too, are uncommon. They include, in addition to the expected Pentecost for the Hours of the Holy Spirit, six miniatures depicting saints blessed by special inspiration. The Hours of the Virgin contain an unusual image of the Return of the Holy Family from Egypt (for Compline) and, reproduced here, an equally unusual First Bath of Christ (for Prime). The anonymous illuminator had a risqué sense of humor. The Virgin's finger, coming between Christ's legs, makes the young Savior appear specially endowed. A similar visual joke appears in the Circumcision where the priest's long knife can easily be misread as part of Christ's genitals.

The manuscript apparently belonged to Cecilia Gonzaga, daughter of Lodovico II and Barbara of Brandenburg. The Gonzaga arms (as here), mottoes, "Bi d[er] Graph" (Righteous power) and "Vrai amor non se cang" (True love does not change), and various devices can be found throughout the volume. Female busts in some of the larger initials (as here) are thought to represent Cecilia herself.

"Hours of Cecilia Gonzaga," for Rome use. Italy, probably Milan, c. 1470, probably for Cecilia Gonzaga (MS M.454, fol. 190r).

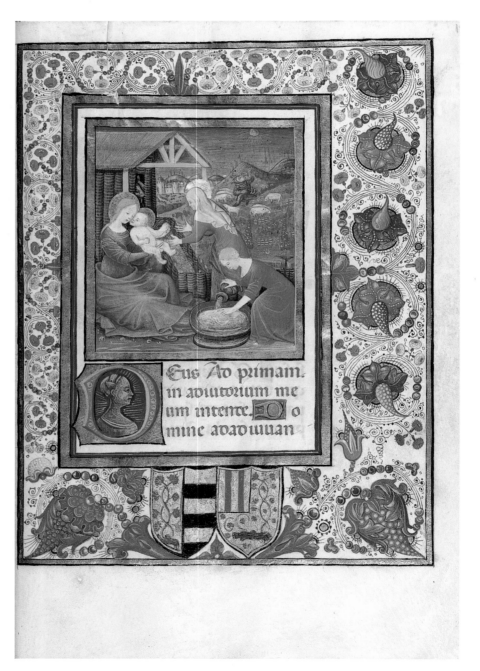

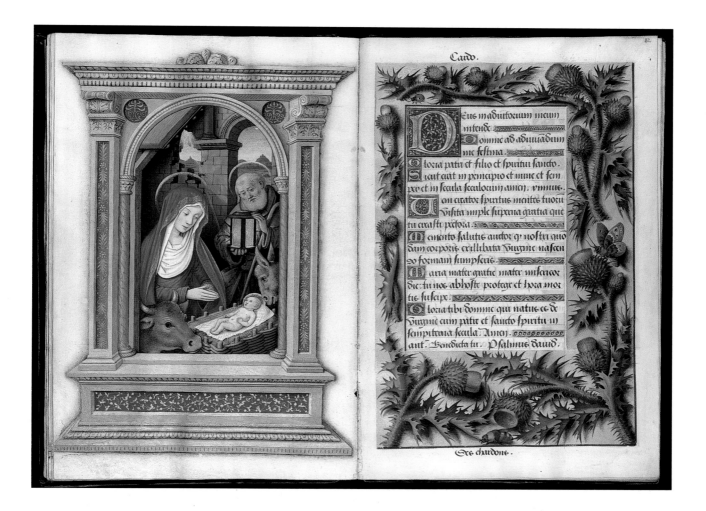

46. NATIVITY

by Jean Bourdichon

In this Nativity miniature for Prime, Jean Bourdichon has pushed all the elements of his composition—the Holy Family, ox and ass, and architecture—up against the picture plane in a technique called by art historians the "dramatic close-up." The device allows the viewer to feel as if he or she were an actual participant in the sacred events depicted. Framing the miniature is a painted structure, based on Italian designs, that makes the picture look like a monumental altarpiece.

Along with Jean Poyet (see no. 39), Bourdichon was a favorite painter of the French royal court. In 1508 Anne de Bretagne, queen to two kings of France (Charles VIII and Louis XII), paid the illuminator the sum of 1,050 *livres tournois*, or 600 gold *écus*, a staggering amount at the time for a book, for her grand Book of Hours (Paris, Bibliothèque Nationale de France, MS lat. 9474). The large flowers and plant specimens adorning the text leaves of the Morgan manuscript, such as the nearly life-size thistle (identified by both its Latin and French names) shown here, are direct cousins of those he lavishly incorporated into Anne's famous Book of Hours.

Hours for Rome use. France, Tours, c. 1515 (MS M.732, fols. 31v–32r).

47. NATIVITY AND CHRIST BEFORE PILATE

While today we are used to seeing the Christ Child of the Nativity tucked into in a straw-filled manger, quite often in the late Middle Ages he was shown naked and lying on the cold bare ground. Nearby his parents tend not to domestic activities, but kneel and worship their Son and God. While some of these elements appear in the previous illustration, they are more dramatically rendered here, in this illustration for Prime, with the Savior, rather forlorn, upon the ground. Representations of the Adoration of the naked Christ Child on the ground and surrounded by rays of light can be traced to the influence of fourteenth-century St. Bridget of Sweden. In the last years of her life, Bridget made a pilgrimage to the Holy Land and while in Bethlehem had a vision of Christ's birth; accounts of her experience, which she wrote before her death, circulated widely, especially after her canonization in 1391.

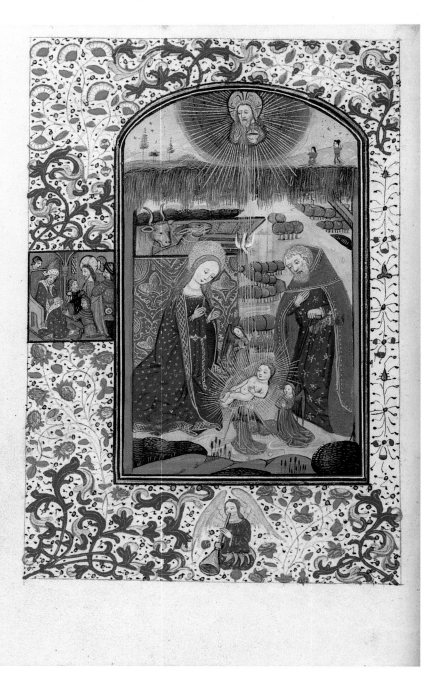

Swinging off to the left of the Nativity, like the small wing of an altarpiece, is an image of Christ before Pilate. The traditional Infancy cycle for the Hours of the Virgin is sometimes accompanied by an ancillary cycle illustrating Christ's Passion. The series normally includes the Agony in the Garden (at Matins), Betrayal (Lauds), Christ before Pilate (as here at Prime), Flagellation (Terce), Christ Carrying the Cross (Sext), Crucifixion (None), Deposition (Vespers), and Entombment (Compline).

Hours for Rome use. Belgium, Bruges, 1460s (MS M.972, fol. 88v).

48. CHRIST NAILED TO THE CROSS

by the Master of the Bible of Jean de Sy

Except for four small pictures of the Joys of the Virgin, all the miniatures in this Book of Hours are Passion images. The Hours of the Virgin feature extra illustrations not included in traditional cycles: there are two pictures of Christ Mocked, a Crowning with Thorns, the Instruments of the Passion, and as shown here, Christ Nailed to the Cross (for None). The Penitential Psalms are marked by a Trinity in which God the Father supports a crucified Christ; the Office of the Dead has an image of Christ as the Man of Sorrows and an "actual-size"

picture of the wound from Christ's side. The last miniature is a second representation of the Instruments of the Passion.

The Master of the Bible of Jean de Sy is one of the most characteristic Parisian illuminators from the third quarter of the fourteenth century. He is named after a Bible with commentary by Jean de Sy that was made for King Jean II of France (Paris, Bibliothèque Nationale de France, MS fr. 15,397). Most of his work, however, was done at the court of Jean's heir, Charles V (ruled 1364–80). This miniature is typical of the artist's delicate tinted grisaille; typical, too, are the nimble-footed, wasp-waisted figures. The manuscript was probably written in Verdun (where the less than fine foliage was painted) and then brought to Paris where the miniatures were pasted in.

Hours for Verdun use. France, probably Verdun and Paris, c. 1375 (MS M.90, fol. 76v).

49. ANNUNCIATION TO THE SHEPHERDS

The traditional illustration for Terce of the Hours of the Virgin is the Annunciation to the Shepherds. In this miniature, the single angel in the sky has yet to get the attention of the frolicking group of shepherds and shepherdesses who have joined hands and dance around a bagpipe player and part of their flock. The sheep in the background, looking up, have received the news of Christ's birth from the descending angel. The peasants in the foreground, their attention focused on their pleasure, dance in pre-Christian, pagan frivolity; this theme can be found in other fifteenth-century French *Horae* such as the Rohan Hours and the Hours of Charles d'Angoulême (Paris, Bibliothèque Nationale de France, MSS lat. 9471, fol. 85v; and lat. 1173, fol. 20v, respectively).

Hours for Rome use. Northern France or Flanders, c. 1445 (MS M.287, fol. 64v).

50. ANNUNCIATION TO THE SHEPHERDS

by the Master of the Geneva Latini and his workshop

The Master of the Geneva Latini, named after a manuscript of Brunetto Latini's *Le trésor* in Geneva (Bibliothèque Publique et Universitaire, MS fr. 160), is an especially engaging illuminator. As this miniature for Terce reveals, his palette—intense greens, pinks, and blues—is cheerful and his figures lively. Active in Rouen from the late 1450s to the early '80s, the artist painted about a dozen copies of the *Bouquechardière*, Jean de Courcy's compilation of the ancient history of the Rouen region, and other Norman chronicles (for the largely municipal patrons [*échevins*] of these commissions he is called by French scholars the Master of the *Échevinage de Rouen*).

While the artist lavished personal attention and care on the illumination of these prestigious oversize manuscripts, his bread and butter was clearly the production of Books of Hours. The Geneva Latini Master set up an enormously efficient workshop. He created models for the dozen or so standard illustrations for a typical Book of Hours and hired assistants for their ability to paint in his style. The quality of the shop's production is consistent and high during the twenty-five years of the artist's activity. After his death sometime in the early 1480s, the workshop continued like a well-oiled machine into the second decade of the next century, although the style, as might be expected, changed (see no. 63).

Hours for Rouen use. France, Rouen, c. 1470 (MS M.1093, fol. 57r).

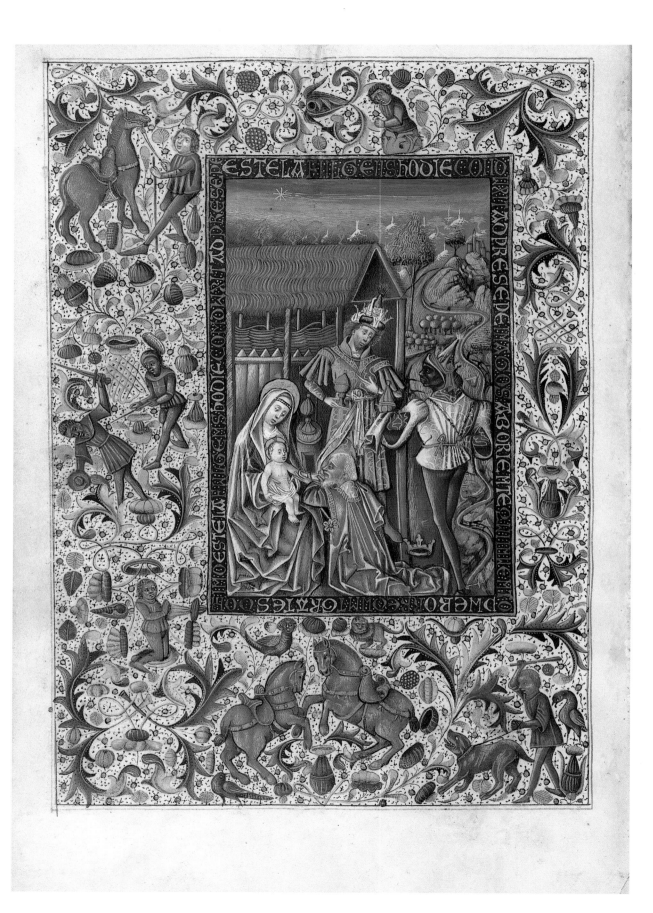

51. ADORATION OF THE MAGI (*opposite*)

Sext of the Hours of the Virgin is usually marked with an illustration of the Adoration of the Magi. Here, the narrative is expanded into the margins where the Magi's grooms attend the horses or kill time while awaiting their masters. These activities in the borders are juxtaposed with the calm dignity of the Adoration itself.

Spanish Books of Hours are rare. In the late fifteenth and sixteenth centuries, Spain, even more than other European countries because of its political ties, imported *Horae* from Flanders. This manuscript was probably made for the Infante Don Alfonso de Castile, younger brother of Isabella the Catholic. The arms of Castile and León appear in the manuscript, and in a frontispiece miniature a blond youth whose appearance corresponds to contemporaneous descriptions of the Infante kneels with his guardian angel before an enthroned God. The young heir to the Spanish throne is thus shown at prayer before the source of his own power. Don Alfonso died, at the age of fifteen, in 1468. Work on the manuscript might have been interrupted at his death, and the book (except for the Calendar, which was never filled in) may have been finished for Isabella, the future queen.

"Hours of the Infante Don Alfonso de Castile," for Rome use. Spain, Castile, 1460s–70s, probably for the Infante Don Alfonso de Castile (MS M.854, fol. 90v).

52. ADORATION OF THE MAGI

possibly by Jean Pichore

This remarkable Book of Hours is apparently the only excursion on the part of the artist Jean Pichore into printing. Collaborating with Rémy de Laistre, Pichore produced this sole edition, but as quickly as he entered this new market he abandoned it. The production of printed *Horae* was dominated at this time by Simon Vostre and the Hardouyns, and it was seemingly not a place for an untested entrepreneur.

Three metalcuts in the book, designed by the Master of Anne de Bretagne, first made their appearance in Vostre's *Horae* of the late 1490s. The other twelve cuts, in a new broad and expansive style, represent a dramatic departure from the earlier, essentially late Gothic style. Nine of these, outfitted with Renaissance architectural frames, may be by the Master of Petrarch's Triumphs, an artist working in Pichore's shop (see nos. 9, 10). The other three cuts, including this Adoration of the Magi for the Hour of Sext, are in an even broader style and may have been designed by Pichore himself. They are close to his style and compositions; nevertheless, they also incorporate some very un-French elements (like, here, the emphasis on the kneeling Magus's feet) that seem to derive from the work of German artists such as Martin Schongauer or Albrecht Dürer.

Hours for Rome use. France, Paris, 5 April 1503, printed by Jehan Pychore (as the name is spelled in the volume) and Rémy de Laistre (PML 583, fol. D7r).

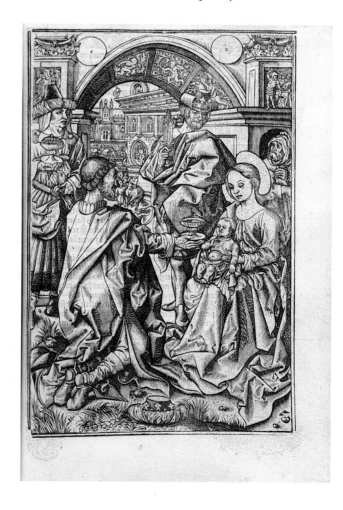

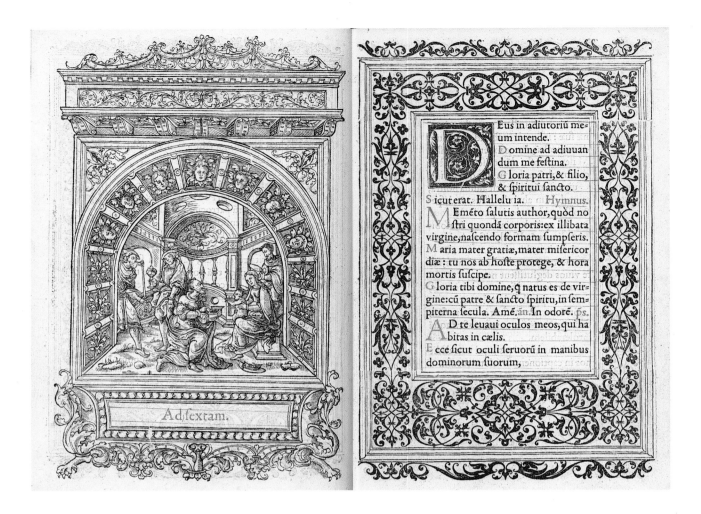

53. ADORATION OF THE MAGI

Stylistically, this Book of Hours falls between the elegant Books of Hours of the 1520s and early '30s—such as the work of the 1520s Hours Workshop (see next reproduction) and the printed editions of Geoffroy Tory (see no. 40)—and the almost bombastic products of the later 1540s and '50s (see no. 42). Although printed in 1543, various of the book's borders contain dates of 1536, 1537, and 1539. The woodcuts, while still clearly French in nature, are much influenced by German graphic art (as is evident in this Adoration of the Magi for the Hour of Sext); they are framed by monumental Italianate structures. The borders surrounding all the text pages are of two types: Italianate elements (like swags, balustrades, and putti) or arabesques (as here), the two-dimensional designs of which are like those in printed pattern books, such as for lace making.

This Book of Hours belonged to William the Rich, duke of Cleves. His name, title, and the year 1550 are written in bold red ink below the woodcut of John on Patmos at the front of the book.

Hours for Rome use. France, Paris, 1543, printed by Simon de Colines (PML 126045, fols. f7v–f8r).

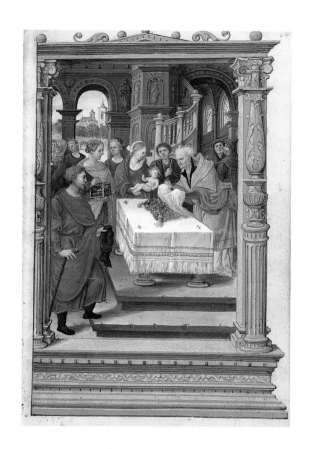

54. PRESENTATION IN THE TEMPLE

by the Master of the Getty Epistles

The Hour of None is traditionally illustrated by an image of Christ's Presentation in the Temple. The version reproduced here is by an artist called the Master of the Getty Epistles after the two miniatures he contributed to a manuscript of St. Paul's Epistles in the J. Paul Getty Museum in Los Angeles (Ludwig MS I.15). The hand of the Getty Epistles Master is one of a number of distinctly identifiable artists working in an atelier that has been dubbed the 1520s Hours Workshop after the general date and genre of their production. Active into the '30s, the artists created illumination of the most refined delicacy and not just for Books of Hours. Heirs to the legacy of Jean Poyet and Jean Bourdichon (see nos. 39, 46), they also borrowed motifs and figures from Antwerp Mannerists to create a style of illumination that is still distinctly French. The illuminators of the next generation, like those who painted the Hours of Claude Gouffier in the 1550s (see no. 42), were to take this style even further.

Hours for Paris use. France, probably Tours, c. 1530–35 (MS M.452, fol. 64r).

55. CIRCUMCISION

The traditional Presentation in the Temple for the Hour of None is sometimes replaced by an image of Christ's Circumcision. Here, the Virgin steadies the struggling Child for the operation; behind her a woman holds a candle and Joseph the basket of sacrificial pigeons. The image is couched within the large "D" with which the Hour begins, "Deus in adjutorium meu(m) intende . . ." (O God, come to my aid). The historiated initial is characteristic of High Gothic illumination. The background is made up of finely tooled, burnished gold and alternating blue and red areas upon which delicate diaper patterns have been applied. The elegant figures, robed in fine drapery, retain the gentle "sway" so typical of Gothic figures. Their heads are painted porcelain white with features delicately penned in with ink.

The manuscript is a fragment. It is roughly the second half of what was originally a Psalter-Hours, a manuscript that combined the full Psalter with the Hours of the Virgin and other prayers (as discussed in the introduction).

Hours for Arras use. France, probably Arras, c. 1310 (MS G.59, fol. 39r).

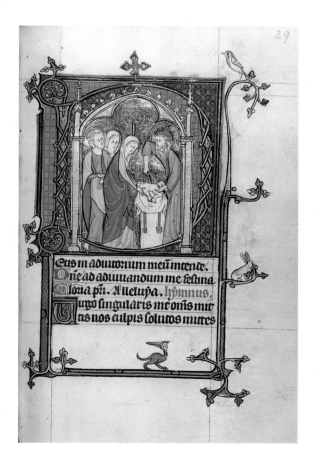

56. FLIGHT INTO EGYPT (*opposite*)

by the Guise Master

This Book of Hours is a remarkable collaborative effort on the part of five distinct illuminators. The Bedford Master (compare no. 36), a follower of the Boucicaut Master, the Master of Morgan 453 (see nos. 37, 66, 105), an artist called the Spitz Master (after a manuscript formerly owned by Mrs. Joel Spitz but now in Los Angeles, J. Paul Getty Museum, MS 57), and the Guise Master executed the thirteen large and thirty-three small miniatures, as well as the countless marginal figures in this especially rich manuscript. The Guise Master, named after the Hours of François de Guise in Chantilly (Musée Condé, MS 64), painted this Flight into Egypt, the traditional illustration for Vespers of the Hours of the Virgin. This miniature contains a particularly striking example of the brilliantly luminous skies for which the artist is notable.

This manuscript is known as the Hours of Charlotte of Savoy because sometime after 1451, when Charlotte married the dauphin (later Louis XI), or 1452, when her brother Amedée married the dauphin's sister Yolande, the arms of France, Savoy, France impaling Savoy, and Savoy impaling France were added to some borders of the manuscript (as seen here, for example). Charlotte's exceptionally rich library contained more than a hundred manuscripts, including six Books of Hours.

"Hours of Charlotte of Savoy," for Paris use. France, Paris, c. 1420–23, for Charlotte of Savoy (MS M.1004, fol. 54r).

57. FLIGHT INTO EGYPT

This book represents a kind of climax—and not an entirely successful one—of the Gothic tendencies in printed *Horae*. The metalcuts, such as this Flight into Egypt for the Hour of Vespers, are imitations of the work of the Master of Anne de Bretagne, but they are rather dull and lifeless. The page design, too, lacks the balance achieved by Simon Vostre in his classic 1498 editions (see no. 38). The page here has been saddled with a disparate batch of miscellaneous border elements; religious and secular elements, shoehorned together, vie for our attention. The resulting page is a kind of incoherent, disquieting *horror vacui* (fear of empty space).

Hours for Rome use. France, Paris, 24 November 1503, printed by Antoine Chappiel for Gillet Hardouyn (PML 19286, fol. E3v).

58. CORONATION OF THE VIRGIN (*opposite*)

by Simon Marmion

The typical miniature for the final Hour of Compline is the Coronation of the Virgin. With this subject, the traditional cycle illustrating the Infancy of Christ thus leaps ahead in time, concluding with the last momentous event in Mary's life, her coronation by her Son as Queen of Heaven.

This miniature is by one of the greatest Flemish artists, Simon Marmion. The Renaissance poet Jean Lemaire called him "the very prince of book illumination" and equated Marmion with Jean Fouquet and Jan van Eyck, two other artists who excelled in both illumination and panel painting. Marmion based himself in Valenciennes and was active from the late 1450s till his death in 1489, executing commissions for the highly refined tastes of the court of Burgundy. This miniature exemplifies Marmion's subtle palette and his delicate figures with their gentle features and restrained gestures. Below the miniature is a border of strewn flowers, fruit, and even a fly. Such trompe-l'oeil borders will become a popular feature of late fifteenth-century and sixteenth-century Flemish manuscripts. Painted around 1480, this manuscript reveals Marmion to be an early master of these foliate marvels. The manuscript, however, was written and its textual borders painted in northern France a few years before. Marmion, commissioned to complete the book, expanded his miniatures beyond the customary area of the text block, allowing them and the borders below to fill out nearly all the available vellum surface to the very edges of the folios.

Hours for Rome use. Northern France and Belgium, c. 1480 (MS M.6, fol. 57v).

59. CORONATION OF THE VIRGIN

by Georges Trubert

The artist Georges Trubert is unusual because we know not only his name but also a good deal about his career, where he worked, and for whom. Originally from Troyes, Trubert was in the retinue of King René d'Anjou from 1467 to 1480; his name appears regularly in account books as *valet de chambre* and one of the "painters of the king." After René's death in 1480, Trubert set up shop in Avignon; when commissions began to dry up, he moved to Nancy in 1491 where he painted for the court of René's grandson, René II of Lorraine, till 1499. By 1508 he was dead.

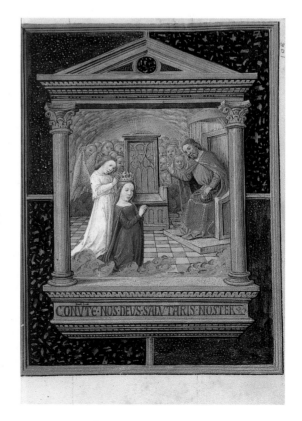

This Coronation, surrounded by a gold architectural frame set into a border of precious stones, is similar to other work Trubert executed during his Avignon period. Collaborating with him on this manuscript was a second artist, the Master of the della Rovere Missals, named after a four-volume Missal made for Cardinal Domenico della Rovere, one volume of which is today in the Morgan Library (MS M.306) and the other three in the Archivio di Stato in Turin (MSS J.II.b.2–4). The della Rovere Master was also French (possibly identifiable with Jacques Ravaud) but worked for a while in Rome in the late 1470s and '80s. Returning to France, he made a stop in Avignon where he painted ten miniatures in this manuscript. Curiously, neither he nor Trubert completed the book; it was finished by a follower of Jean Bourdichon, probably in Tours, where the della Rovere Master had apparently taken the unfinished Hours.

Hours for Rome use. France, Avignon, c. 1485–90 (MS M.348, fol. 106r).

60. Death of the Virgin

by the Master of the Harvard Hannibal

While usually marked by a Coronation, Compline of the Hours of the Virgin is sometimes illustrated by the preceding event, Mary's Death. In this touching representation, an angel gently closes the Virgin's eyes and mouth while Christ, offering his mother a final benediction, cradles her soul, in the form of a young girl robed in white, in his arm. Surrounding the deathbed are the apostles; Peter, with his aspergillum and holy water situla, is right behind Christ.

The Master of the Harvard Hannibal is named after his miniature of the Coronation of Hannibal in a French translation of Livy's *Roman History* now at Harvard University (Houghton Library, MS Richardson 32). Active from about 1410 to 1430, the Hannibal Master began his career in the workshop of the Boucicaut Master. Work-

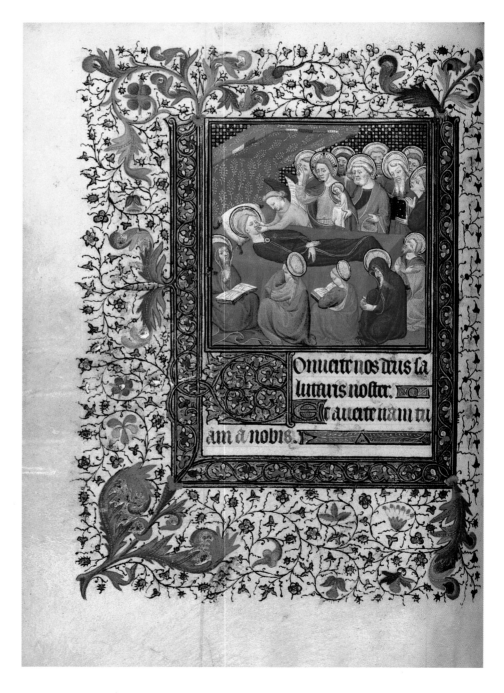

ing more as a collaborator than an assistant, however, he never assimilated the Boucicaut Master's style. He soon left this shop and set up one of his own, hiring assistants. The English occupation of Paris in 1420 made much business evaporate, and the Hannibal Master, as did a number of illuminators, left the French capital and moved north to French Flanders. The artist had a highly decorative style, with intense areas of local color. The fringe on the canopy, alternating white, blue, green, and mauve, is a typical touch.

Hours for Paris use. France, Paris, c. 1417 (MS M.455, fol. 84v).

IV. HOURS OF THE CROSS AND HOURS OF THE HOLY SPIRIT

THE HOURS OF THE CROSS and the Hours of the Holy Spirit are to be found in most Books of Hours. Much shorter than the Hours of the Virgin, the canonical sequencing is the same as with the Hours of the Virgin, Matins through Compline, except that there is no Lauds. These two additional Hours, one after the other, often follow the Hours of the Virgin.

Sometimes, however, there occur in Books of Hours what are called mixed Hours. In these cases, the individual Hours are integrated within the Hours of the Virgin. Thus, Matins of the Cross is found right after Matins and Lauds of the Virgin, Prime of the Cross after Prime of the Virgin, Terce of the Cross after Terce of the Virgin, and so forth. Some *Horae* also mix in the Hours of the Holy Spirit. In those cases, Matins and Lauds of the Virgin are followed by Matins of the Cross and then by Matins of the Holy Spirit; Prime of the Virgin is followed by Prime of the Cross and then Prime of the Holy Spirit, Terce of the Virgin is followed by Terce of the Cross and Terce of the Holy Spirit, and so forth.

Each Hour consists of two pairs of versicles and responses, a "Gloria Patri" followed by an antiphon (**A.**), a short hymn followed by a versicle and a response, and a prayer, *oratio* (**Or.**); there are no Psalms. Opening like the Hours of the Virgin, the complete Matins of the Hours of the Cross is thus:

V. *Lord, Thou shalt open my lips.*

R. *And my mouth shall sing thy praise.*

V. *God, come to my assistance.*

R. *Lord, hasten to help me.*

Glory be to the Father, and to the Son, and to the Holy Spirit. As it was in the beginning, is now, and ever shall be, world without end, amen.

A. *Hail precious cross, consecrated by the blood of Christ, and adorned with his limbs like pearls.*

Hymn *Circled by his enemies,*

By his own forsaken,

Christ the Lord at Matin Hour

For our sakes was taken:

Very Wisdom, Very Light, Monarch long expected,

In the garden by the Jews

Bound, reviled, rejected.

V. *We adore thee Christ and we bless thee.*

R. *Because through your holy cross thou hast redeemed the world.*

Or. *Lord Jesus Christ, Son of the living God, interpose thy Passion, cross, and death between thy judg-*

ment and my soul now and in the hour of my death; and vouchsafe to grant mercy and grace to the living and rest and forgiveness to the dead and peace and true accord to thy Church; and to us sinners everlasting life and joy. Who lives and reigns, God, world without end, amen.

The structure and contents of each of the remaining Hours (Prime through Compline) is the same except for the hymn, which is, in each Hour, a different stanza from a devotional poem whose verses form meditations on sequential moments of Christ's Passion. Matins's hymn, as we have seen, dwells on the betrayal and arrest of the Savior. Prime speaks of Christ before Pilate; Terce, Christ's crowning with thorns; Sext, the Crucifixion; None, Christ's death; Vespers, the Deposition; and Compline, the Entombment. The Hours of the Cross conclude with an eighth stanza invoking Christ's comfort at the time of our death.

The Hours of the Holy Spirit follow the same sequence as those of the Cross: Matins through Compline, with no Lauds. Matins is thus:

V. *Lord, Thou shalt open my lips.*
R. *And my mouth shall sing thy praise.*
V. *God, come to my assistance.*
R. *Lord, hasten to help me.*
Glory be to the Father, and to the Son, and to the Holy Spirit. As it was in the beginning, is now, and ever shall be, world without end, amen.
A. *Come Holy Spirit, fill the hearts of thy faithful, and kindle in them the fire of thy love.*
Hymn *Let the Holy Spirit's grace,*
On our souls descending,
Guide us all our journey through,
Cheer us at its ending;
He that brooded o'er the deep,
He whose operation
In the Virgin's holy womb
Wrought the Incarnation.
V. *Send forth thy spirit and they shall be created.*
R. *And thou shall renew the face of the earth.*
Or. *Almighty and everlasting God, grant us that grace of the Holy Spirit that you sent your disciples on the holy day of Pentecost. Who lives and reigns, God, world without end, amen.*

Each of the separate Hours touches upon a different theme relating to the attributes of the Holy Spirit or the role he played or will play in the history of mankind's redemption. Matins of the Holy Spirit, as seen in the hymn, discusses the Incarnation; Prime, Redemption through Christ's Passion; Terce, Pentecost; Sext, the Apostles' proselytization; None, the qualities of the Holy Spirit; Vespers, the Holy Spirit as Protector; and Compline, the Last Judgment. The Hours conclude with a stanza that invokes the Holy Spirit's aid in achieving eternal salvation in heaven. (The excerpts from the hymns in this chapter are from the translation by John Mason Neale [1818–66], the English religious poet. They are offered because they capture something of the meter, rhyme, and spirit of the original Latin.)

Sometimes the Hours of the Cross and the Hours of the Holy Spirit are full Offices. As Offices, they

are much longer (equal in length to the Hours of the Virgin) and their structure parallels that of the Hours of the Virgin. As Offices, they include the Hour of Lauds; all Hours contain Psalms; and Matins has lessons. These longer Offices appear in manuscript Books of Hours much less frequently than the shorter Hours, and in printed *Horae* they hardly appear at all.

For an outline of the entire Hours of the Cross and the Hours of the Holy Spirit, see appendix 1.

61. CRUCIFIXION

by a Master of the Gold Scrolls

The artist of this Crucifixion—the traditional subject marking the Hours of the Cross—is one of a group of Flemish illuminators active in the second quarter of the fifteenth century collectively called the Masters of the Gold Scrolls. The eponymous scrolls are much in evidence here; they fill the red background with their gilt squiggles. Straightened, more gold lines shoot off like sunbeams from the heads of Mary and John the Evangelist, forming their distinctive halos.

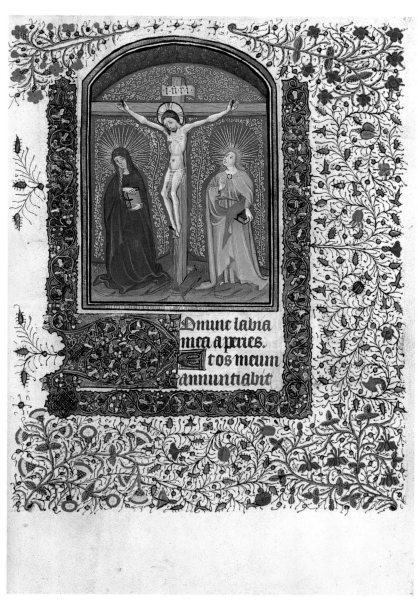

The quality of the illumination produced by the various artists working in this style can vary greatly. The hand who painted all but the last four miniatures in this manuscript is particularly good. The flesh tones have been rendered lifelike with the use of a light green undertone; facial features are deftly executed. The robed figures are dressed in finely delineated drapery. This artist's color sense, too, can be quite inventive, as seen here in the juxtaposition of chartreuse, orange, and gray in John's clothing. Note the subtlety with which the blood from Christ's side flows underneath the transparent folds of his loincloth. This motif is iconographically significant: it expresses the commingling of the blood from Christ's last wound with that of his first (the Circumcision).

Hours for Rome use. Belgium, Bruges? c. 1440 (MS M.19, fol. 89r).

62. MOCKING OF CHRIST

Some Books of Hours include, instead of the short Hours of the Cross, the much longer Hours of the Passion (also called the long Hours of the Cross or the Office of the Cross). The latter, like the Hours of the Virgin, often have a miniature at each of the eight canonical Hours. Such is the case here, where the Passion cycle includes the Betrayal, Mocking of Christ (reproduced here), Christ before Pilate, Flagellation, Christ Carrying the Cross, Crucifixion, Deposition, and Entombment. In the Mocking scene, for Lauds, two tormentors tug at a large blindfold encircling Christ's head.

The main pictures in this book are actually historiated initials set beneath architectural structures of Gothic gables and pinnacles that make the sacred events look as if they are taking place inside small chapels. Throughout the book, outside this sacred space, kneels the female patron of the manuscript, her Book of Hours often shown in her hands. Every page of this manuscript is filled with delightful marginalia; here, for instance, three figures dance to the music of a bagpipe and viol. On the other hand, much of the margins' imagery is scatological; this folio is one of the few without any naked buttocks, of which over a hundred representations—of men, women, and monkeys—can be spotted.

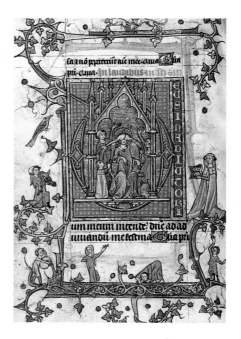

This manuscript is the second half of its former whole; the first part is in the British Library (Add. MS 36,684).

Hours for St.-Omer and Hospitallers use. France, probably Thérouanne, c. 1320s (MS M.754, fol. 59v).

63. ISAIAH SAWN ASUNDER

by a late follower of the Master of the Geneva Latini

While the occasional typological subject might appear in a Book of Hours, such as the Vision of the *Ara coeli* for Lauds of the Virgin (see no. 43), some *Horae* have whole cycles where Old Testament and/or pagan episodes substitute for the New Testament events they were thought to prefigure. The Hours of the Virgin in this manuscript are thus marked by Moses and the Burning Bush (Matins), the Flowering of Aaron's Rod (Lauds), Augustus and the Tiburtine Sibyl (Prime), Jacob's Ladder (Terce), Solomon Receiving the Queen of Sheba (Sext), Sacrifice of Isaac (None), Jacob Fleeing Esau (Vespers), and Solomon and the Queen of Sheba Enthroned (Compline). This typological approach affected the other Hours, too. The Office of the Dead is marked by a Judgment of Solomon, the Hours of the Holy Spirit by a Tower of Babel, and the Hours of the Passion, shown here, by an image of Isaiah Sawn Asunder. According to the *Speculum humanae salvationis* (Mirror of Human Salvation), the prophet's legendary martyrdom prefigured Christ's death, the prophet's "division" an allusion to the separation of Christ's soul from his body.

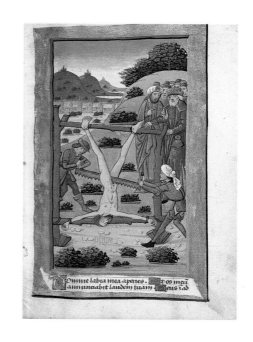

This manuscript was illuminated by Rouen artists who followed in the steps of the Master of the Geneva Latini (see no. 50). Whereas the palette is based on that of the earlier artist, colors are now less intense, less pure. The figures are direct descendants of those by the Geneva Master, with their flattened faces and hand gestures, but some of the originator's subtlety has been lost.

Hours for Rouen use. France, Rouen, c. 1500 (MS H.1, fol. 17r).

64. Pentecost

by a follower of Willem Vrelant

This Book of Hours is one of a small handful of manuscripts written and illuminated on vellum stained or painted black. The result is quite arresting. The text is written in silver and gold, with gilt initials and line endings composed of chartreuse panels enlivened with yellow filigree. Gold foliage on a monochromatic blue ground make up the borders. The miniatures, like this traditional Pentecost marking the Hours of the Holy Spirit, are executed in a restricted palette of blue, old rose, and flesh tones, with dashes of green, gray, and white. The solid black background is utilized to great advantage, especially by means of gold highlighting. This manuscript is extremely well preserved, unlike the more famous Black Hours that was made about the same time and place for Galeazzo Maria Sforza (Vienna, Österreichische Nationalbibliothek, Cod. 1856), whose folios, partly eaten away by the acids in the stain, are now preserved between glass.

The anonymous painter is an artist whose style depends mainly upon that of Willem Vrelant, one of the dominant illuminators working in Bruges from the late 1450s until his death in 1481 (see no. 83). As in the work of Vrelant, figures in angular drapery move somewhat stiffly in shallowly defined spaces. The men's flat faces are dominated by large noses.

"Black Hours," for Rome use. Belgium, Bruges, c. 1470 (MS M.493, fols. 18v–19r).

65. MYSTICAL PENTECOST

Here the Hours of the Holy Spirit are illustrated by a rare allegorical Pentecost. At the top of the woodcut, the Dove of the Holy Spirit radiates the usual flames of inspiration; the Holy Spirit's fire is transformed, however, into Christ's blood when it reaches earth. From a life-giving fountain, the twelve apostles partake of this liquid sustenance before setting out to convert the world.

This book is one of only three known vellum copies of the "Grandes Heures Royales" published under the patronage of (and probably strict distribution by) King Charles VIII of France—"par commandement du roy," the book tells us. The *Horae* produced by Antoine Vérard—known as the "father of the French illustrated book"—are known for their beauty. This particular edition is remarkable for its multitudinous marginal illustrations, large format, and special texts. The last include prayers composed or translated by the French humanist Guillaume Tardif, Charles VIII's former tutor: a series of Suffrages Tardiff wrote and arranged according to the liturgical calendar (as opposed to celestial hierarchy; see chapter VIII) and a translation, into concise French, of the Penitential Psalms.

This copy has been associated with Louis d'Orléans (later Louis XII). His arms appear in the book but they have been painted (probably in the nineteenth century to make the book more valuable) over those of the original owner.

"Grandes Heures Royales," for Paris use. France, Paris, after 20 August 1490 (almanac 1488–1508), printed by Antoine Vérard (PML 127725 [ChL 1523B], fol. ā5r).

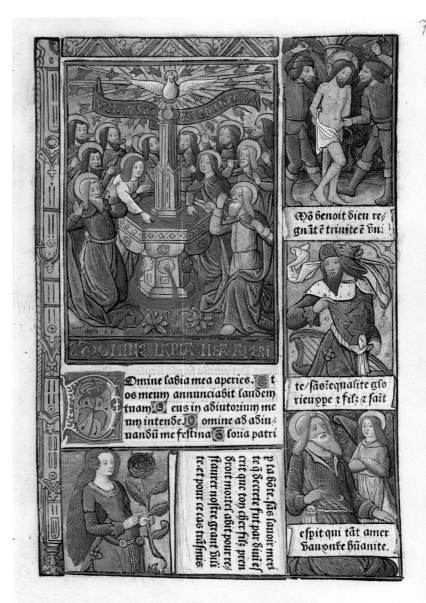

66. PAUL BAPTIZING THE CONVERTED

by the Master of Morgan 453

Both the Hours of the Cross and those of the Holy Spirit in this manuscript are provided with cycles of pictures instead of the usual single miniature for each. The series for the Hours of the Cross, as might be expected, illustrates the story of Christ's Passion from the Agony in the Garden to the Entombment. Cycles for the Hours of the Holy Spirit, however, being much rarer, were never standardized. Artists, or the clerical iconographers who might advise them, were sometimes hard-pressed to cite seven specific instances when, in the Old or New Testament, the Holy Spirit is known to have manifested himself. The miniatures in this book, for example, depict the Pentecost, Angels Tolling Bells for Unbelievers, the Baptism of Christ, Paul Baptizing the Converted (for the Hour of Sext; reproduced here), Peter Preaching, Peter and John Inspired by God, and the Faithful Inspired by the Holy Spirit.

The hand of the Netherlandish illuminator called the Master of Morgan 453 can be found in two other Morgan Books of Hours: the eponymous M.453 (see nos. 37, 105) and M.1004 (see no. 56). Like the latter, this manuscript is an early work, when he was collaborating with the Boucicaut Master (who, with assistants, painted much of this manuscript) before establishing a workshop of his own.

This *Horae* received its charming nickname, the "Strawberry Hours," from Beatrice Bishop Berle's children, who were shown the manuscript— but not permitted to touch it—as a reward for good behavior; they christened it after the fruit in the borders. Mrs. Berle donated the book to the Morgan Library in 1982.

"Strawberry Hours," for Paris use. France, Paris, c. 1420 (MS M.1000, fol. 151v).

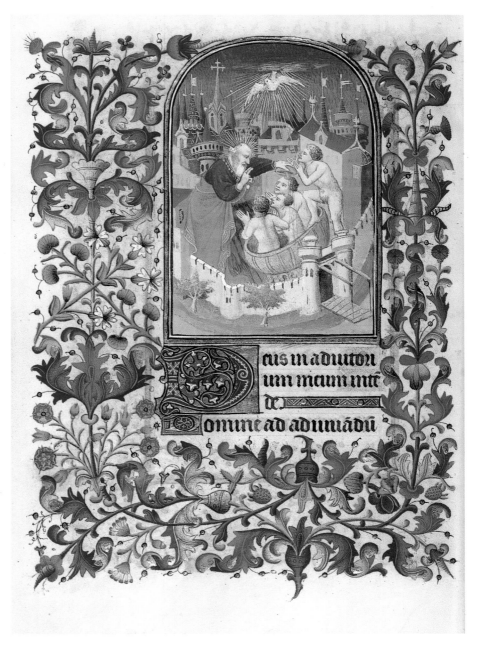

V. "OBSECRO TE" AND "O INTEMERATA"

THERE ARE TWO SPECIAL PRAYERS to the Virgin that appear in nearly all Books of Hours. They are known by their incipits (opening words): "Obsecro te" (I beseech you) and "O intemerata" (O immaculate Virgin). Written in the first person singular, the prayers address the Virgin directly in especially plaintive, urgent tones. They are among the most moving of all prayers in Books of Hours and encapsulate the essence of late medieval spirituality, especially as it relates to the cult of the Virgin and her role in one's personal salvation.

The "Obsecro te" (whose complete text is given here) has four main sections. It opens by addressing the Virgin, getting her attention, so to speak, by reciting a list of her qualities, especially those emphasizing her tenderness:

I beseech you, Mary, holy lady, mother of God, most full of piety, daughter of the greatest king, most glorious mother, mother of orphans, consolation of the desolate, the way for those who stray, salvation for those who hope in you, virgin before giving birth, virgin while giving birth, virgin after giving birth, fountain of pity, fountain of salvation and grace, fountain of piety and joy, fountain of consolation and kindness,

The prayer then invokes the Virgin's help by reminding her of the joyful role she played in the Incarnation:

through that holy, unutterable joy with which your spirit rejoiced in that hour when the Son of God was announced to you by the archangel Gabriel and was conceived, and through that divine mystery, that was then worked by the Holy Spirit; and through that holy unutterable piety, grace, mercy, love, and humility through which your Son descended to accept human flesh in your most venerable womb and which he saw in you when he commended you to St. John the Apostle and Evangelist and when he exalted you over the angels and archangels; and through that holy inestimable humility in which you responded to the archangel Gabriel, "Behold the handmaiden of the Lord, be it done unto me according to thy word"; and through those most holy fifteen joys that you had in your Son, Our Lord Jesus Christ;

The prayer then moves on to the Virgin's sorrows and the role she played in Christ's Passion:

and through that holy, great compassion and that most bitter sorrow in your heart that you had when you saw your Son, Our Lord Jesus Christ, nude and lifted up on the cross, hanging, crucified, wounded, thirsty but served gall and vinegar, and you heard him cry "Eli" and you saw him dying; and through the five wounds of your Son and through the collapse of his flesh because of the great pain of his wounds; and through the sorrow that you had when you saw him wounded; and through the fountains

of his blood and through all his suffering; and through all the sorrow of your heart and through the fountains of your tears;

Finally, the prayer's petition appears:

with all the saints and elect of God, come and hasten to my aid and counsel, in all my prayers and requests, in all my difficulties and needs, and in all those things that I will do, that I will say, that I will think, in every day, night, hour, and moment of my life. And secure for me, your servant, from your esteemed Son the fullness of all mercy and consolation, all counsel and aid, all help, all blessings and sanctification, all salvation, peace, and prosperity, all joy and gladness, and an abundance of everything good for the spirit and the body, and the grace of the Holy Spirit so that he might set all things in good order for me, guard my soul, rule and protect my body, lift up my mind, direct my course, preserve my senses, control my ways, approve my actions, fulfill my wishes and desires, instill holy thoughts, forgive the evils I have done in the past, correct those of the present, and temper those of the future, grant me an honest and honorable life, and grant me victory over all the adversities of this world, and true peace for my spirit and body, good hope, charity, and faith, chastity, humility, and patience, rule and protect my five bodily senses, make me fulfill the seven works of mercy, make me firmly believe in and hold to the twelve articles of faith † and the Ten Commandments of the law, and from the seven deadly sins ‡ keep me free and defend me until my end.*

The prayer ends with its most moving request:

And at the end of my life show me your face, and reveal to me the day and hour of my death. Please hear and receive this humble prayer and grant me eternal life. Listen and hear me, Mary, sweetest virgin, Mother of God and of mercy. Amen.

The slightly shorter "O intemerata" has a similar tone and structure. It, however, asks both the Virgin and St. John, as witnesses to the Crucifixion and thus through their special relationship to the crucified Christ, to "be, at every hour and every moment of my life, inside and outside me, my steadfast guardians and pious intercessors before God. . . , for you can obtain whatever you ask from God without delay." This last phrase is crucial to our understanding of the late medieval Catholic faith. The Christian's goal was to secure the aid of intercessors to plead his or her case before a God who was more just than merciful. The Virgin and St. John, with hearts more forgiving than a righteous God's, would certainly pity the sinner. And surely God would not deny a petition from the only two people who did not fail him at the foot of the cross.

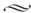

*The Seven Corporal Works of Mercy are: to feed the hungry, to give drink to the thirsty, to clothe the naked, to harbor the stranger, to visit the sick, to minister to prisoners, and to bury the dead.

†The Twelve Articles of faith are those beliefs enumerated in the Apostles' Creed: 1. Belief in God, the Almighty Father and Creator; 2. And in Jesus Christ; 3. Who was conceived of the Holy Spirit; and so forth.

‡The Seven Deadly Sins are pride, avarice, lust, envy, gluttony, anger, and sloth.

67. MADONNA ENTHRONED

Since the first part of the "Obsecro te" emphasizes the Virgin's joy during the Infancy of Christ, the prayer is frequently illustrated with the Virgin and Child. Here, angels tend to the pair, one of them amusing the Savior with a lute.

The "Obsecro te," written in the first person singular, was a popular place for patrons to insert their portraits. Although the anonymous patron liberally sprinkled his coat of arms throughout the manuscript, his only portrait appears opposite this miniature.

Hours for Rome use. Belgium, Bruges or Valenciennes? c. 1470, for a member of the Sivry (or Montigny-St. Christophe) family of Hainaut (MS M.285, fol. 108v).

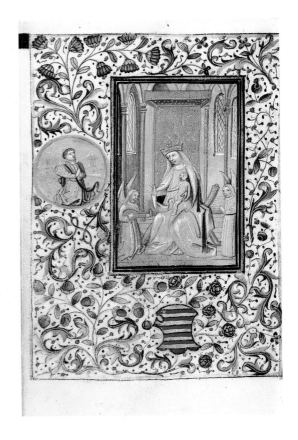

68. MADONNA ENTHRONED, WITH PATRON

by Maître François

As in the previous reproduction, musical angels entertain the Virgin and Child in this miniature for the "Obsecro te." More striking here, however, is the presence of the patron within the intimate space of the celestial interior. It is as if the prayer had transported him to heaven, before the Virgin herself. As revealed by his glance, the patron appeals to Mary, who caresses her Son; Christ, encouraged by his mother, offers the man the sought–for blessing.

Maître François, whose name is known from a contemporaneous document, was Paris's leading illuminator in the 1460s and '70s. His was a very rational art: figures bear quiet dignity (even when alarmed), his palette is particularly harmonized (with the French penchant for blue and white), and space is clearly measured, darkened by a gentle suggestion of chiaroscuro. After his death, Maître François's workshop continued and developed the style into the 1480s and '90s under the direction of an artist nicknamed his Chief Associate (see no. 93).

Hours for Paris use. France, Paris, c. 1470 (MS M.73, fol. 13r).

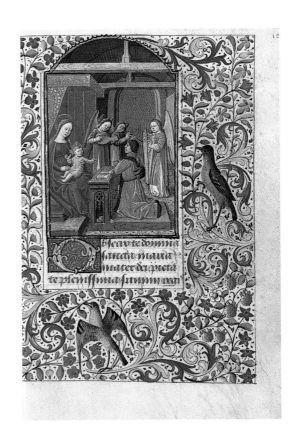

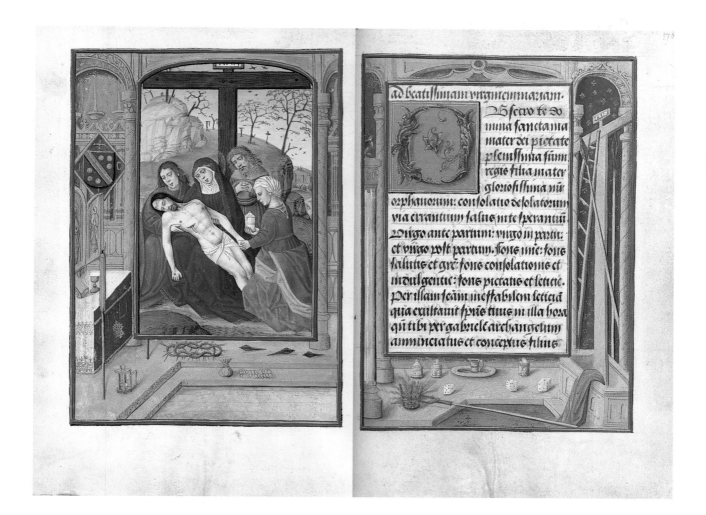

69. LAMENTATION

attributed to the Master of Sir George Talbot

After celebrating the joys of the Virgin, the "Obsecro te" enumerates the sorrows she, as coredemptrix, experienced during the course of her Son's Passion and death. Thus the Lamentation—the anguishing climax of the Virgin's agonies—sometimes illustrates the prayer.

The borders of this opening make the miniature look like a giant panel set up in a private chapel; at the left is the altar, prepared for Mass. Arranged throughout the space are the instruments of the Passion: the lantern used at Christ's arrest, the crown of thorns and three nails, Judas's payment of silver coins, and so forth. Flemish illuminators in the late fifteenth and early sixteenth centuries specialized in trompe-l'oeil borders. Flowers were the most popular (such as depicted in no. 58), but architectural structures and, as here, interiors also appear. The miniatures and imaginative borders in this manuscript are possibly by the Master of Sir George Talbot, an artist who illuminated a prayer book for George Talbot, earl of Shrewsbury and Knight of the Garter, around 1500 (Oxford, Bodleian Library, MS Gough Liturg. 7).

"Hours of Jean Carondelet," for Rome use. Belgium, Bruges, early sixteenth century, for Jean Carondelet, archbishop of Palermo, primate of Sicily, and chancellor of Flanders (MS M.390, fols. 169v–170r).

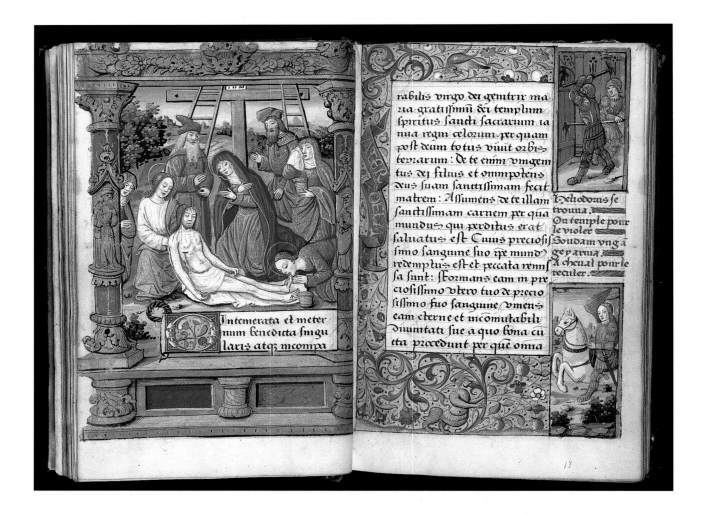

70. LAMENTATION

by a follower of the Chief Associate of Maître François

As was the case with many Books of Hours, the "Obsecro te" in this manuscript is illustrated with a Virgin and Child Enthroned while a Lamentation marks the second prayer, the "O intemerata." The main theme of the latter prayer is the faithfulness of both the Virgin and John the Evangelist during the Crucifixion. Reciting both prayers, one after the other, the reader is reminded by the texts and their pictures of two major themes: the Virgin's joys during Christ's Infancy and her sorrows during his Passion. The pictures thus illustrate both the great high and low points in Mary's life.

This Book of Hours is typical of Parisian illumination from the late fifteenth century. The artist's style is based on that of the Chief Associate of Maître François (see no. 93), but it is now even broader and more quickly done. The border vignettes on the right, like the more than six hundred to be found in this book, are modeled on those to be found in contemporaneous printed *Horae*, including the accompanying French rhymes (here Heliodorus attempts to loot the Temple, but is stopped by a horseman sent from God; from 2 Machabees 3:23–26). Manuscripts like this one are evidence that the producers of manuscript Books of Hours clearly felt pinched by the competition from printed *Horae*. Illuminators of middle-of-the-line *Horae* were pressed to paint more and more pictures per manuscript, but at the cost of quality.

Hours for Paris use. France, Paris, c. 1500 (MS H.5, fols. 17v–18r).

VI. PENITENTIAL PSALMS
AND LITANY

MEDIEVAL TRADITION ASCRIBED the authorship of the Seven Penitential Psalms (6, 31, 37, 50, 101, 129, and 142) to King David, who composed them as penance for his grievous sins. These transgressions included adultery with Bathsheba and the murder of her husband, Uriah (David had the unsuspecting spouse sent to the front lines of battle, ensuring his death; 2 Kings [also referred to as 2 Samuel] 11–12). The prophet Nathan reproached the king, and in spite of David's repentence and forgiveness by God, his son was taken from him. David repented more and was forgiven. In a second occurrence of sin, David offends God out of pride by commanding a census of Israel and Judah. This time the prophet Gad rebukes the ruler, and God sends, as punishment, a choice of famine, war, or pestilence (2 Kings 24 and 1 Paralipomenon [also referred to as 1 Chronicles] 21). After plague ravages Israel, David's penance appeases the avenging God.

These particular seven Psalms have a long history associated with atonement. It is thought that by the third century, and probably much earlier, they had formed a part of Jewish liturgy. In the Christian tradition, they were certainly known by the sixth century, when the Roman author and monk Cassiodorus referred to them as a sevenfold means of obtaining forgiveness. Pope Innocent III (papacy, 1198–1216) ordered their liturgical recitation during Lent. Since the number of these Psalms was the same as the Deadly Sins, the two became linked, and the Penitential Psalms were recited to ask for forgiveness for the dead. Like the Office of the Dead (see chapter IX), the Psalms were thought especially efficacious in reducing the time the departed had to spend in purgatory. But it is also clear that the Psalms were recited to benefit the living, as a means of avoiding these sins in the first place. This was important because the Seven Deadly Sins—pride, covetousness, lust, envy, gluttony, anger, and sloth—had the ability to land one in hell for all time. This is why they were called Deadly or Mortal.

The Penitential Psalms usually follow the Hours of the Cross and the Hours of the Holy Spirit, beginning with Psalm 6, "Domine, ne in furore tuo arguas me . . .":

O Lord, rebuke me not in thy indignation, nor chastise me in thy wrath. Have mercy on me, O Lord, for I am weak: heal me, O Lord, for my bones are troubled. And my soul is troubled exceedingly: but thou, O Lord, how long? Turn to me, O Lord, and deliver my soul. . . .

Guilty, but chastised, the sinner regrets having offended God. Broken in body and soul, the sinner seeks God's mercy and forgiveness: "I will water my couch with my tears." The second Psalm (31) contrasts the happiness of the cleansed conscience with the pangs of remorse:

Blessed are they whose iniquities are forgiven: and whose sins are covered. Blessed is the man to whom the Lord hath not imputed sin: and in whose spirit there is no guile. Because I was silent my bones grew old. . . .

The theme of Psalm 37 is the same as the first Penitential Psalm, and it even opens with the same phrase, "Rebuke me not, O Lord, in thy indignation," but its ideas are more developed. The psalmist complains of great pains ("My sores are putrified and corrupted"), the abandonment by his friends, and the insults of his enemies. The fourth Penitential Psalm (50) is the one, its title informs us, that David wrote "When Nathan the prophet came to him, after he had sinned with Bathsheba": "Have mercy on me, O God, according to thy great mercy. . . ." Psalm 101, "Hear, O Lord, my prayer: and let my cry come to thee. Turn not away thy face from me: in the day when I am in trouble, incline thy ear to me. . . ," is associated with the Babylonian Captivity; it was an appeal for divine help at a time of deep distress. Psalm 129 (the famous "De profundis"), "Out of the depths I have cried to thee, O Lord. . . ," is also thought to have been written when the Jews were in Babylonia. As the prayer of one cut off but patiently awaiting God's forgiveness, it embodies the voice of those in purgatory; as such it also appears twice in the Office of the Dead. (Penitential Psalms 6 and 50 are also incorporated into the Office of the Dead.) The final Psalm (142), "Hear, O Lord, my prayer: give ear to my supplication in thy truth. . . ," is thought to have been written by David during his conflicts with his son Absalom.

The Penitential Psalms are followed immediately by the Litany. The Litany was a hypnotic enumeration of saints whom one asked to pray for us. The list begins with "Kyrie eleison, Christe eleison, Kyrie eleison" (Lord, have mercy; Christ, have mercy; Lord, have mercy), a shortened form of the nine-part "Kyrie" that is recited by the priest at the beginning of every Mass. Christ, God the Father, the Holy Spirit, and the Trinity are then invoked. Following these preliminary petitions is the Litany proper. It is a list of saints with each invocation followed by "Ora ["orate," in the plural] pro nobis" (Pray for us):

Holy Mother of God—pray for us.
St. Michael—pray for us.
St. Raphael—pray for us.
All ye holy angels and archangels—pray for us.
All ye holy orders of blessed spirits—pray for us.
St. John the Baptist—pray for us.

The Virgin, as we see, heads the list, followed by archangels, angels, other celestial spirits, and John the Baptist (our future intercessor at the Last Judgment). Next are the apostles, male martyrs, confessors (male nonmartyr saints), female virgin martyrs, and, finally, widows. (These ranked categories reflect the hierarchy not only of heaven but also of medieval society.)

The Litany continues with a series of petitions called the "Ab's" (*Froms*), "Per's" (*Throughs*), and "Ut's" (*Thats*). For example:

From lightning and tempest—O Lord, deliver us.
From the scourge of earthquake—O Lord, deliver us.
From plague, famine, and war—O Lord, deliver us.

Through the mystery of thy holy Incarnation—O Lord, deliver us.
Through thy coming—O Lord, deliver us.
Through thy Nativity—O Lord, deliver us.

That thou render eternal blessings to our benefactors—We beseech thee, hear us.

That thou vouchsafe to give and preserve the fruits of the earth—We beseech thee, hear us.
That thou vouchsafe to grant eternal rest to all faithful departed—We beseech thee, hear us.

After these enumerations comes a recitation of the "Agnus Dei" (Lamb of God, you who take away the sins of the world, have mercy on us) and a repetition of the shortened "Kyrie" (both extracts from the Mass). The Litany concludes with various prayers for the dead, of which the characteristic "Fidelium Deus" is always present:

O God, the Creator and Redeemer of all the faithful, give to the souls of thy servants departed the remission of all their sins; that through pious supplications they may obtain the pardon which they have always desired.

71. DAVID IN PRAYER

by the Master of Sir John Fastolf

The usual subject for the miniature marking the Penitential Psalms is the elderly David kneeling in prayer. Having committed adultery with Bathsheba and compounded this sin with murder by sending her husband, Uriah, to be killed in battle, David was chastized by the prophet Nathan and reprimanded by God. As seen here, David is usually shown isolated, alone in the landscape to which he withdrew in his penance. Often, too, he kneels in a kind of valley or trench, a reference to the cave to which he retired or, possibly, to the opening line of the sixth Penitential Psalm (129), "Out of the depths have I cried unto thee." Figures enmeshed in the tendrils of the foliate border allude to David's sins of the flesh: a nude huntress at the top and, at the bottom, two heads about to kiss.

The Fastolf Master is named after a manuscript of Christine de Pisan's *Épître d'Othée* written for Sir John Fastolf in 1450 (Oxford, Bodleian Library, MS Laud Misc. 570). He started his career in Paris in the second decade of the fifteenth century, but migrated around 1420 to Rouen, where he set up shop (see no. 87). By the '40s we find him in England (where he painted this manuscript), having followed his patrons' return there.

The *Horae* is called the Berkeley Hours after Captain R. G. Berkeley of Spetchley Park, Worcester, at whose sale William S. Glazier (whence the "G" of the shelf number) bought it in 1949.

"Berkeley Hours," for Sarum use. Southern England, c. 1440–50 (MS G.9, fol. 75r).

72. DAVID IN PRAYER

by the Master of the Dresden Prayer Book

This exquisitely tiny manuscript is by the Master of the Dresden Prayer Book, an artist named after a Book of Hours in that city's Sächsische Landesbibliothek (MS A 311). Active in Bruges in the last quarter of the fifteenth century, the Dresden Master has been known primarily for the Calendar vignettes he painted in Books of Hours. Recently, however, he has been shown to be a most gifted and prolific artist; nearly fifty manuscripts and illuminated incunables have been attributed to him. This Book of Hours, from the start of his career, already demonstrates that he is in complete control of figures, their relation to landscape, and their narrative capabilities. The quality of this David miniature for the Penitential Psalms is very fine; the king's face, drapery, and landscape are all delicately rendered. David's hat, scepter, and harp (wrapped in its protective case) lie on the ground, an expression of his humility.

The manuscript is signed "Rombout sc(ri)psit" by the scribe near the end of the book (on folio 204v). This is Rombout Ians, from Utrecht, whose name can be found in the register for the Bruges Guild of Sts. John and Luke from 1475 to 1482.

Hours for Rome use. Belgium, Bruges, c. 1475 (MS M.1077, fols. 118v–119r).

73. DAVID AND GOLIATH AND DAVID IN PRAYER (*opposite, top*)

by Attavante degli Attavanti

While the elderly David kneels in penance within the initial "D" (of "Domine"—O Lord) that begins the first of the Penitential Psalms, this double-page opening is dominated by the large miniature of the young David, triumphant in his victory over Goliath. Sword in hand, the blond youth plants a firm foot on the decapitated giant's head and jauntily places his left hand on his hip. The figure mimics—and thus pays tribute to—the bronze David of the early 1470s by Andrea del Verrocchio (in the Bargello, Florence). Attavante degli Attavanti (1452–1520?), believed to have studied under Verrocchio, is one of the most celebrated illuminators of Renaissance Florence. His patrons include Duke Federigo da Montefeltro of Urbino, Bishop Thomas James of Dol (in Brittany), King Matthias Corvinus of Hungary, and King Manuel of Portugal. At the end of his career he was apparently called to Rome by the Medici Pope Leo X (papacy, 1513–21), for whom he illuminated a magnificent *Preparatio ad missam pontificalem*, which is dated 1520 (Morgan Library, MS H.6).

Attavante's sun-filled pictures are framed by his characteristic borders. Red and green grounds with gold foliage or, conversely, gold ground with colored foliage are set with medallions containing busts of apostles or prophets.

Hours for Rome use. Italy, Florence, 1490s, for a member of the Pitti-Taddei de' Gaddi family (MS M.14, fols. 104v–105r).

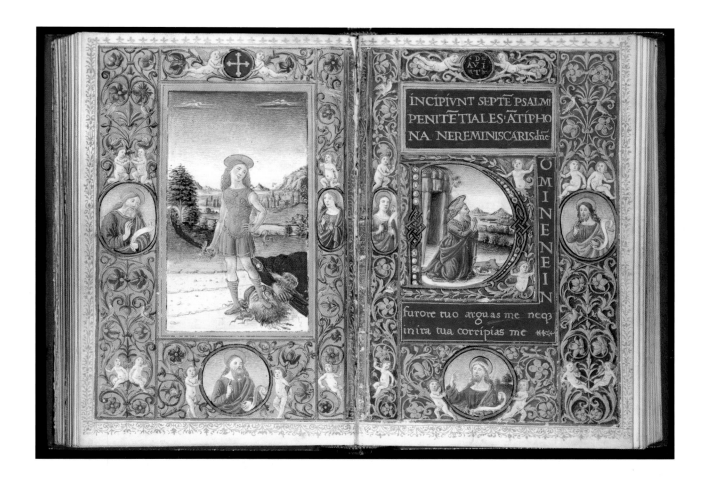

74. Bathsheba at Her Bath

Surely it is a sign of Renaissance times that the Penitential
Psalms in Books of Hours of the late fifteenth and sixteenth cen-
turies—in manuscripts and especially printed editions—are marked
not by pictures of David, the penitent sinner, but with the source
of his sin herself. Rising from an afternoon nap, King David looked
out from the top of his palace and espied the beautiful Bathsheba
at her bath; he lured her inside and committed adultery. Images of
Bathsheba in these late *Horae* seem to offer less of an admonition
against sin than an occasion for it. In a leaf from the Hours of
Louis XII, for example, Jean Bourdichon painted little silver waves
in the water that highlight rather than conceal her anatomically
correct genitalia (New York, Bernard H. Breslauer collection, MS
II). While Bathsheba's anatomy is not so detailed in this printed
Book of Hours, the image's charged eroticism cannot be denied.
Her flowing hair and provocative hand gestures are no less sugges-
tive than the depiction of her pert breasts. The figure crowning
the fountain—a proud youth in a codpiece—seems to embody the
palpitating reaction of David above.

Hours for Rome use. France, Paris, 5 August 1513, printed by
Thielman Kerver (PML 594, fol. G4r).

75. Lust

by Robinet Testard

The connection between the Seven Penitential Psalms and the Seven Deadly Sins is made quite clear in a most unusual series of miniatures in this Book of Hours. Each Psalm is illustrated by a personification of the sin the Psalm was meant to counter: Pride, mounted on a lion, admires himself in a mirror; Envy rides a camel while holding a thieving magpie; Anger, astride a leopard, stabs his chest while biting on his heart; Avarice, on a wolf, spills coins from a purse; Gluttony, riding a pig, swills wine while gripping a leg of ham; Sloth slides off his stumbling ass; and (reproduced here) a foppishly clad Lust mounts a goat whose horn he suggestively fingers. He gazes lovingly at a bird, probably a nightingale, which was thought to encourage illicit desire. Each personification is amplified by a *bas-de-page*; here the demon Asmodeus exhorts men and women to commit sins of the flesh.

Robinet Testard's amazingly long career began in the early 1470s in Poitiers. In 1484 he attained the title of *valet de chambre* at the Cognac court of Charles de Valois, count of Angoulême; at the death of the count, his employment was continued by the widow, Louise of Savoy. Testard's star continued to rise as Louise's son became the heir apparent and then King François I. The final mention of Testard is in 1531 when François settles the accounts of the dead artist.

Hours for Rome use. France, Poitiers, c. 1475 (MS M.1001, fol. 98r).

76. Last Judgment (*opposite*)

by the workshop of Willem Vrelant

The great accounting of one's life will be at the Last Judgment, when good deeds will be weighed against sins. An image of Judgment Day thus provided a continual reminder of this forthcoming reckoning and an inducement, in particular, to praying the Penitential Psalms as a means of warding off temptation. This subject, universally preferred for these Psalms in thirteenth- and fourteenth-century *Horae*, fell out of favor in much of Europe by the fifteenth, when images of David gained ground. The Last Judgment remained prevalent, however, in Dutch and Flemish Books of Hours.

Christ sits as judge upon a rainbow, the earth his footstool. Behind him are the twelve apostles and, on either side, the Virgin and John the Baptist; the latter two act as intercessors for the dead resurrecting below. The good are escorted by St. Peter to the gates of heaven, the bad dragged to the caldrons of hell.

Willem Vrelant, one of Bruges's leading illuminators from the late 1450s to 1481, ran a large and prolific workshop. While the quality of the output can vary, the miniatures in this Book of Hours are particularly good, both stylistically and iconographically (see no. 97 for a second miniature). Here he works in a limited palette: grisaille with blue, green, gold, and flesh tones.

Hours for Rome use. Belgium, Bruges, c. 1470 (MS H.7, fol. 91v).

77. CORPUS CHRISTI PROCESSION

by Giulio Clovio

Litanies in Books of Hours are hardly ever illustrated. This is a glorious exception. No better description of these double pages has been written than Giorgio Vasari's in the second edition (1568) of his *Lives of the Painters*: "But he who would sate himself with marvelling, let him look in the Litanies, where minutely he [Clovio] has made a tangle of [figures and] the letters of the names of the Saints: where in the margin above is a Heaven full of Angels around the most holy Trinity, and the Apostles and the other Saints one by one, and on the other side the Heaven continues with Our Lady and the Virgin Saints. In the margin below he has then depicted with the minutest figures the procession that Rome enacts for the feast of Corpus Christi, thronged with officers with torches, Bishops, and Cardinals, and the most holy Sacrament carried by the Pope, with the rest of his Court and the guard of Lances, and finally the Castello Sant' Angelo firing cannons: all such as to cause every acutest wit to marvel and be amazed."

Made for Cardinal Alessandro Farnese, this *Horae* is the most famous manuscript of the Italian High Renaissance. Vasari, who tells us that Giulio Clovio (1498–1578) labored nine years on it, described all its miniatures so that this private treasure could be shared by all. Crowning Clovio for his achievement, he called him "a new, if smaller, Michelangelo."

"Farnese Hours," for Rome use. Italy, Rome, dated 1546, for Cardinal Alessandro Farnese (MS M.69, fols. 72v–73r).

VII. ACCESSORY TEXTS

Books of Hours are like automobiles. While they consist of certain prayers and texts (those discussed in all the other chapters except this one) without which they cannot properly function nor be properly called Books of Hours, there was a nearly inexhaustible array of ancillary prayers that people, depending on their piety and their pocketbook, felt free to add. Medieval people personalized their prayer books the way modern people accessorize their cars (and for some of the same reasons).

One of the most frequently encountered accessory prayers is the Joys of the Virgin (fifteen is the usual number, although five, seven, and nine also appear); they celebrate the happy moments in Mary's life from the Annunciation to her Assumption into Heaven. There is also a group of prayers whose number of components is fixed at the same mystical, magical digit: Seven Requests to Our Lord, Seven Prayers of St. Gregory, Seven Verses of St. Bernard, and the Seven Last Words of Our Lord. Extra Hours (that is, in addition to those of the Virgin, Cross, and Holy Spirit) also appear. Favorites include the Hours of St. Catherine, the Hours of John the Baptist, and the Weekday Hours (Sunday Hours of the Trinity; Monday, of the Dead; Tuesday, of the Holy Spirit; Wednesday, of All Saints; Thursday, of the Blessed Sacrament; Friday, of the Cross; and Saturday, of the Virgin). These ancillary Hours are short, structured like those of the Cross and of the Holy Spirit.

Since Books of Hours were used in church as well as at home, many contained Masses, that is, the actual prayers and texts that were recited by the priest at the altar or sung by the choir. These Masses usually contain those texts that changed from feast to feast: Introit, Collect, Epistle, Gradual, Sequence, Gospel, Offertory, Communion, and Postcommunion. But often, too, these Masses might include some of the unchanging parts of the service: "Confiteor," "Kyrie," Apostles' Creed, "Sanctus," "Agnus Dei," and so forth. A series of seven Masses for the days of the week follows the same themes listed in the previous paragraph for the Weekday Hours: Sunday Mass of the Trinity, Monday Mass of the Dead, Tuesday Mass of the Holy Spirit, and so forth. Only the most elaborate Books of Hours contain all seven, however; the one that occurs most frequently, independent of the series, is the Saturday Mass of the Virgin. In a tradition that can be traced back to the tenth century, the Middle Ages dedicated all Saturdays to Mary, and it was the custom to celebrate Mass in her honor on that particular day of every week (except during Lent or when a higher feast took precedence). The text of the Mass deserves some comment; the following is a summary of the more meaningful of the changing parts.

The Introit, "Salve sancta parens . . . ," opens the Saturday Mass with a short hymn of praise to the Virgin:

> *Hail, holy Mother, thou who didst bring forth the King, who ruleth heaven and earth for ever and ever.*
> *All who celebrate your commemoration recognize your consolation.*

The Collect, "Concede nos famulos tuos . . . ," is the next changing prayer in the Mass; its requests are quite direct:

> *Grant us, your servants, we pray you, Lord God, to enjoy perpetual health of mind and body; and by*

the glorious intercession of blessed Mary ever Virgin, to be delivered from present sorrow and to enjoy everlasting happiness.

The Epistle reading is from Ecclesiasticus 24:14–16:

From the beginning, and before the world, was I created, and unto the world to come I shall not cease to be: and in the holy dwelling place I have ministered before him. And so I was established in Sion, and in the holy city likewise I rested: and my power was in Jerusalem. And I took root in an honorable people, and in the portion of my God his inheritance: and my abode is in the full assembly of saints.

Mary's intercessory role in salvation was envisioned by God from the beginning; she dwells in the New Jerusalem, that is, the Church, and she will reign eternally from heaven. The Gospel reading, from Luke 11:27–28, "In illo tempore loquente Jesu ad turbas . . ." (At that time, as Jesus was speaking to the multitudes), relates the story of a woman who, filled with admiration for Christ, praises the womb that bore him. The Savior answers her by saying that, rather, "Blessed are they who hear the word of God and keep it." Those who believe, including the medieval men and women reading these words, are thus brought into the fold. The Postcommunion, the last of the changing parts of the Mass, sums up:

Grant, we pray you, Lord, that having received these helps to salvation, we may everywhere be protected by the patronage of blessed Mary ever Virgin, in veneration of whom we have offered this sacrifice to your majesty.

Even more numerous than actual Masses in Books of Hours, however, are the many quasi-liturgical prayers for the laity. (That is, they are reflections of or extractions from the officially sanctioned liturgy, but they never equal official Church practice.) These prayers translated the Church's theology into lay terms, aiding the worshiper's understanding of the impact of the actions taking place upon the (at times distant or unseen) altar. These prayers have such rubrics as, "Upon entering church," "When taking holy water," "At the Elevation," "After the Elevation," "Upon receiving Communion," etc. (The practice of worshipers' saying prayers different from those recited by the priest lasted until the Second Vatican Council.) Of all these unofficial prayers, the most frequently encountered are those said at the Elevation of the Eucharist. The desire to see the host raised by the celebrant moments after its consecration was zealously felt in the late Middle Ages. In an era of infrequent Communion (medieval practice was normally once a year), seeing the transubstantiated host was second only to receiving it.

One of the most popular prayers in honor of the Eucharist is the "O salutaris Hostia":

O saving Victim, opening wide
The gate of heaven to man below:
Our foes press on from every side;
Thine aid supply, thy strength bestow.
To thy great name be endless praise,
Immortal Godhead, one in three:
Oh, grant us endless length of days,
In our true native land with thee.

The prayer is actually the last two stanzas from a longer hymn prayed by the clergy, as part of the Divine

Office, on the Feast of Corpus Christi. Appended to it in Books of Hours is sometimes a prayer that is also extracted from the Corpus Christi liturgy:

O God, who left to us in this wonderful sacrament a memorial of your Passion, grant us, we pray, so to venerate the sacred mysteries of your body and blood that we may always find within us the fruit of your redemption.

Another popular accessory text is the "Stabat Mater." Its emotional intensity, rhythm, and rhymes make this prayer one of the most moving and memorable of the Middle Ages. Written probably in Franciscan circles in the thirteenth century, it spread quickly and by the late fifteenth century had been incorporated into the Church's official liturgy of both the Mass and the Divine Office. It has been set to music many times, most famously by Palestrina, Pergolesi, Verdi, Dvořák, and Poulenc. The first stanza opens:

At the cross her station keeping,
Stood the mournful mother weeping,
Close to Jesus to the last.
Through her heart, his sorrow sharing,
All his bitter anguish bearing,
Now at length the sword had passed.

Throughout its course, the prayer empathetically asks the Virgin to share her pain with us, just as she partakes of Christ's miseries. It ends with a plea to the Savior:

Christ, when you shall call me hence,
Be your mother my defense,
Be your cross my victory.
While my body here decays,
May my soul your goodness praise,
Safe in heaven eternally.

Another accessory text, the "Salve sancta facies," is a prayer to the holy face of Christ that was especially popular in late fifteenth- and sixteenth-century Flemish *Horae*. It was frequently accompanied by generous indulgences. The first two stanzas are offered here:

All hail, my kind Redeemer's face,
Whence stream divinest rays of grace;
Upon a kerchief glittering white impressed,
And on Veronica bestowed, love blessed.

All hail, honor of worlds, mirror of saints,
Whose vision to behold each heavenly spirit faints;
Purge us free from every sinful stain,
The company of the blessed host to gain.

Prayers to guardian angels have an ancient tradition; various forms can be traced back to the ninth or tenth century. Nearly all touch on similar themes: the protection by an angel specially appointed to

oneself; petitions for protection, day and night, from evil; encouragement to do good; and, of course, the hope for eternal reward. It was only natural that these prayers, in Latin and the vernacular, make frequent appearances in *Horae*. The following version, "Sancte angele Dei minister celestis . . . ," preceded by the antiphon "Angele qui meus es custos . . . ," is thought to have originated in the late twelfth century at the monastery of Eynsham (near Oxford). The translation is of a version in a Flemish Book of Hours from about 1460 in the Morgan Library (MS M.387 [no. 83], fols. 72r–73r):

> A. *O angel, you who are my divinely appointed guardian, save, defend, and guide me, who is consigned to thy care.* Or. *Holy angel, celestial minister, whom Almighty God appointed as my keeper, through his majesty, mercy, and love, I beg you to keep, day and night, my soul and my senses from improper and perverse desires, from harmful and impure thoughts, from the snares and delusions of evil spirits, and from sudden and unexpected death, and keep my body from all evil and all harm. Instill in me the fear of God and love of my neighbor, and let me persevere in good works until my death, and after this life, place my soul in eternal joy where I may rejoice with Jesus Christ and his saints forever. Amen.*

78. CRUCIFIXION, WITH CATHERINE OF CLEVES (*opposite*)
by the Master of Catherine of Cleves

The manuscript was made for Catherine of Cleves, duchess of Guelders and countess of Zutphen, who clearly asked for, and received, one of the richest Books of Hours ever created. Not only are there 157 miniatures (9 others are missing), but they are also framed by borders of remarkable inventiveness. Planned with extraordinary care, the book luxuriates in pictures and texts. It contains, for example, a cycle of illustrated Weekday Hours plus a complete set of illustrated weekday Masses. Reproduced here is the miniature for the Saturday Mass of the Virgin. Catherine, encouraged by a patron saint, asks the Virgin to "Pray for me, Holy Mother of God"; Mary intercedes with her Son for the sake of her "whose breasts nursed him"; Christ pleads the case in the "name of his wounds"; God the Father replies, "Your prayer has been heard with favor." The miniature illustrates how Christ—the God-Man—is the uniquely qualified mediator between God and man. It also illustrates how Mary plays the vital roles of mediatrix for mankind, coredemptrix with Christ, and dispensatrix of God's grace.

The anonymous illuminator is named after this masterpiece, the greatest of all Dutch Books of Hours (see also no. 107). His rich palette, heightened powers of observation, and facility with complex iconography rank the Cleves Master as one of the greatest of all illuminators.

"Hours of Catherine of Cleves," for Windesheim use. The Netherlands, Utrecht, c. 1440, for Catherine of Cleves (MS M.917, p. 160).

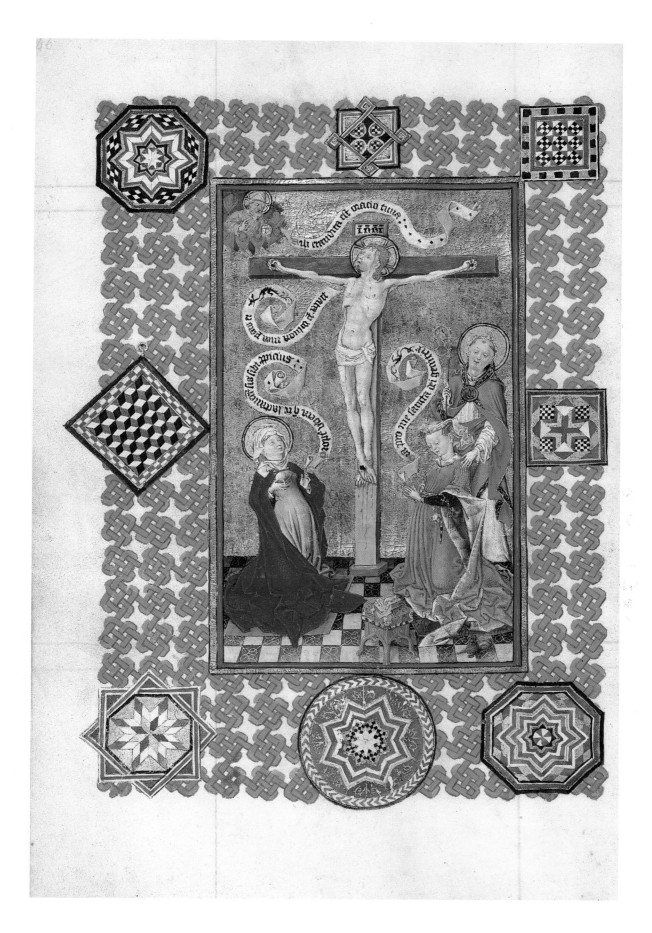

79. Miraculous Bleeding Host of Dijon

by Robinet Testard

The Bleeding Host of Dijon was a true late medieval wonder. According to legend, this Communion wafer was desecrated by a Jew and miraculously began to bleed. In 1433 Pope Eugene IV presented it to Duke Philip the Good of Burgundy. He installed the precious relic in the Sainte Chapelle of the Chartreuse de Champmol, the Carthusian monastery that his grandfather Philip the Bold established in Dijon as a mausoleum for himself and his heirs. In 1454 the duke's wife, Duchess Isabelle of Portugal, donated a silver-gilt monstrance for displaying the host. René d'Anjou had commemorated his release from a Dijon prison in 1436 with a daily Mass in its honor; King Louis XII, cured of a malady by it, sent his coronation crown to the shrine in 1505. In 1794, the host and its monstrance were destroyed by a Revolutionary mob. In the nineteenth century, scientists discovered *Micrococcus prodigiosus* (microbe of miracles), bacteria that, settling on food or bread kept in the dark, produces a reddish culture resembling blood.

Images of the wafer (less than ten are known) usually accompany the Eucharistic prayer, "O salutaris Hostia." Here, however, the host occurs without the prayer; the owner must have known it by heart. The wafer is stamped with an image of Christ as Judge, arms outstretched and flanked by the instruments of the Passion. Drops of blood dot the surface like wounds from a scourging; some form a ring around the perimeter, a reference, no doubt, to the crown of thorns.

Hours for Rome use. France, Poitiers, c. 1475 (MS M.1001, fol. 17v).

80. Mass of St. Gregory

by the Master of the Munich Golden Legend

According to legend, the sixth-century Pope Gregory the Great was celebrating Mass when one of his assistants doubted the real presence of Christ in the Eucharist. During the service, the Savior himself miraculously appeared at the altar, allaying any doubts as to the true nature of the Communion wafer. This miniature accompanies a prayer to the Eucharist said at the Elevation; the picture translates the prayer's message into visual form. Christ is shown as the Man of Sorrows, that is, the spent Savior, bleeding and exhausted, nearly dead; supported by an angel, he is surrounded by the Instruments of the Passion.

The Master of the Munich *Golden Legend* is named after his illumination in a manuscript of Jacobus de Voragine's text in that city (Bayerische Staatsbibliothek, Cod. gall. 3). Active in Paris (and, perhaps, western France) in the two or three decades after 1420, he was the main rival of the Bedford Master, with whose similar style that of the Munich Master is sometimes confused. The Munich Master's colors, however, tend to be a bit more intense, his angular faces less round, and his angels often have a full head of blond hair.

Heraldic evidence has traditionally connected this manuscript with Duke Arthur III of Brittany, who helped Joan of Arc drive the English out of France.

"Hours of Duke Arthur III of Brittany," for Orléans and Angers use. France, Paris or Angers? c. 1435 (MS M.241, fol. 40v).

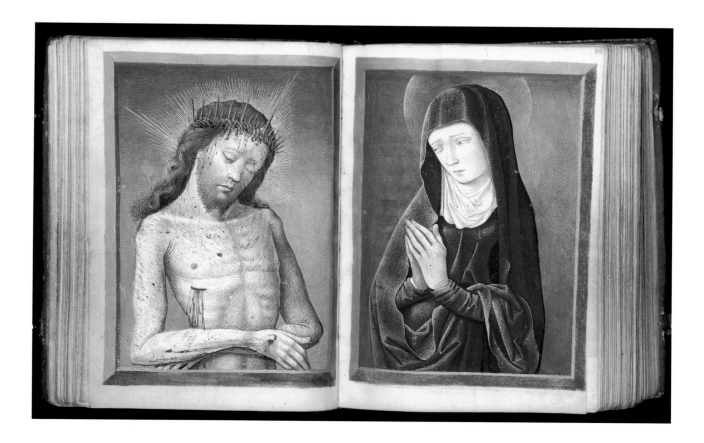

81. MAN OF SORROWS AND VIRGIN PRAYING

by Jean Colombe

This Book of Hours has unusually rich cycles of pictures. Instead of the usual eight miniatures, the Hours of the Virgin have forty-nine. Inspired by the Psalms and other parts of the Hours, these illustrate a number of rarely depicted New and Old Testament events (Abiram, Korah, and Dathan Engulfed by the Earth, for just one example). The Office of the Dead has twenty-four miniatures instead of the customary one. Among the many unusual pictures in the book are the two reproduced here, a Man of Sorrows and the facing image of Mary in Prayer. They form a diptych introducing the "Stabat Mater." The beaten, scourged, crowned, and bleeding Christ is painted half-length, bringing his body as close as possible to the picture plane. The viewer is encouraged to dwell on each carefully depicted wound, on every drop of meticulously painted blood. The humble Savior's eyes glance down and away, but they also appear as if, at any moment, they might actually look up at us. The Virgin is presented as the model worshiper—quiet, attentive, thoughtful.

As the arms of France and the emphasis on the name Anne indicate, this very special manuscript was apparently a gift to Princess Anne of France, daughter of Louis XI and Charlotte of Savoy. Charlotte employed the artist, Jean Colombe, from 1469 to 1479. For other works by him, see nos. 30, 94.

"Hours of Anne of France," for Rome use. France, Bourges, 1470s, probably for Anne of France (MS M.677, fols. 37v–38r).

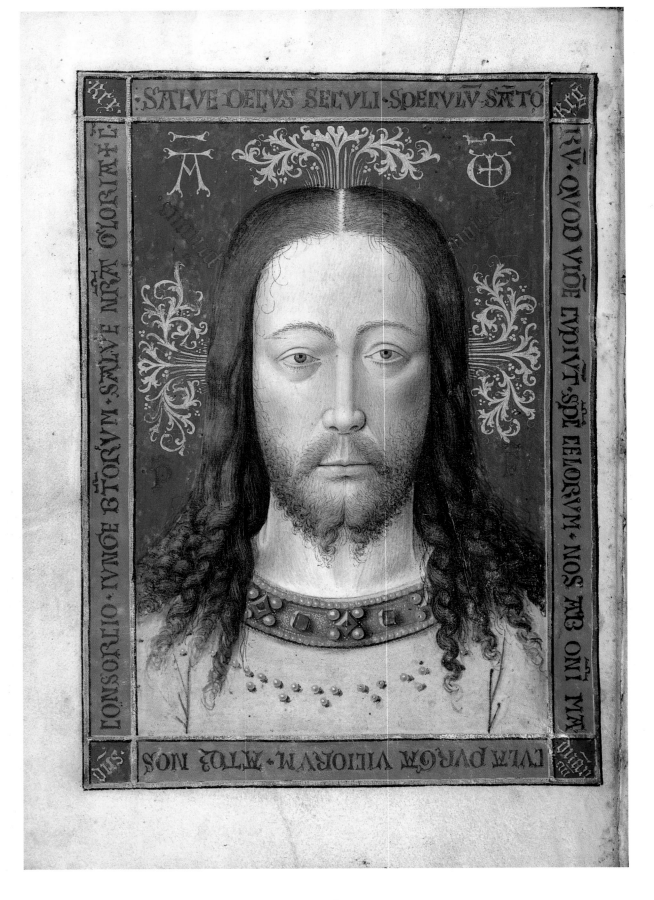

82. VERA ICON (*opposite*)

by the Master of Jean Chevrot

The prayer to the holy face of Christ, the "Salve sancta facies," was widespread, especially in Flemish *Horae*. Pictures thought to reproduce Veronica's Veil, the famous relic preserved since ancient times in St. Peter's in Rome, almost always accompany this petition since indulgences could be gained only if the prayer is recited while looking at an image of the Redeemer's visage. This miniature is of particular interest because it is one of the earliest, most faithful, and most complete of the surviving copies of Jan van Eyck's version of the Vera Icon, the original of which is lost. The image is loaded with gold and (now oxidized) silver inscriptions. The surrounding frame quotes the prayer's second stanza (translated on page 101) and the opening words of the third: "Salve decus seculi * Speculu(m) sa(nc)toru(m) */ Quod vide(re) cupiu(n)t * Sp(iritu)c [sic] celorum */ Nos ab o(m)ni(a) ma*cula purga viciorum */ Atq(ue) nos consorcio * Iunge b(ea)torum */ Salve n(ost)ra gloria + (et) c(etera) *."

Above Christ's head are inscribed the Alpha and the Omega and, radiating from it, "Primus" and "Novissi(mus)" (the First and the Last). Below the arms of the cruciform halo are the letters "P" and "F" for "Principium" and "Finis" (the Beginning and the End). Finally, the four corners are inscribed "Rex Reg(um) D(omi)n(u)s D(omi)nanciu(m)" (King of Kings, Lord of Lords).

The Master of Jean Chevrot was named by Anne van Buren after the two frontispieces he painted in a two-volume manuscript of St. Augustine's *City of God* that was made for Bishop Jean Chevrot of Tournai in 1445 (Brussels, Bibliothèque Royale, MSS 9015–16). The Chevrot Master had a firsthand knowledge of Eyckian designs and style; he collaborated with Jan on the Turin-Milan Hours, the infamous manuscript that took seven artistic campaigns over fifty years to complete (Turin, Biblioteca Nazionale, MS K.IV.29 [destroyed], and Museo Civico, Inv. no. 47).

Hours for Rome use. Belgium, Bruges, c. 1450 (MS M.421, fol. 13v).

83. MAN PRAYING TO HIS GUARDIAN ANGEL

by Willem Vrelant

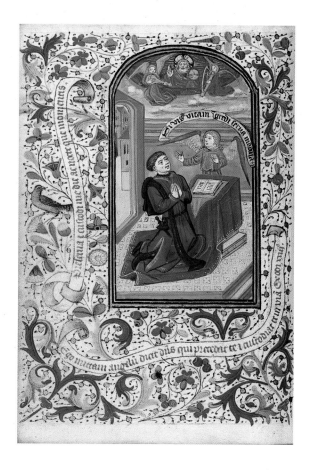

Miniatures accompanying prayers to one's guardian angel, which became popular in late fifteenth- and sixteenth-century *Horae*, became a logical place for the men and women who commissioned the manuscripts to insert their portraits (see also, for example, no. 8). Here the anonymous patron implores the aid of his angel, who directs his prayers heavenward. The man's plea is written on the scroll behind him, "Preserve and guard me, day and night and at every moment." God's advice appears on the scroll floating above the angel's head, "If you desire life, walk with the servant sent you." A third scroll in the bottom border quotes God's paternal promise to the Israelites in the Book of Exodus (23:20): "I will send my angel, says the Lord, who shall go before you and keep you in your journey."

On the prie-dieu lies the man's Book of Hours. Spreading beyond it is the book's cloth binding. Books of Hours were often bound in this manner, with luxurious chemise wrappers that helped protect their contents. For the illuminator, Willem Vrelant, see nos. 64 and 76.

Hours for Rome use. Belgium, Bruges, c. 1460 (MS M.387, fol. 71v).

84. CHRIST CHILD

by the Master of Charles V

Prayers in Books of Hours were sometimes accompanied by rubrics promising great salvific merit. Shown here is a prayer to Christ and the Virgin whose adjacent rubric claims, "This prayer is in honor of the Virgin Mary and was discovered under her sepulchre in the valley of Josephat. It is of such virtue that he who says it or will say it, or carries it on his person will not perish in water, nor in fire, nor in battle, nor will he be vanquished by his enemies, and furthermore, if he has the devil in his body, it will depart, and if he has the affliction of St. John [epilepsy], he will be cured. And the woman suffering pain in labor who carries it or says it will then give birth. And he who carries this on his person and says it everyday will see the Virgin Mary three hundred days before his death."

The miniature reproduced here was clearly inspired by the prayer's opening words, "Lord Jesus Christ, Son of God the all-powerful Father, you who are Lord of the angels, Son of the Virgin Mary. . . ." Paralleling these words, the Savior is represented as the Christ Child holding the cross-surmounted globe of the world, entertained by angels, his sex openly revealed in reference to his humanity. For the Master of Charles V, see no. 8.

"Hours of Charles V," for Rome use. Belgium, Brussels, c. 1540, for Emperor Charles V (MS M.696, fols. 40v–41r).

VIII. SUFFRAGES

WHAT A COMFORT the panoply of saints who appear in nearly all Books of Hours must have been for the reader. Saints were the protectors of medieval people, their helpers in childbirth, their guardians during travel, their nurse in toothache, their doctor in plague. If the Virgin was the person to whom one addressed the all-important petition for eternal salvation, it was from the saints that one sought more basic, or temporal, kinds of help. While the Virgin became, as the Mother of God, almost a goddess herself, saints always retained more of their humanity and thus their approachability. The saints whom medieval men and women saw painted onto altarpieces, stained into glass, sculpted from stone, woven in tapestries, and stitched upon liturgical vestments were the same saints whose special invocations were to be found in one's own Book of Hours. They could be held in one's hands, taken home, called upon at any time.

The typical Book of Hours contained a dozen or so Suffrages (these petitions are also called Memorials, from the Latin *memoriae*). The Suffrages typically appear at the end of the volume, but some *Horae* include them after Lauds of the Hours of the Virgin, in imitation of monastic practice. Their order is a reflection of celestial hierarchy (itself a mirror of medieval society). God or the three Persons of the Trinity (who, of course, are not saints) always begin the Suffrages, followed by the Virgin, the archangel Michael, and John the Baptist (the last two prominently positioned because of their importance as judge and intercessor, respectively, at the Last Judgment). The apostles appear next, followed by male martyrs and confessors (nonmartyr saints). Female saints come next, virgin martyrs first.

Each Suffrage is composed of four elements (although these are not always clearly marked by the rubrics): three ejaculations (antiphon, versicle, response) followed by a longer prayer (*oratio*). The first three elements constitute a string of praises. As for the prayer, its first half recounts, albeit briefly, an episode from the saint's life or touches on some important aspect of the saint's holiness; the second half of the prayer is always a petition for aid from God through the saint's intercession. The mixture of these four elements mirrors the arrangement found in Breviaries (used by the clergy), and, indeed, many of the elements that compose a given Suffrage are quotations or extractions from the offical liturgical texts in Breviaries. Some Suffrages, too, draw from Missals, quoting the prayer, which was particular for that Mass, that follows the "Gloria Patri." The prayers in both Breviaries and Missals change from feast to feast, and their petitions to specific saints made them a logical quarry for the popular versions that appear in Books of Hours as Suffrages.

Translations of five typical Suffrages follow:

A. *We pray you, through St. Thomas' blood, which he for you did spend; cause us, O Christ, to climb, where Thomas did ascend.* V. *You crowned him with glory and honor.* R. *And placed him above your other creations.* Or. *O God, for whose Church the glorious Bishop Thomas fell by the swords of ungodly men; grant, we beseech you, that all who implore his help may obtain for their salvation the grace that they ask. Through Our Lord Jesus Christ, who lives and reigns with you.* (FROM MS G.9, FOL. 30V;

SOUTHERN ENGLAND, C. 1440–50. While the antiphon, versicle, and response in MS M.105 [no. 87] are atypical [and thus not translated here], the *oratio* is the same as the above.)

A. *Among those born of women, there has risen no one greater than John the Baptist.* V. *There was a man sent from God.* R. *Whose name was John.* Or. *Grant, we beseech you, almighty God, that your people may walk in the way of salvation, and by following the exhortations of the blessed John, your fore-runner, may safely come to him whom he foretold, Our Lord Jesus Christ, your Son, who lives and reigns with you.* (FROM MS M.282, FOLS. 124V–125R; FRANCE, PROBABLY PARIS, C. 1460)

A. *Nicholas, friend of God, when invested with the episcopal insignia, showed himself a friend to all.* V. *Pray for us, O most blessed father Nicholas.* R. *That we may be made worthy of the promises of Christ.* Or. *O God, you adorned the pious blessed Bishop Nicholas with countless miracles; grant, we beseech you, that through his merits and prayers, we may be delivered from the flames of hell. Through Jesus Christ Our Lord.* (FROM MS M.26, FOL. 238R–V; FRANCE, LANGRES? C. 1485–90)

A. *Michael, angel and archangel, prince of paradise, come help the people of God, and may you defend us from the power of evil and lead us into the company of God.* V. *An angel stood by the altar of the temple.* R. *Having in his hand a censer of gold.* Or. *O God, in wonderful order you arrange the min-istries of men and angels; mercifully grant, that those who always stand before you and minister to you in heaven, may also guard our life on earth. Through Our Lord Jesus Christ, who lives and reigns with you.* (FROM MS M.451, FOL. 104R; BELGIUM, BRUGES, DATED 1531)

85. ST. WENCESLAS AND ST. NICHOLAS

While the main pictorial component in this book is a prefatory cycle of thirty-two miniatures (see no. 11), the dozen historiated initials illustrating the Suffrages form the second major part of the illustration. Reproduced here are Sts. Wenceslas and Nicholas. Wenceslas, patron saint of Bohemia, was martyred in 929 by his own pagan brother, Boleslaus, who opposed his Christian brother. Wenceslas is traditionally represented as a soldier; here, dressed in mail, he holds his lance and sword (with belt attached). Nicholas (c. 270–c. 343), one of the most wide-ly venerated saints in all of Christendom (and "ancestor" of our Santa Claus), is represented as a bishop, dressed in episcopal attire of chasuble and miter, and holding his crozier. Central European manuscripts could be richly painted and embellished with gold leaf or, as here, they could be more simply decorated with pen-and-ink drawings against colored backgrounds. No longer Romanesque in its stylization, but not yet fluid and elegant enough to be considered Gothic, the decoration here is typical of art produced around the year 1200.

Hours for Premonstratensian use. Bohemia, probably the Monastery of Luka, near Znaim, c. 1215, probably for Princess Agnes of Bohemia (M.739, fol. 149r).

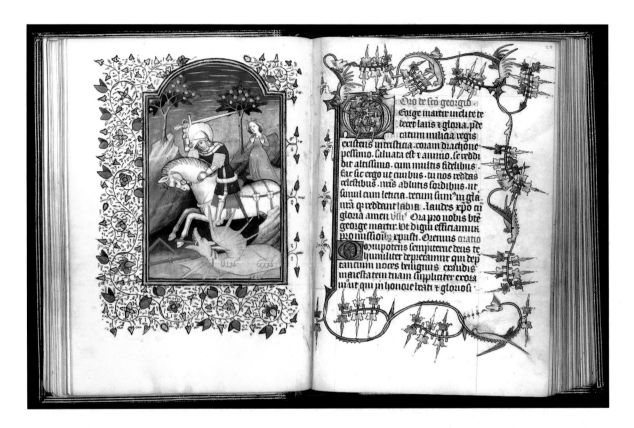

86. St. George Fighting the Dragon

by the Master of Guillebert de Mets

The totally fictive George was the prototypical "knight in shining armor" of the Middle Ages. Legend has it that the saint was an officer in the Roman army. One day he was traveling through a city that was terrorized by a dragon that, having already devoured all the cattle from the surrounding countryside, had to be satisfied with humans. George happened to be there when the king's daughter was about to be sacrificed. The knight rescued the princess, the paradigm of the damsel in distress. George's cult remains strong in Russia and Greece; he is the patron of England, and the model for all Christian soldiers.

The Master of Guillebert de Mets is named after the scribe who signed a manuscript of Boccaccio's *Decameron* made for Duke Philip the Good of Burgundy (Paris, Bibliothèque de l'Arsenal, MS 5070), to which the illuminator contributed nearly a third of the hundred miniatures. Active about 1420 to 1445, probably in Ghent, the Guillebert Master and the somewhat younger Master of the Ghent Privileges (see no. 41) were the two leading illuminators in Flanders of the second quarter of the fifteenth century (their similar styles are easily confused). The striking border on the text leaf shown here typically appears in early manuscripts by the Guillebert Master; it consists of a vigorous ivy whose leaves grow in parallel groups. His later manuscripts opt for borders composed of a broad acanthus.

Hours for Sarum and Rome use. Belgium, Ghent? and England (additions), 1420–30 (MS M.46, fols. 27v–28r).

87. MARTYRDOM OF ST. THOMAS BECKET

by the Master of Sir John Fastolf

Although Thomas Becket (c. 1118–70) was one of the most popular of English saints, pictures of him are hardly ever to be found in Books of Hours made in England or for English use. Personification of papal allegiance, Becket became an intolerable figure during the English Reformation. After his break with Rome, King Henry VIII decreed in 1538 "that his ymages and pictures, through the hole realme, shall be putte downe and auoyded out of all churches, chapelles, and other places, and that hense forthe, the dayes vsed to be festiuall in his name, shall not be obserued, nor the seruice, office, antiphones, collettes, and prayers in his namme redde, but rased and put out of all bokes."

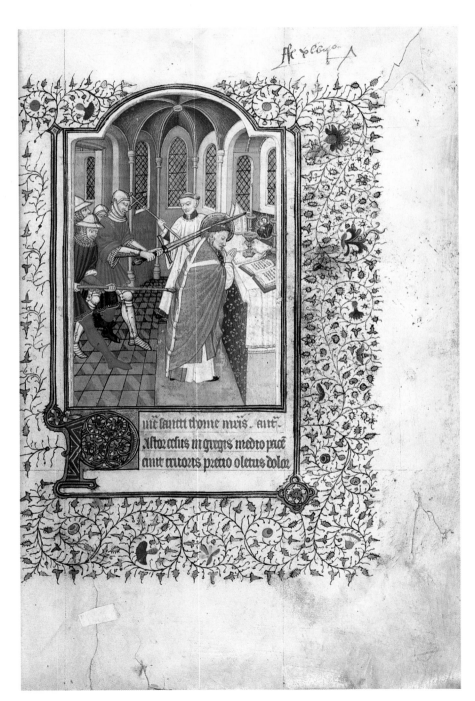

After the Fastolf Master left Paris, but before he migrated to England (see no. 71), he lived and worked in Rouen from around 1420 to 1440. This manuscript was made for Sir William Porter, an Englishman who took part in the siege of Rouen, was present at its surrender in 1419, and lived there intermittently until 1431. To celebrate his successes, Porter commissioned this grand Book of Hours, the Fastolf Master's most ambitious work. The book contains seventy-nine miniatures (at least another four are missing), including a portrait of a richly dressed Porter kneeling at a prie-dieu before an image of the Virgin and Child on the facing page.

"Hours of William Porter," for Sarum use. France, Rouen, c. 1420–25, for William Porter (MS M.105, fol. 46r).

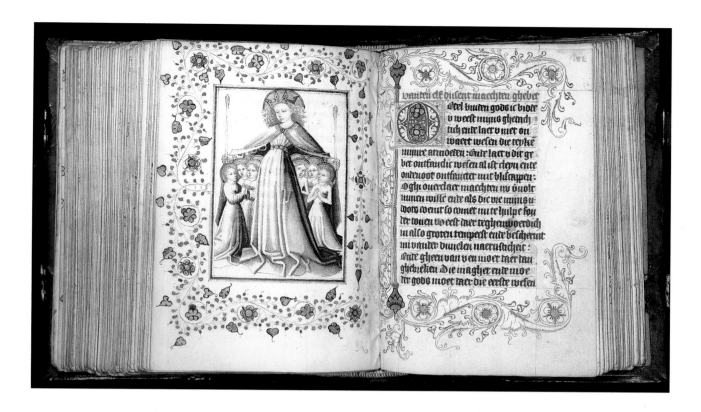

88. St. Ursula and the 11,000 Virgins

by a Master of the Delft Grisailles

As St. Ursula's celebrity grew in the course of the Middle Ages, so did the number of her companions. According to medieval tradition, Ursula, the fifth-century daughter of a British king, and a group of some ten maiden followers were martyred by Huns in Cologne. It seems that at some point an inscription referring to them, "XI M.V." meaning "Undecim martyres virgines" (Eleven virgin martyrs), was translated as "Undecim milia virginum" (Eleven thousand virgins), and the fantastic number stuck. In the twelfth century, the excavation of a cemetery in Cologne provided enough bones for ecclesiastic authorities to claim a "discovery" of the martyrs' lost relics. The cult, which even Pope Benedict XIV could not suppress in the eighteenth century, thrives today.

In the miniature, Ursula offers her retinue protection beneath the folds of her cloak. She holds arrows, the instruments of their martyrdom. The picture is executed in a delicate grisaille with touches of gold. The border, too, is quite restrained with leaves in a pale green and flowers composed of small petals of blue or old rose. Toward the middle of the fifteenth century, a group of artists in the city of Delft specialized in such grisaille miniatures. They were usually painted and sold as single leaves that could be inserted into Books of Hours.

Hours for Windesheim use. The Netherlands, Delft, c. 1440 (MS M.349, fols. 181v–182r).

89. DECAPITATION OF ST. JOHN THE BAPTIST

by a late follower of the Master of the Munich Golden Legend

Instead of the usual static image of a standing saint (such as in the previous illustration), the miniature reproduced here, one of the finest from the manuscript's particularly rich cycle of Suffrages, depicts a dramatic narrative. Herod and Herodias, dining in the background, are unaware that, in a few moments, they will be presented with the bloody head of John the Baptist, which Salome receives from the executioner in the palace courtyard. Vignettes in the margins, where a swan and a dragon receive blows to their heads, offer a gloss on the violent activities depicted in the large miniature.

The illuminator is a late follower of the Master of the Munich *Golden Legend* (see no. 80). His is an engaging style that includes much attention to the depiction of everyday objects: window grills, plateware, swords. He had a particularly observant eye when it came to fashion, both real—such as the costumes of Herodias, the waiter, and Herod's dining companion—and fantastic—like Herod's and Salome's headgear.

Hours for Rome use. France, probably Paris, c. 1460 (MS M.282, fol. 124v).

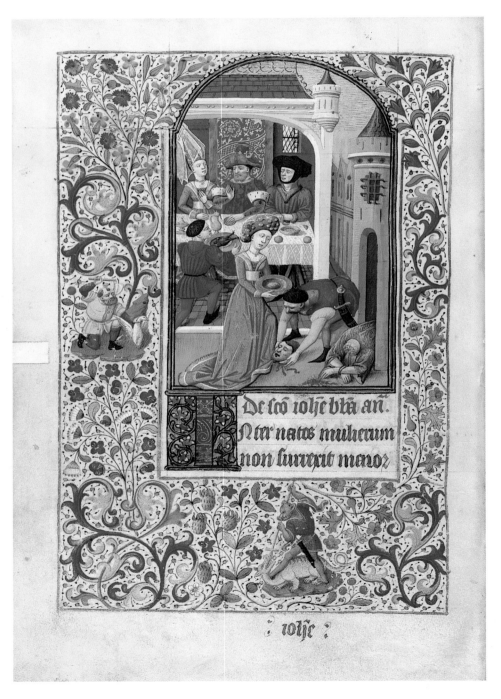

90. St. Nicholas Resuscitating the Three Youths

It is as the patron of children that Nicholas owes his fame in the late medieval and modern West. In one legend he saved a trio of young girls from a life of prostitution by providing money for their dowries. This story, it would appear, gave rise to another relating to children. Nicholas's attribute of three purses of gold, sometimes depicted as yellow spheres, were mistaken as three tow-haired heads, thus giving birth to the story of the mutilated boys. According to tradition, an unscrupulous innkeeper had killed and dismembered three youths, storing their mangled bodies in a pickling tub as food for his guests. Nicholas was able to bring the boys back to life simply by making the sign of the cross over the barrel. The story seems to have originated in France; the earliest account appears in the twelfth century, but the story is no doubt older.

Hours for Rome use. France, Langres? c. 1485–90 (MS M.26, fol. 238r).

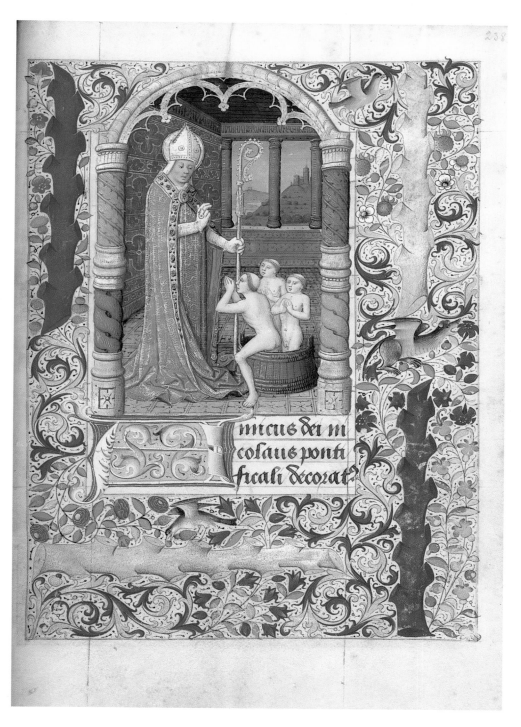

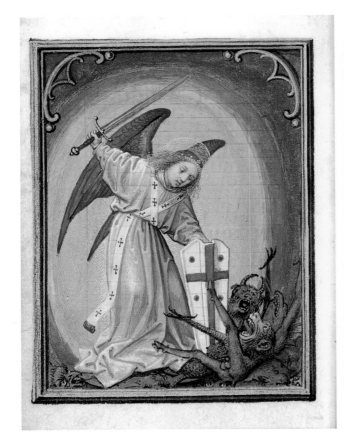 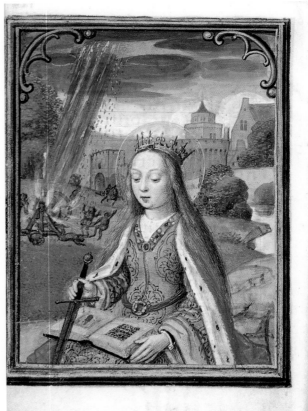

91. ST. MICHAEL BATTLING DEMONS AND ST. CATHERINE

by Simon Bening

The image of St. Michael is playful, nearly sweet. The almost childlike archangel battles demons who, as a sign of their nefarious nature, shamelessly expose their private parts. The results, however, are hardly frightening. The picture of Catherine (easily the most popular female saint of the Middle Ages), with the figure positioned close to the picture plane, can perhaps engage us more. In the background, a heavenly firestorm destroys the spiked wheels upon which her unsuccessful suitor, the Emperor Maxentius, hoped to torture her. Oblivious to the violence, Catherine prays from her illuminated Book of Hours, grasping the sword with which she met her eventual martyrdom.

The colophon states that the "author and scribe of this work is named Antonius van Damme, an old resident of Bruges, the year 1531." Van Damme indeed must have been elderly, since he was already a member of the Guild of St. Luke in 1495. Firmly dated, this manuscript is an anchor for the work of its illuminator, Simon Bening. The small but very fine pictures were created about fifteen years after the artist painted the Da Costa Hours (see no. 17). Bening's palette has become more subtle, his compositions more complex, and his landscapes rendered with more attention to atmospheric conditions.

Hours for Rome use. Belgium, Bruges, dated 1531 (MS M.451, fols. 103v and 126v).

IX. OFFICE OF THE DEAD

THE OFFICE OF THE DEAD was in the back of every Book of Hours the way death itself was always at the back of the medieval mind (the Office usually followed the Penitential Psalms and Litany). While all the other texts in a Book of Hours are considered quasi-liturgical (reflecting but not wholly equaling official Church practice), the Office of the Dead (sometimes called the Vigils of the Dead) in Books of Hours is exactly the same Office found in the Breviaries and Antiphonaries used by the Church's ordained.

It is perhaps easier to understand the function of this service by recalling its old name, Office *for* the Dead. It was the cause of considerable anguish for medieval men and women to think of the potentially long periods of time their relatives would spend in the painful fires of purgatory. The ideal Christian death took place at home, in bed, with one surrounded by relatives and—most importantly—having confessed, been forgiven, and having just received Last Communion and Extreme Unction. Such a death cleansed the soul and ensured its immediate entry into heaven. As was its nature, however, death often caught its victims unprepared. It was assumed that most people's entry into heaven would be detoured by a stay in purgatory, a delay projected to last, judging from the indulgences of the time, potentially thousands of years. Along with the funding of funerary Masses, praying the Office was considered the most efficacious means of reducing this fiery price of obtaining paradise. These aids were essential, because only the living could help the dead.

The Office of the Dead consists of the three Hours of Vespers, Matins, and Lauds. Vespers was ideally prayed in church over the coffin on the evening before the funeral Mass. It was either recited or chanted by monks hired specially for that purpose by the deceased's family or confraternity. Matins and Lauds were then prayed, again by monks paid for this service, on the morning of the funeral itself. The word *dirge*, today meaning a mournful hymn used at funerals, comes from the opening Latin antiphon for Matins, "Dirige, Domine, Deus meus, in conspectu tuo viam meam" (Direct, O Lord, my God, my steps in your sight). In the Middle Ages the word *dirge* was a common way of referring to the Office of the Dead itself. While monks recited it from Breviaries or chanted it from Antiphonaries, laymen and laywomen would say their Office from Books of Hours. Funerals, however, were not the only time the Office was prayed. The tradition that required the ordained to recite the Office on a daily basis also encouraged the laity to pray it at home as often as possible. Whatever the setting, the purpose was always the same: to get one's dearly departed out of purgatory and into heaven as soon as possible. The dead could not pray for themselves.

The Office is not to be confused with the text of the funeral Mass or that of the rite of burial. Quite different from the Office, these are to be found in two service books used by the priest, respectively, the Missal and the Ritual. Like other Offices, this one is composed mostly of Psalms, and these offer comfort to the dead. Thus begins Psalm 22 in the second nocturn of Matins:

The Lord ruleth me: and I shall want nothing. He hath set me in a place of pasture. He hath brought me up on the water of refreshment: he hath converted my soul. He hath led me in the paths of justice,

for his own name's sake. For though I should walk in the midst of the shadow of death, I will fear no evils. . . . (Some readers might be more familiar with the King James Version's translation of this Psalm [numbered 23 in that Bible]: *The Lord is my shepherd; I shall not want. He maketh me to lie down in green pastures: he leadeth me beside the still waters. He restoreth my soul: he leadeth me in the paths of righteousness for his name's sake. Yea, though I walk through the valley of the shadow of death, I will fear no evil. . . .*)

Psalm 26 in the same nocturn continues this element of hope:

The Lord is my light and my salvation: whom shall I fear? The Lord is the protector of my life: of whom shall I be afraid? Whilst the wicked draw near against me, to eat my flesh. My enemies that trouble me, have themselves been weakened and have fallen.

The more remarkable component of the Office of the Dead, however, is a moving series of readings from the Old Testament Book of Job that make up the nine lessons for Matins. The trials endured by Job become an allegory for one's time on earth—or in purgatory. Thus the "I" of the readings ceases to be Job, ceases even to be the person reading the Office and, instead, becomes the voice of the dead man himself, crying for help. Pity and mercy are continually asked for throughout the lessons, but through a veil of near despair. The first lesson (Job 7:16–21) begins:

Spare me, O Lord, for my days are nothing. What is man that thou shouldst magnify him? Or why dost thou set thy heart upon him?. . . Why hast thou set me opposite to thee, and I am become burdensome to myself?. . . Behold now I shall sleep in the dust: and if thou seek me in the morning, I shall not be.

The second lesson (Job 10:1–7) asks, "Tell me why thou judgest me so? Doth it seem good to thee that thou shouldest calumniate me, and oppress me, the work of thy own hands?" The third lesson (Job 10:8–12) repeats this existential question, "Thy hands have made me and fashioned me wholly round about. And dost thou thus cast me down headlong on a sudden?" In the fourth lesson (Job 13:22–28), the forlorn voice demands, "Make me know my crimes and offences"; in the fifth (Job 14:1–6), it bemoans, "Man, born of woman, living for a short time, is filled with many miseries. Who cometh forth like a flower, and is destroyed, and fleeth as a shadow. . ."; and in the sixth (Job 14:13–16), asks, "Who will grant me this, that thou mayest protect me in hell, and hide me till thy wrath pass, and appoint me a time when thou wilt remember me?" In desperation, the voice of the seventh lesson (Job 17:1–3, 11–15) laments, "I have said to rottenness: thou art my father; to worms, my mother and my sister."

It is not until the end of the eighth lesson (Job 19:20–27) that a note of hope is sounded, "For I know that my Redeemer liveth, and in the last day I shall rise out of the earth. And I shall be clothed again with my skin: and in my flesh I shall see my God." But this glimmer is short-lived, and the last lesson (Job 10:18–22) asks the final question, "Why didst thou bring me forth out of the womb? . . . I should have been as if I had not been, carried from the womb to the grave." Like the tolling of a funeral bell, the Office of the Dead ends:

Eternal rest grant them, O Lord,
And let perpetual light shine on them.
V. From the gates of hell,
R. Deliver their souls, O Lord.
V. May they rest in peace,
R. Amen.

92. LAST RITES

Among the most common illustrations for the Office of the Dead—the Last Judgment, Raising of Lazarus, Parable of Dives and Lazarus, Three Living and Three Dead, Job on the Dungheap, and Death Personified—the most fascinating are those illustrating the medieval funeral. The miniatures chosen for this chapter depict the various stages of the medieval rituals surrounding death and burial. Assembled as a series, they allow the events to unfold scene by scene, in an almost cinematic manner.

The ideal Christian death took place at home, with the dying person in bed, surrounded by loved ones, and, most important, receiving the Last Rites. Upon entering the house, the priest would bless the sick person with holy water and commence to pray; after death, the deceased—a woman here, her eyes closed in death—was blessed again.

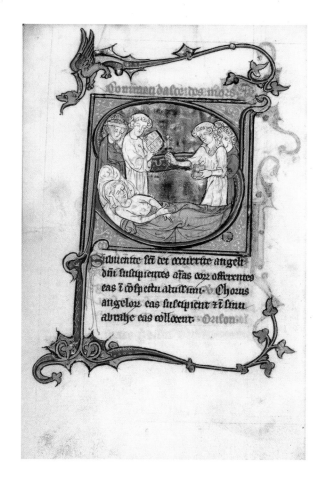

This miniature marks the beginning of the *Commendatio animae* (Recommendation of the Departing Soul to God), prayers recited at the deathbed. The *Commendatio*, when present, is usually appended to the end of the Office of the Dead; it was especially popular in the fifteenth century in Books of Hours made in England or for English use.

Hours for St.-Omer use. Northern France, possibly Thérouanne, early fourteenth century (MS M.60, fol. 63v).

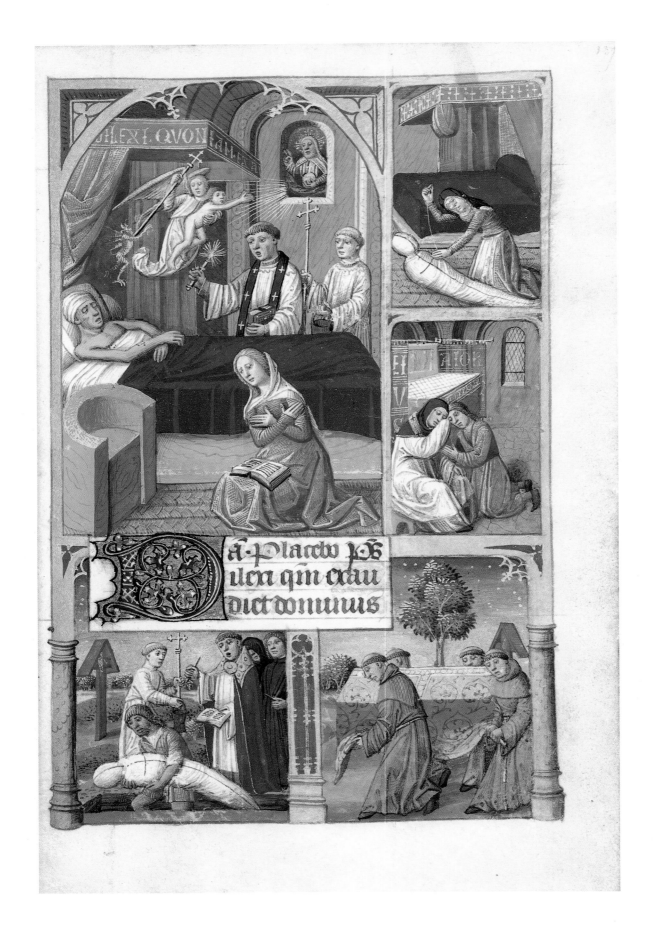

93. LAST RITES (*opposite*)

by the Chief Associate of Maître François

As the priest blesses the dying man with holy water, the latter expires. His soul, in the form of a naked child, flies heavenward to God, assisted by an angel who wards off a demon with his staff. The Last Rites were administered to secure safe passage for the soul on the journey to God, the *migratio ad Dominum*. At the side of the bed, the dead man's grieving wife prays the Office of the Dead from her Book of Hours.

The border vignettes illustrate subsequent events in the medieval funeral: the sewing of the man's corpse into a shroud; a family member confessing (to obtain a state of grace before praying for the deceased); a funeral procession; and, finally, the interment. These small rectangular illustrations, filling, as they do, the margins of the page, are a hallmark of the Chief Associate, one of Paris's leading illuminators in the late fifteenth century. Capitalizing on this device, the early Parisian printers of *Horae* seized upon this idea and used it to their advantage (see, for example, nos. 4, 18, 38, 57, and 65).

Hours for Paris use. France, Paris, c. 1485–90 (MS M.231, fol. 137r).

94. FUNERAL PROCESSION TO THE CHURCH

by Jean Colombe and his workshop

After death the corpse was washed, sewn into its shroud (as seen in the previous illustration), and then placed into a wood coffin. The body was then borne from home to church in the first of two formal funeral processions, this one taking place usually on the day before the Requiem Mass and burial. Shown here, as was the custom, the coffin is not only carried by monks but also preceded by a group of clerics, whose large numbers fill the nave of the church. The retinue behind the bier is made up of lay mourners.

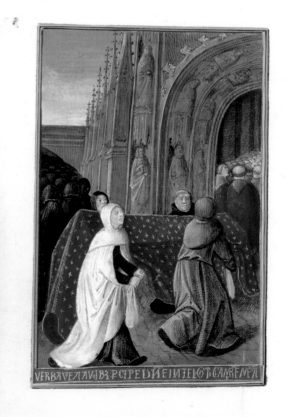

Colombe's vast output was hugely popular, and he became the official illuminator to the court of Savoy at the end of his career. It was for Duke Charles I of Savoy and his wife, Blanche de Montferrat, that Colombe completed, in the late 1480s, the most famous of all Books of Hours, the *Très Riches Heures* of Jean, duc de Berry (Chantilly, Musée Condé, MS 65), left unfinished when Berry and the Limbourg brothers all died of the plague in 1416. For his completion of the *Très Riches Heures* and similar commissions (such as no. 29), Colombe is sometimes called "the great finisher." Indeed, this *Horae* was also completed by him; it was begun five years earlier in Angers by a follower of the Master of Jouvenel des Ursins. (For other manuscripts illuminated by Colombe, see nos. 30 and 81.)

Hours for Angers use. France, Angers and Bourges, c. 1465 and c. 1470 (MS M.248, fol. 87v).

95. Chanting the Office of the Dead

After the coffin was brought to church, the family or confraternity of the deceased would pay for the Office of the Dead to be recited or sung by monks or priests. This took place on the night before or the morning of the funeral Mass; Vespers, ideally, was prayed on the evening before the funeral Mass, Matins and Lauds in the morning of the day itself. Images of the recitation or chanting of the Office over the funeral bier are among the more frequently found illustrations for the Office in Books of Hours. Here, the coffin, covered by a blue pall, is flanked by a group of mourners, bowing their heads in prayer, and a pair of priests singing the Office of the Dead from a choir book.

Hours for Rome use. Central France, c. 1470 (MS M.159, fol. 104r).

96. Requiem Mass (*opposite*)

The funeral Mass followed the praying of the Office and usually took place in the morning. This miniature illustrates the climax of the service when the priest elevates the consecrated host; eyes turn to view the transubstantiated wafer. The picture is rich with detail. Suspended above the altar hangs a ciborium (the reserve for consecrated hosts), protected by an embroidered canopy. At the foot of the altar, two men hold tall candles to illuminate the raised wafer, common medieval practice at the Elevation. A wood catafalque, set with candles all around, surrounds the coffin. Nearby are two smudge pots, earthenware jugs in which charcoal was burned to purify the air and protect against contagion.

Hours for Paris use. France, Brittany or Angers, c. 1440 (MS M.157, fol. 129v).

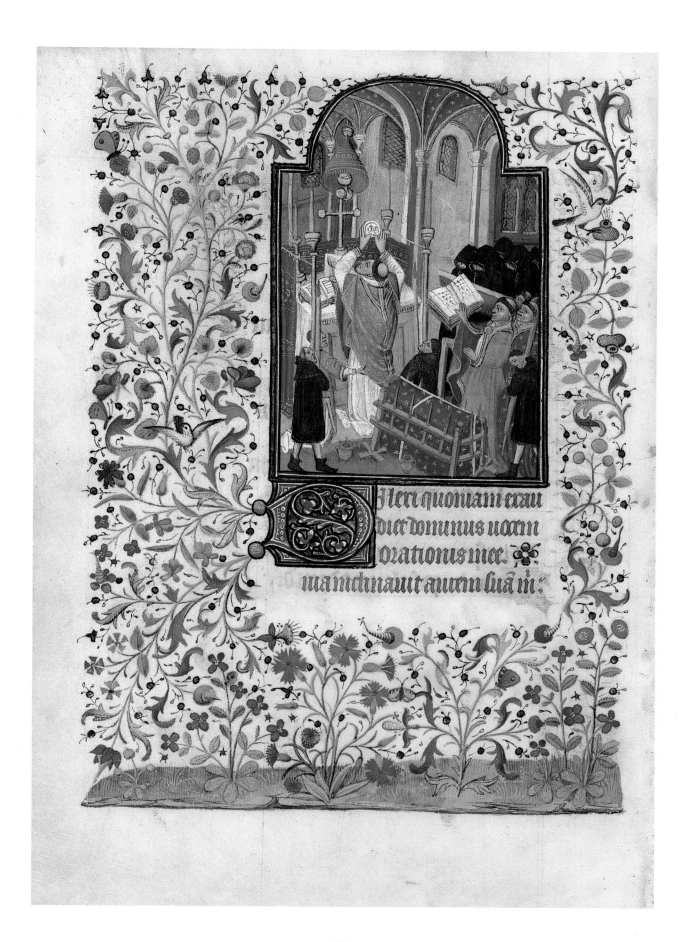

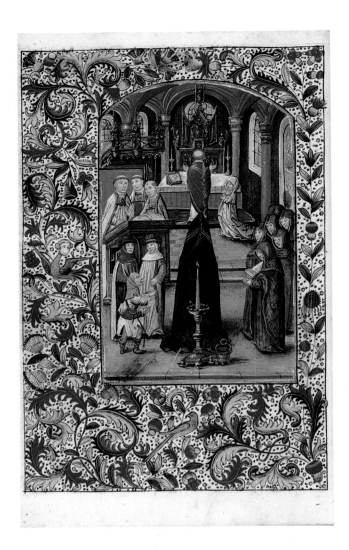

97. REQUIEM MASS

by the workshop of Willem Vrelant

As Mass is being said at the altar, the choir, at left, awaits its time to sing while mourners, at right, continue their prayers. One of two men standing near the coffin places alms into a beggar's outstretched bowl. Distribution of money to the poor—whose subsequent prayers for the deceased were thought especially efficacious—was an integral part of the medieval funeral; wills often stipulated the amounts to be disbursed.

For a second miniature from this manuscript and a discussion of the illuminator, Willem Vrelant, see no. 76; for another Book of Hours by Vrelant, see no. 83, and for a *Horae* by a follower, see no. 64.

Hours for Rome use. Belgium, Bruges, c. 1470 (MS H.7, fol. 108v).

98. ABSOLUTION (*opposite*)

attributed to William Abell

Immediately after Mass came the Absolution. The priest would leave the altar, change into a black cope, and then approach the bier in order to offer the deceased a final blessing of absolution. Assisted by acolytes who bring a cross and a Ritual (the service book containing the prayers), the priest sprinkles the coffin with holy water and then, as shown in this miniature, censes it with swings of his thurible.

The original illumination in this manuscript is the work of two English artists, one of whom is thought to be William Abell. Abell was a London "lymnour" who, documents tell us, was paid in 1447–48 for the decoration of the founding charter of Eton College (still housed by that institution's library). At least seventeen manuscripts are attributed to Abell, one of the more important English illuminators active in the mid-fifteenth century. Sometime around 1482 the manuscript found itself in Italy, where a section of text with miniatures was added; the latter are thought to be early works by Tommaso da Modena.

Because Henry Beauchamp's motto, "Deserving causyth," and "Warrewyk" were written onto the bottom of folio 12, the manuscript is thought to have been commissioned by him between his succession as earl in 1439 and his death in 1446. Style and costume, however, indicate a slightly earlier date.

"Warwick Psalter-Hours," for Sarum use. England, London? 1430s, possibly for Henry Beauchamp, earl (and subsequently duke) of Warwick (MS M.893, fol. 60r).

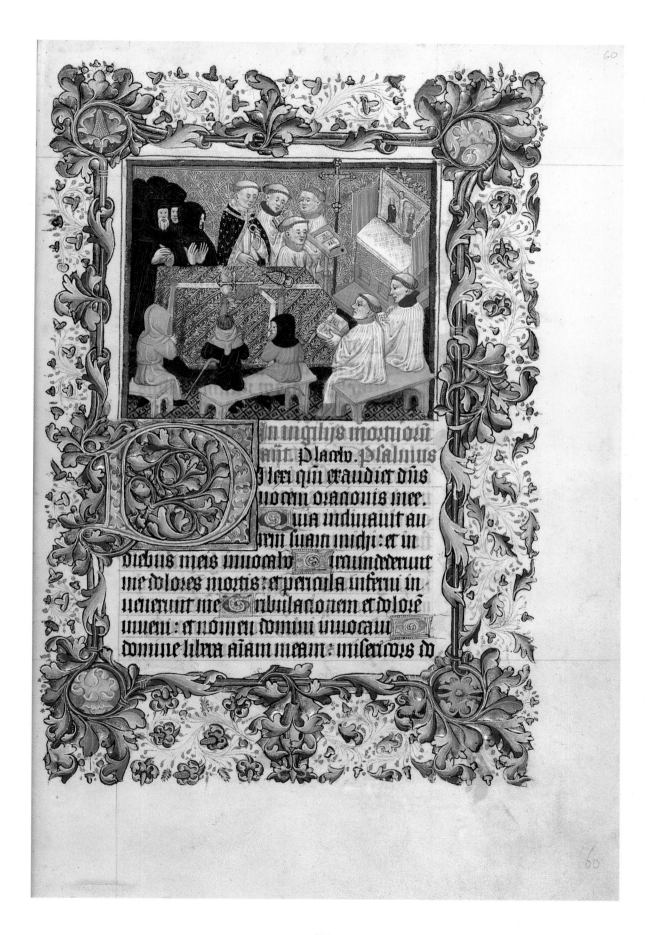

99. ABSOLUTION

Like the previous reproduction, this miniature illustrates the Absolution that immediately follows the Requiem Mass. The priest, his cope held back by an assisting acolyte, circles the coffin censing the deceased's feet, middle, and head along one side and then the other. The striking element in this picture, however, is the great catafalque—outfitted with no less than seventeen tall candles—that towers over the bier.

Depictions of medieval funerals inevitably reveal the range of expenses these services could entail. Hired mourners, clergy for processions and prayers, alms for the poor, and candles for catafalques could all be endlessly multiplied—to the pain of one's pocketbook, but for the salvation of one's soul.

Hours for Rome use. Belgium, Tournai? 1480s (MS M.234, fol. 108v).

100. BURIAL WITHIN THE CHURCH

by the Master of Charles de Neufchâtel

Lucky were the few whose professional, social, or financial position enabled them to be buried within the church itself. Intramural entombment was a benefit usually reserved for bishops, abbots, benefactors, and distinguished members of the upper class. The ideal was burial *ad sanctos*, interment close to an altar that housed the tomb of a saint or was situated directly over a martyr's grave. Thus privileged, the dead hoped to receive special protection from the nearby saint and, furthermore, stood to benefit from the prayers of the assembled faithful who trod over their graves.

The Master of Charles de Neufchâtel was named by Eberhard König after the miniatures he contributed to one of the most lavishly illuminated Missals from the late Middle Ages. The two-volume Missal (Auckland, Public Library, Med. MSS G.138–139) was commissioned by Charles de Neufchâtel shortly after his election as archbishop of Besançon in 1463. The artist's style could not be called elegant, but his miniatures have a charmingly direct narrative quality and his figures, while stocky and sometimes even ugly, are somehow endearing.

Hours for Besançon use. France, Besançon, c. 1470 (MS M.28, fol. 111r).

101. Procession to the Graveyard

by the Master of Jeanne de Laval

Most people, of course, were not buried beneath the church floor. Following the Absolution, a second formal procession escorted the deceased from church to graveyard. The cortege, as in this miniature, was led by a cleric holding aloft a processional cross and accompanied by the celebrant, both of whom are shown looking upon, rather concernedly, the four Franciscans struggling with the weight of the coffin. Lay mourners, in black, follow at the back. Within the cemetery walls, at left, the grave is being opened.

The Master of Jeanne de Laval, active in Angers from about 1430 to 1480, is named after the Psalter he painted for Jeanne de Laval, second wife of King René d'Anjou (Poitiers, Bibliothèque Municipale, MS 41). He painted for Jeanne another manuscript that is in the Morgan Library, a *Mortifiement de vaine plaisance* (MS M.705), copying the miniatures created by Barthélemy van Eyck for the (now lost) originals made for René (who actually composed the treatise). The present *Horae* is one of the Laval Master's earlier productions. In addition to that of van Eyck, his work reflects the influences of the distinctive Rohan Master and the Master of Marguerite d'Orléans (see no. 104).

Hours for Nantes and Angers use. France, Angers, 1440s (MS M.63, fol. 89r).

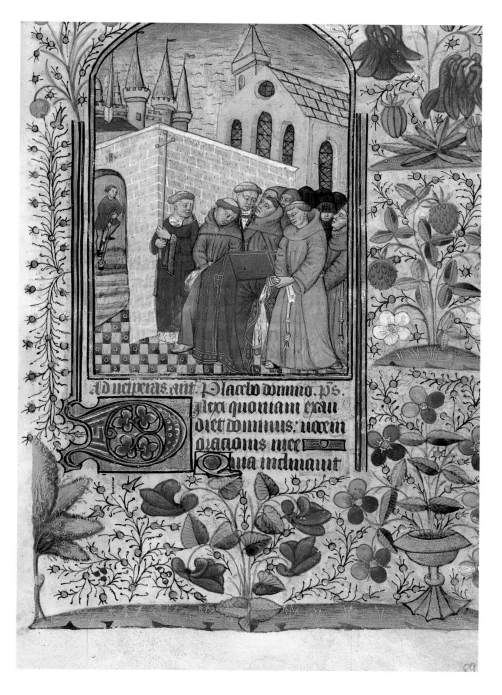

102. PREPARATION FOR BURIAL

This robust miniature captures the poignant moments after the procession has reached the graveyard and just before the burial service begins. While the priest locates his place in his Ritual, an elderly man and woman grieve privately over the nearly nude body of a young man (their son?). The coffin cover has just been lifted—the young man's soul flies toward heaven, barely escaping the clutches of two dark demons.

Hours for Rome use. Northern France, early fifteenth century (MS M.264, fol. 101r).

103. BURIAL

Interring a corpse in a coffin is basically a modern practice, becoming prevalent only at the end of the eighteenth century. In the Middle Ages, the coffin was a means of transporting the dead from home to church and from church to cemetery. Once there, the pall was withdrawn, the cover lifted, and the corpse removed.

In this miniature, the crude stitching of the shroud is clearly visible. As the gravediggers lower the corpse at the end of the Rite for Burial, the priest recites the Our Father and offers the deceased a final benediction of holy water. The service nearing its end, the mourners begin to turn away.

Hours for unknown use. Belgium, possibly Brussels, c. 1475 (MS M.485, fol. 132v).

104. BURIAL

by the Master of Marguerite d'Orléans

In the Middle Ages, the concept of a permanent individual burial plot did not apply for most people. Grave sites were not forever. The bones of previous occupants, as seen here, were continually disturbed in the constant digging and redigging of the cemetery. The flesh eaten away, the bones were collected and stored in charnel houses, open-air structures, as also seen here, surrounding the churchyard. The most famous of all medieval graveyards was the Cemetery of the Innocents—called the great *chair-mange* (flesh-eater)—where over a thousand years of Parisian dead were buried, albeit temporarily. The cemetery and its huge charnel houses were destroyed in the eighteenth century as a health hazard; its massive mounds of bones—estimated to be the remains of 6 million people—were removed to Paris's catacombs where they can be visited today.

The Master of Marguerite d'Orléans, named after her Book of Hours (Paris, Bibliothèque Nationale de France, MS lat. 1156B), is one of the more individual French artists of the second quarter of the fifteenth century. Trained in Paris, he worked successively in Bourges, Rennes (where he painted Marguerite's commission), and, finally, Poitiers where he illuminated this *Horae*, the last that can be attributed to him. Made for Marie de Rieux, the present manuscript is a fragment; other portions are in Edinburgh (National Library of Scotland, Blairs deposit MS 32), Paris (Bibliothèque Nationale de France, MS lat. 1170), and Tours (Bibliothèque Municipale, MS 217).

Note the mourner in the lower left border; he is reading Matins of the Office of the Dead: "Dirige, Domine, Deus" (Direct, O Lord, my God).

"Hours of Marie de Rieux," for Rome use. France, Poitiers, 1440s, for Marie de Rieux (MS M.190, fol. 1r).

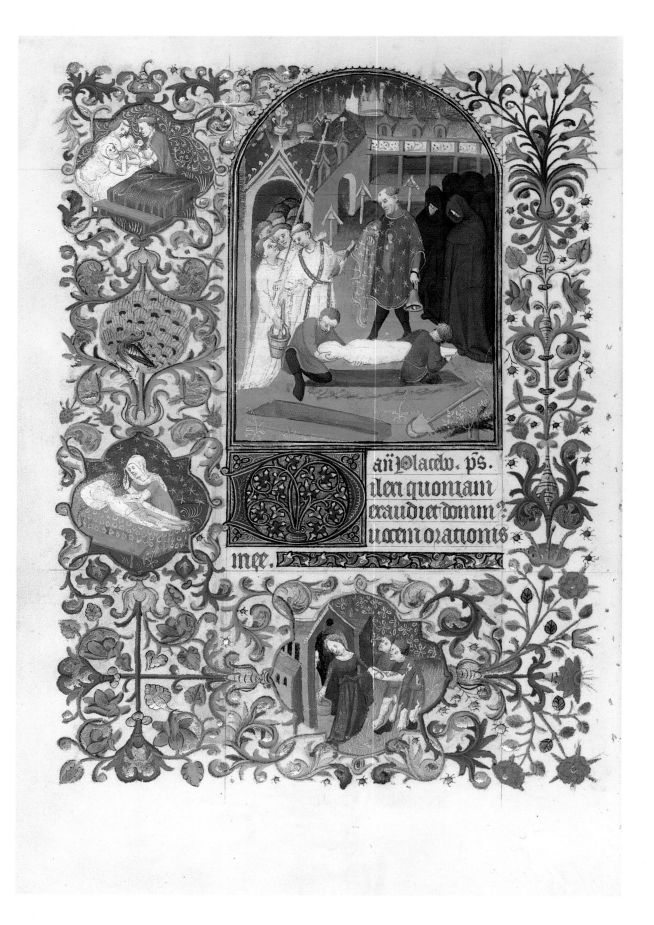

aū Placebo. ps.
Dileri quoniam
exaudier dominus
vocem orationis
mee.

105. BURIAL (*opposite*)

by the Master of Morgan 453

As in the previous reproduction, a charnel house filled with skulls encloses the graveyard in which this burial takes place. Distinctive here, however, is the man standing at center. He is the representative of the deceased's confraternity or parish guild. Dressed in the association's identifying robe (with an image of a praying female saint on the front), he holds the group's pall in his right hand and, in his left, the bell with which he led the funeral procession. One of the primary functions of many medieval confraternities was taking care of all the details of a member's burial, akin to the role of the modern funeral director; as a charity, they also tended to the funerals of the poor. The border vignettes show a dying man receiving his Last Communion; his corpse being sewn into a shroud; and charitable distribution of bread to the poor by his family.

For another miniature from this manuscript and discussion of the Master of Morgan 453, see nos. 37 and 66. Hours for Paris use. France, Paris, c. 1425–30 (MS M.453, fol. 133v).

106. BURIAL, WITH A SOUL RELEASED FROM PURGATORY

by a follower of the Coëtivy Master

The salvific purpose of the Office of the Dead is literally illustrated in this miniature. While his burial takes place in the foreground, the dead man's soul is being released from the flames of purgatory by two angels. This is the goal of praying the Office of the Dead by the deceased's family, by the clergy they hired, and by the poor to whom they gave money.

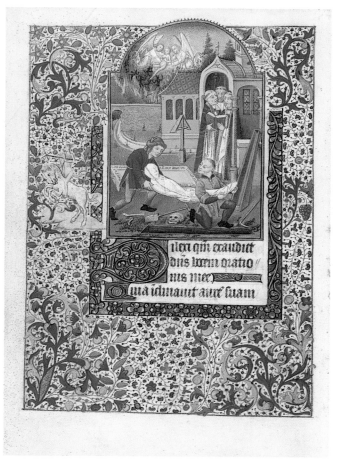

The artist is a follower of the Coëtivy Master, named after the Book of Hours of Olivier Coëtivy and his wife, Marguerite de Valois (Vienna, Österreichische Nationalbibliothek, Cod. 1929). The Coëtivy Master (who has tentatively been identified with Henri de Vulcop and, more recently, with Colin d'Amiens) was active in Paris from about 1450 to 1485 and was, along with Barthélemy van Eyck and Jean Fouquet, the third great artist of this period patronized by the royal court. He painted panels, designed tapestries and stained glass, and illuminated manuscripts. The work of the multifaceted Coëtivy Master was influential, and the illuminator of this *Horae*, who might have trained with him or, at the very least, had studious contact with his work, was clearly a gifted follower. The luminous palette, short and square-jawed figures, and strong narrative component are features gleaned by our illuminator from the Coëtivy Master's style.

Hours for Rouen use. France, Rouen, c. 1465–75 (MS. M.1055, fol. 87v).

107. HELL

by the Master of Catherine of Cleves

This is one of the most frightening hells painted before those of Hieronymus Bosch. Introducing the Office of the Dead, prayers recited for benefit of the dead, this image had a major purpose: to scare the living. From the mouth of the green demon at the bottom, upon whose back the entire framed image weighs, spew scrolls inscribed with the names of the Seven Deadly Sins, the committing of any one of which ensured eternal damnation. In the horrible hell above, a battery of sadistic demons push, chase, pull, cart, pitch, and spear struggling naked souls into a huge gaping hell mouth, stretched open to reveal yet another inner, red-hot maw. Within these burning jaws is hell's furnace, supplying the churning fire that incinerates the damned; we see them through the open door in the throat of yet a third hell mouth whose yawning head domes the infernal cathedral of death.

The inventive Master of Catherine of Cleves outdid himself in this creation (see no. 78, another miniature from this manuscript). Hell is hardly ever depicted in Books of Hours. The thought was too much for the medieval mind to bear.

"Hours of Catherine of Cleves," for Windesheim use. The Netherlands, Utrecht, c. 1440, for Catherine of Cleves (MS M.945, fol. 168v).

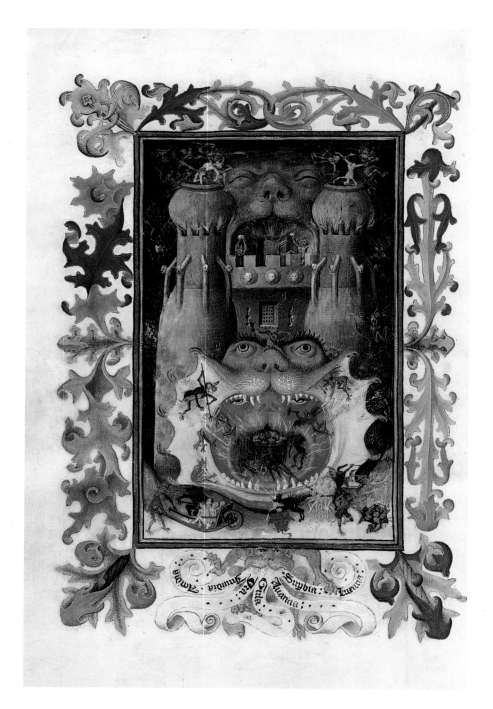

BOOKS FOR FURTHER READING

INTERESTED READERS SHOULD CONSULT the bibliography in my publication *Time Sanctified: The Book of Hours in Medieval Art and Life*, New York, 1988. In addition to art history, this list includes references to books on prayer and its relation to the Book of Hours; it also refers to tools useful in determining "use." In the citations that follow, I restrict myself to those especially helpful publications that have appeared since.

"Books for Everybody," the witty sixth chapter in the second edition of Christopher de Hamel's *A History of Illuminated Manuscripts*, London, 1994, remains a most pleasant introduction; it is supplied with a set of images almost completely different from the first edition. Claire Donovan sheds much light on the origins of *Horae* in her discussion of one of the—if not *the*—earliest surviving independent Book of Hours: *The de Brailes Hours: Shaping the Book of Hours in Thirteenth-Century Oxford*, London, 1991. We learn much, not only about fifteenth-century English *Horae*, but also about late medieval spirituality from Anne F. Sutton and Livia Visser-Fuchs in their monograph on a manuscript once owned by one of England's more controversial figures, *The Hours of Richard III*, Wolfeboro Falls (N.H.), 1990. The distinctive textual, pictorial, and devotional aspects of Dutch Books of Hours can be gleaned from the exhibition catalogue, *The Golden Age of Dutch Manuscript Painting*, New York, 1990, with catalogue entries by Henri L. M. Defoer et al. One of the most important, and beautiful, of the Books of Hours in that exhibition has been published in a handsome monograph by James H. Marrow: *The Hours of Margaret of Cleves*, Lisbon, 1995. Two hundred years of Parisian painting—including some of the most stellar Books of Hours ever illuminated—are given magisterial treatment by Charles Sterling in *La peinture médiévale à Paris, 1300–1500*; the first of these two handsome tomes was published in Paris in 1987, the second in 1990. Two recent exhibition catalogues also greatly expand our knowledge of French *Horae*: the monumental volume by François Avril and Nicole Reynaud, *Les manuscrits à peintures en France, 1440–1520*, and the elegant volume by Myra Dickman Orth and Thierry Crépin-Leblond, *Livres d'heures royaux: La peinture de manuscrits à la cour de France au temps de Henri II*, both published in Paris in 1993. Claude Schaefer has written a major monograph on one of the most important French painters of manuscripts and panels: *Jean Fouquet: An der Schwelle zur Renaissance*, Dresden, 1994; complementing this is the insightful article by Stephen C. Clancy, "The Illusion of a 'Fouquet Workshop': The *Hours of Charles de France*, the *Hours of Diane de Croy*, and the *Hours of Adelaïde de Savoie*," *Zeitschrift für Kunstgeschichte*, LVII/2, 1993. All one-hundred-twenty of the French Books of Hours in the rich collection of the Walters Art Gallery are now carefully catalogued by Lilian M.C. Randall in her *Medieval and Renaissance Manuscripts in the Walters Art Gallery. Volume I: France, 875–1420*, and *Volume II: France, 1420–1540*, Baltimore, 1989 and 1992, respectively. Her *Volume III: Belgium, 1250–1530*, appearing shortly, will include all the Flemish *Horae* at the Walters. Pre–Eyckian Flemish illumination, including, naturally, many Books of Hours, was the subject of a revealing exhibition and catalogue in 1993 at Louvain, Cultureel Centrum Romaanse Poort, *Vlaamse Miniaturen voor Van Eyck (ca. 1380–ca. 1420)*. Maurits Smeyers (who helped organize the latter) and Jan Van der Stock published *Flemish Illuminated Manuscripts, 1475–1550* in Ghent in 1996 on

the occasion of an exhibition that traveled to both Saint Petersburg and Florence; it includes a number of little known but significant later Flemish *Horae*. Recent research on major monuments of Italian illumination, including many *Horae*, is to be gleaned from *The Painted Page: Italian Renaissance Book Illumination, 1450–1550*, Munich, 1994, edited by Jonathan J. G. Alexander; it accompanied an exhibition presented in London and New York. Joaquín Yarza Luaces is the main author of a major study of the fourteenth-century Spanish Book of Hours made for María de Navarra, queen of Aragon, *Libro de Horas de la reina María de Navarra*, Barcelona, [1996]; this monumental publication includes a complete transcription of the Latin texts of the manuscript and a translation of them into Spanish.

An interesting hypothesis on how Books of Hours were read is argued by Paul Saenger in "Books of Hours and Reading Habits of the Later Middle Ages," in *The Culture of Print: Power and the Uses of Print in Early Modern Europe*, edited by Roger Chartier, Princeton, 1989 (which is a translation of *Les usages de l'imprimé [XVe–XIXe siècle]*, Paris, 1987; the article originally appeared, in English, in the less accessible *Scrittura e civiltà*, IX, 1985). How Books of Hours were used and what they meant to their readers are topics masterfully explored by Eamon Duffy in the three chapters that make up the section "Prayers and Spells" in his excellent *The Stripping of the Altars: Traditional Religion in England, c. 1400–c. 1580*, New Haven, 1992. I have learned much from my former collaborator Virginia Reinburg, who kindly shared with me parts of her forthcoming *Practices of Prayer in Late Medieval and Reformation France*; in the meantime I cite her "Hearing Lay People's Prayer," in *Culture and Identity in Early Modern Europe (1500–1800): Essays in Honor of Natalie Zemon Davis*, edited by Barbara B. Diefendorf and Carla Hesse, Ann Arbor, 1993.

While the vast compilation of liturgical ejaculations that constitute the body of Knud Ottosen's *Responsories and Versicles of the Latin Office of the Dead*, Aarhus, 1993, will interest only specialists, his first chapter on the history of the Office is a useful general summary. Two recent books on death, while not directly concerned with Books of Hours, relate to the themes and reproductions in chapter IX of this book: Paul Binski's handbook, *Medieval Death: Ritual and Representation*, Ithaca, 1996, and Michael Camille's meditational *Master of Death: The Lifeless Art of Pierre Remiet, Illuminator*, New Haven, 1996.

Portraiture in Books of Hours is discussed by Joan Naughton, "A Minimally–Intrusive Presence: Portraits in Illustrations for Prayers to the Virgin," in *Medieval Texts and Images: Studies of Manuscripts from the Middle Ages*, edited by Margaret M. Manion and Bernard J. Muir, Chur, 1991; and by me in "The Savoy Hours and Its Impact on Jean, Duc de Berry," *Yale University Library Gazette*, LXVI, 1991, where I also hint at the influence of the Savoy Hours for the history of *Horae*. Of iconographic interest are an article by Margareth Boyer Owens, "The Image of King David in Prayer in Fifteenth-Century Books of Hours," in *Imago Musicae*, VI, 1989; a short essay by Bridget Ann Henisch, "In Due Season: Farm Work in the Medieval Calendar Tradition," in *Agriculture in the Middle Ages: Technology, Practice, and Representation*, edited by Del Sweeney, Philadelphia, 1995; and a study by Maurits Smeyers, "An Eyckian Vera Icon in a Bruges Book of Hours, ca. 1450 (New York, Pierpont Morgan Library, Ms. 421)," in *Serta Devota in Memoriam Guillelmi Lourdaux. Pars Posterior: Cultura Mediaevalis*, Louvain, 1995.

Readers interested in how illuminated manuscripts, including Books of Hours, were made should consult Christopher de Hamel's slender but useful *Scribes and Illuminators*, Toronto, and Jonathan J. G. Alexander's groundbreaking *Medieval Illuminators and Their Methods of Work*, New Haven; both were published in 1992.

INDICES

1. *Of manuscript and printed Books of Hours*

2. *Of artists*

3. *Of publishers and printers*

4. *Of manuscripts cited*

Brussels, Bibliothèque Royale
 MSS 9015-16: no. 82.
Cambridge, Harvard University, Houghton Library
 MS Richardson 32: no. 60.
Chantilly, Musée Condé
 Hours of Etienne Chevalier: no. 29.
 MS 64: no. 56.
 MS 65: p. 25, nos. 17, 94.
Dresden, Sächsische Landesbibliothek
 MS A 311: no. 72.
Edinburgh, National Library of Scotland
 Blairs deposit MS 32: no. 104.
Eton, College Library
 founding charter: no. 98.
Geneva, Bibliothèque Publique et Universitaire
 MS fr. 160: no. 50.
London, British Library
 Add. MS 36,684: no. 62.
Los Angeles, J. Paul Getty Museum
 MS 57: no. 56.
 Ludwig MS I.15: no. 54.
 Ludwig MS IX.11: no. 33.
Munich, Bayerische Staatsbibliothek
 Cod. gall. 3: no. 80.
New Haven, Yale University, Beinecke Library
 MS 390: p. 17.
New York, Bernard H. Breslauer Collection
 MS 11: no. 74.
New York, Pierpont Morgan Library
 MS H.6: no. 73.
 MS M.306: no. 59.
 MS M.377: no. 20.
 MS M.705: no. 101.
Oxford, Bodleian Library
 MS Gough Liturg. 7: no. 69.
 MS Laud Misc. 570: no. 71.
Paris, Bibliothèque de l'Arsenal
 MS 5070: no. 86.
Paris, Bibliothèque Nationale de France
 MS fr. 594: no. 26.
 MS fr. 15,397: no. 48.
 MS lat. 1156B: no. 104.
 MS lat. 1170: no. 104.
 MS lat. 1173: no. 49.
 MS lat. 9471: no. 49.
 MS lat. 9474: no. 46.
 MS lat. 18014: p. 17.
 MSS lat. 11972-73, 11978: no. 6.
 MS nouv. acq. lat. 392: no. 32.
 MS nouv. acq. lat. 3120: no. 18.
Poitiers, Bibliothèque Municipale
 MS 41: no. 101.

Tours, Bibliothèque Municipale
 MS 217: no. 104.
Turin, Archivio di Stato
 MSS J.II.b.2–4: no. 59.
Turin, Biblioteca Nazionale
 MS E.V.49 (destroyed in 1904): p.17.
 MS K.IV.29 (destroyed in 1904): no. 82.
Turin, Museo Civico
 Inv. no. 47: no. 82.
Vienna, Österreichische Nationalbibliothek
 Cod. 1856: no. 64.
 Cod. 1859: no. 8.
 Cod. 1929: no. 106.
 Cod. 2583: no. 41.

5. Of early owners

Agnes, princess of Bohemia: nos. 11, 85.
Alfonso, Infante de Castile: no. 51.
Anne, princess of France: no. 81.
Arthur III, duke of Brittany: no. 80.
Beauchamp, Henry, earl and duke of Warwick:
 no. 98.
Berkeley, Captain R.G.: no. 71.
de Bosredont, Pierre: no. 6.
Carondelet, Jean: no. 69.
Catherine of Cleves, duchess of Guelders: nos. 78, 107.
Charles V, emperor: nos. 8, 39, 84.
Charles VIII, king of France: no. 7.
Charlotte of Savoy: no. 56.
Chauvet, Louise: no. 29.
da Costa, Alvaro: no. 17.
DuBois, Hawisia: no. 5.
Farnese, Alessandro: no. 77.
Gonzaga, Cecilia: no. 45.
Gouffier, Claude: no. 42.
Henry VIII, king of England: no. 39.
Isabella the Catholic, queen of Castile: no. 51.
Louis d'Orléans, dauphin of France: no. 65.
Molé, Claude: no. 9.
Montigny-St. Christophe family member: no. 67.
Pitti-Taddei de' Gaddi family member: no. 73.
Porter, William: no. 87.
Raguier, Antoine: no. 29.
de Rieux, Marie: no. 104.
Robertet, Jean: no. 29.
Sá family member: no. 17.
Sivry family member: no. 67.
William the Rich, duke of Cleves: no. 53.
Yolande, vicomtesse de Soissons: no. 1.

APPENDICES

1. Incipit outline of major Offices: Hours of the Virgin, Hours of the Cross, Hours of the Holy Spirit, and Office of the Dead

A. = antiphon
Abs. = absolution
Ben. = benediction
Cant. = canticle
Cap. = capitulum
Inv. = Invitatory
Les. = lesson
Or. = oration
Ps. = psalm
R. = response
Recom. = recommendation
V. = versicle

HOURS OF THE VIRGIN

The Hours of the Virgin outlined here are for the use of Rome. Use is reflected in textual variations that go back to the ancient monastic traditions of different locales. The variations most easily detected are in the Hours of Prime and None, in particular, the capitulum (a short reading near the end of the Hour) and the antiphon that immediately precedes it. Thus, for Rome use, Prime's capitulum is "Que est ista. . ." and its antiphon "Assumpta est Maria. . ."; None's capitulum is "In plateis. . . " and its antiphon "Pulchra es. . . ."

MATINS

V. Domine labia mea aperies
R. Et os meum annuntiabit laudem tuam
V. Deus in adiutorium meum intende
R. Domine ad adiuvandum me festina
Gloria patri. . .
Inv. Ave Maria gratia plena. . .
Ps. Venite exultemus. . . (Ps. 94)
Hymn Quem terra ponthus. . .

(1st Nocturn, for Sunday, Monday, and Thursday:)
A. Benedicta tu
Ps. Domine Dominus noster. . . (Ps. 8)
A. Benedicta tu in mulieribus. . .
A. Sicut myrra

Ps. Celi enarrant. . . (Ps. 18)
A. Sicut myrra electa. . .
A. Ante thorum
Ps. Domini est terra. . . (Ps. 23)
A. Ante thorum huius virginis. . .
V. Difussa est. . .
R. Propterea benedixit. . .
Pater noster. . .

(2nd Nocturn, for Tuesday and Friday:)
A. Specie tua
Ps. Eructavit cor meum. . . (Ps. 44)
A. Specie tua et pulchritudine. . .
A. Adiuvabit eam
Ps. Deus noster. . . (Ps. 45)
A. Adiuvabit eam Deus vultu. . .
A. Sicut letantioum
Ps. Fundamenta eius. . . (Ps. 86)
A. Sicut letantium omnium nostrum. . .
V. Sancta Dei genetrix. . .
R. Intercede pro nobis. . .
Pater noster. . .

(3rd Nocturn, for Wednesday and Saturday:)
A. Gaude Maria
Ps. Cantate Domino. . . (Ps. 95)
A. Gaude Maria virgo. . .
A. Dignare me
Ps. Dominus regnavit. . . (Ps. 96)
A. Dignare me laudare te. . .
A. Post partum
Ps. Cantate Domino. . . (Ps. 97)
A. Post partum virgo. . .
V. Adiuvabit eam. . .
R. Deus in medio. . .
Pater noster. . .
Abs. Precibus et meritis. . .
V. Iube Domine. . .
Ben. Nos cum prole. . .

Les. I: In omnibus requiem. . . (Ecclus. 24:11–13)
R. Sancta et immaculata. . .
V. Benedicta tu. . .
Les. II: Et sic in Syon. . . (Ecclus. 24:15–16)
R. Beata es. . .
V. Ave Maria. . .
Les III: Quasi cedrus. . . (Ecclus. 24:17–20)
R. Felix namque. . .
V. Ora pro populo. . .
Gloria patri. . .
Cant. Te Deum. . . (Hymn of St. Ambrose)

LAUDS

 V. Deus in adiutorium meum intende
 R. Domine ad adiuvandum me festina
 Gloria patri. . .
 A. Assumpta est
Ps. Dominus regnavit. . . (Ps. 92)
 A. Assumpta est Maria. . .
 A. Maria virgo
Ps. Iubilate Deo. . . (Ps. 99)
 A. Maria virgo assumpta est. . .
 A. In odorem
Ps. Deus Deus meus. . . (Ps. 62)
Ps. Deus misereatur. . . (Ps. 66)
 A. In odorem unguentorum. . .
 A. Benedicta
Cant. Benedicite omnia opera. . . (Canticle of the Three Children, Daniel 3:57–88, 56)
 A. Benedicta filia tua. . .
 A. Pulchra es
Ps. Laudate Dominum. . . (Ps. 148)
Ps. Cantate Domino. . . (Ps. 149)
Ps. Laudate Dominum. . . (Ps. 150)
 A. Pulchra es decora. . .
Cap. Viderunt eam. . . (Canticle of Canticles 6:8)
Hymn O gloriosa domina. . .
 V. Benedicta tu in mulieribus. . .
 R. Et benedictus. . .
 A. Beata Dei
Cant. Benedictus Dominus. . . (Canticle of Zachary, Luke 1:68–79)
 A. Beata Dei genitrix. . .
Or. Deus qui de beate Marie. . .
 A. Sancti Dei omnes. . .
 V. Letamini in Domino. . .
 R. Et gloriamini. . .
Or. Protege Domine. . .
Or. Omnes sancti. . .
Or. Et pacem tuam. . .

PRIME

 V. Deus in adiutorium meum intende
 R. Domine ad adiuvandum me festina
 Gloria patri. . .
Hymn Memento salutis. . .
 A. Assumpta est
Ps. Deus in nomine tuo. . . (Ps. 53)
Ps. Benedixisti Domine. . . (Ps. 84)
Ps. Laudate Dominum. . . (Ps. 116)
 A. Assumpta est Maria. . .
Cap. Que est ista. . . (Canticle of Canticles 6:9)
 V. Dignare me. . .

 R. Da michi virtutem. . .
Or. Deus qui virginalem. . .
 A. Sancti Dei omnes. . .
 V. Letamini in Domino. . .
 R. Et gloriamini. . .
Or. Exaudi nos Deus. . .
Or. Omnes sancti. . .
Or. Et pacem tuam. . .

TERCE

 V. Deus in adiutorium meum intende
 R. Domine ad adiuvandum me festina
 Gloria patri. . .
Hymn Memento salutis. . .
 A. Maria virgo
Ps. Ad Dominum. . . (Ps. 119)
Ps. Levavi oculos. . . (Ps. 120)
Ps. Letatus sum. . . (Ps. 121)
 A. Maria virgo assumpta est. . .
Cap. Et sic in Syon. . . (Ecclus. 24:15)
 V. Difussa est. . .
 R. Propterea benedixit. . .
 V. Domine exaudi. . .
 R. Et clamor meus. . .
Or. Deus qui salutis. . .
 A. Sancti Dei omnes. . .
 V. Letamini in Domino. . .
 R. Et gloriamini. . .
Or. Protege Domine. . .
Or. Omnes sancti. . .
Or. Et pacem tuam. . .

SEXT

 V. Deus in adiutorium meum intende
 R. Domine ad adiuvandum me festina
 Gloria patri. . .
Hymn Memento salutis. . .
 A. In odorem
Ps. Ad te levavi. . . (Ps. 122)
Ps. Nisi quia Dominus. . . (Ps. 123)
Ps. Qui confidunt. . . (Ps. 124)
 A. In odorem unguentorum. . .
Cap. Et radicavi. . . (Ecclus. 24:16)
 V. Benedicta tu. . .
 R. Et benedictus fructus. . .
 V. Domine exaudi. . .
 R. Et clamor meus. . .
Or. Concede misericors Deus. . .
 A. Sancti Dei omnes. . .
 V. Letamini in Domino. . .
 R. Et gloriamini. . .

Or. Exaudi nos Deus. . .
Or. Omnes sancti. . .
Or. Et pacem tuam. . .

NONE

V. Deus in adiutorium meum intende
R. Domine ad adiuvandum me festina
Gloria patri. . .
Hymn Memento salutis. . .
 A. Pulchra es
Ps. In convertendo. . . (Ps. 125)
Ps. Nisi Dominus. . . (Ps. 126)
Ps. Beati omnes. . . (Ps. 127)
 A. Pulchra es et decora. . .
Cap. In plateis. . . (Ecclus. 24:19–20)
 V. Post partum. . .
 R. Dei genitrix. . .
 V. Domine exaudi. . .
 R. Et clamor meus. . .
Or. Famulorum tuorum. . .
 A. Sancti Dei omnes. . .
 V. Letamini in Domino. . .
 R. Et gloriamini. . .
Or. Presta quesumus. . .
Or. Omnes sancti. . .
Or. Et pacem tuam. . .

VESPERS

V. Deus in adiutorium meum intende
R. Domine ad adiuvandum me festina
Gloria patri. . .
 A. Dum esset rex
Ps. Dixit Dominus Domino meo. . . (Ps. 109)
 A. Dum esset rex in accubitu. . .
 A. Leva eius
Ps. Laudate pueri. . . (Ps. 112)
 A. Leva eius sub capite. . .
 A. Nigra sum
Ps. Letatus sum. . . (Ps. 121)
 A. Nigra sum sed formosa. . .
 A. Iam enim
Ps. Nisi Dominus. . . (Ps. 126)
 A. Iam enim hyems. . .
 A. Speciosa
Ps. Lauda Iherusalem. . . (Ps. 147)
 A. Speciosa facta es. . .
Cap. Ab initio. . . (Ecclus. 24:14)
Hymn Ave maris stella. . .
 V. Diffusa est. . .
 R. Propterea benedixit. . .
 A. Beata mater

Cant. Magnificat anima mea. . . (Canticle of the Blessed Virgin, Luke 1:46–55)
 A. Beata mater et innupta. . .
 V. Domine exaudi. . .
 R. Et clamor meus. . .
Or. Concede nos famulos tuos. . .
 A. Sancti Dei omnes. . .
 V. Letamini in Domino. . .
 R. Et gloriamini. . .
Or. Protege Domine. . .
Or. Omnes sancti. . .
Or. Et pacem tuam. . .

COMPLINE

V. Converte nos Deus salutaris noster
R. Et averte iram tuam a nobis
V. Deus in adiutorium meum intende
R. Domine ad adiuvandum me festina
Gloria patri. . .
Ps. Sepe expugnaverunt. . . (Ps. 128)
Ps. De profundis. . . (Ps. 129)
Ps. Domine non est exaltatum. . . (Ps. 130)
Cap. Ego mater. . . (Ecclus. 24:24)
Hymn Memento salutis. . .
 V. Ora pro nobis. . .
 R. Ut digni. . .
 A. Sub tuum
Cant. Nunc dimittis. . . (Canticle of Simeon, Luke 2:29–32)
 A. Sub tuum presidium. . .
 V. Domine exaudi. . .
 R. Et clamor meus. . .
Or. Beate et gloriose. . .
 A. Sancti Dei omnes. . .
 V. Letamini in Domino. . .
 R. Et gloriamini. . .
Or. Exaudi nos Deus. . .
Or. Omnes sancti. . .
Or. Et pacem tuam. . .

HOURS OF THE CROSS

MATINS

V. Domine labia mea aperies
R. Et os meum annuntiabit laudem tuam
V. Deus in adiutorium meum intende
R. Domine ad adiuvandum me festina
Gloria patri. . .
Hymn Patris sapientia. . .
 V. Adoramus te. . .

R. Quia per sanctam crucem. . .
Or. Domine Ihesu Christe filii Dei vivi pone passionem. . .

PRIME

V. Deus in adiutorium. . .
R. Domine ad adiuvandum. . .
Gloria patri. . .
Hymn Hora prima ductus est Ihesus ad Pylatum. . .
V. Adoramus te. . .
R. Quia per sanctam crucem. . .
Or. Domine Ihesu Christe. . .

TERCE

V. Deus in adiutorium. . .
R. Domine ad adiuvandum. . .
Gloria patri. . .
Hymn Crucifige clamitant hora tertiarum. . .
V. Adoramus te. . .
R. Quia per sanctam crucem. . .
Or. Domine Ihesu Christe. . .

SEXT

V. Deus in adiutorium. . .
R. Domine ad adiuvandum. . .
Gloria patri. . .
Hymn Hora sexta Ihesus est cruci. . .
V. Adoramus te
R. Quia per sanctam crucem. . .
Or. Domine Ihesu Christe. . .

NONE

V. Deus in adiutorium. . .
R. Domine ad adiuvandum. . .
Gloria patri. . .
Hymn Hora nona Dominus Ihesus expiravit. . .
V. Adoramus te. . .
R. Quia per sanctam crucem. . .
Or. Domine Ihesu Christe. . .

VESPERS

V. Deus in adiutorium. . .
R. Domine ad adiuvandum. . .
Gloria patri. . .
Hymn De cruce deponitur hora vespertina. . .
V. Adoramus te. . .
R. Quia per sanctam crucem. . .
Or. Domine Ihesu Christe. . .

COMPLINE

V. Converte nos. . .
R. Et averte iram. . .
V. Deus in adiutorium. . .
R. Domine ad adiuvandum. . .
Gloria patri. . .
Hymn Hora completorii datur sepulture. . .
V. Adoramus te. . .
R. Quia per sanctam crucem. . .
Or. Domine Ihesu Christe. . .
Recom. Has horas canonicas cum devotione. . .

HOURS OF THE HOLY SPIRIT

MATINS

V. Domine labia mea aperies
R. Et os meum annuntiabit laudem tuam
V. Deus in adiutorium meum intende
R. Domine ad adiuvandum me festina
Gloria patri. . .
Hymn Nobis Sancti Spiritus gratia sit data. . .
A. Veni Sancte Spiritus. . .
V. Emitte Spiritum tuum. . .
R. Et renovabis faciem. . .
Or. Omnipotens sempiterne Deus. . .

PRIME

V. Deus in adiutorium. . .
R. Domine ad adiuvandum. . .
Gloria patri. . .
Hymn De virgine Maria. . .
A. Veni Sancte Spiritus. . .
V. Emitte Spiritum. . .
R. Et renovabis. . .
Or. Omnipotens sempiterne. . .

TERCE

V. Deus in adiutorium. . .
R. Domine ad adiuvandum. . .
Gloria patri. . .
Hymn Suum Sanctum Spiritum. . .
A. Veni Sancte Spiritus. . .
V. Emitte Spiritum. . .
R. Et renovabis. . .
Or. Omnipotens sempiterne. . .

SEXT

V. Deus in adiutorium. . .
R. Domine ad adiuvandum. . .
Gloria patri. . .

Hymn Septiformen gratiam. . .
 A. Veni Sancte Spiritus. . .
 V. Emitte Spiritum. . .
 R. Et renovabis. . .
Or. Omnipotens sempiterne. . .

NONE

 V. Deus in adiutorium. . .
 R. Domine ad adiuvandum. . .
 Gloria patri. . .
Hymn Spiritus paraclitus fuit appellatus. . .
 A. Veni Sancte Spiritus. . .
 V. Emitte Spiritum. . .
 R. Et renovabis. . .
Or. Omnipotens sempiterne. . .

VESPERS

 V. Deus in adiutorium. . .
 R. Domine ad adiuvandum. . .
 Gloria patri. . .
Hymn Dextere Dei digitus. . .
 A. Veni Sancte Spiritus. . .
 V. Emitte Spiritum. . .
 R. Et renovabis. . .
Or. Omnipotens sempiterne. . .

COMPLINE

 V. Converte nos. . .
 R. Et averte iram. . .
 V. Deus in adiutorium. . .
 R. Domine ad adiuvandum. . .
 Gloria patri. . .
Hymn Spiritus paraclitus nos velit. . .
 A. Veni Sancte Spiritus. . .
 V. Emitte Spiritum. . .
 R. Et renovabis. . .
Or. Omnipotens sempiterne. . .
Recom. Has horas canonicas cum devotione. . .

OFFICE OF THE DEAD

The use of the Office of the Dead is a function of
the different responses that immediately follow each
of the nine lessons in the Hour of Matins. The use
outlined in the following is for Paris; the first
response is "Qui Lazarum. . . ," the second "Credo
quod. . . ," and so forth.

VESPERS

 A. Placebo

Ps. Dilexi quoniam. . . (Ps. 114)
 A. Placebo Domino. . .
 A. Heu mihi
Ps. Ad Dominum. . . (Ps. 119)
 A. Heu mihi quia. . .
 A. Dominus
Ps. Levavi oculos. . . (Ps. 120)
 A. Dominus custodit. . .
 A. Si iniquitates
Ps. De profundis. . . (Ps. 129)
 A. Si iniquitates observaveris. . .
 A. Opera
Ps. Confitebor tibi. . . (Ps. 137)
 A. Opera manuum. . .
 A. Qui Lazarum
Magnificat anima mea. . . (Canticle of the Virgin,
Luke I:46–55)
 A. Qui Lazarum resuscitasti. . .
 Pater noster
 V. Et ne nos. . .
 R. Sed libera nos. . .
 V. In memoria eterna. . .
 R. Ab auditione mala. . .
 V. A porta inferi. . .
 R. Erue Domine. . .
 Ps. Lauda anima mea. . . (Ps. 145)
 V. Domine exaudi. . .
 R. Et clamor meus. . .
Or. Inclina Domine aurem. . .
Or. Deus qui nos patrem. . .
Or. Deus venie largitor. . .
Or. Fidelium Deus. .

MATINS

(1st Nocturn:)
 A. Dirige
Ps. Verba mea. . . (Ps. 5)
 A. Dirige Domine. . .
 A. Convertere
Ps. Domine ne in furore. . . (Ps. 6)
 A. Convertere Domine. . .
 A. Nequando
Ps. Domine Deus meus. . . (Ps. 7)
 A. Nequando rapiat. . .
 V. A porta inferi. . .
 R. Erue Domine. . .
 Pater noster
 V. Et ne nos. . .
 R. Sed libera nos. . .
Les. I: Parce mihi Domine. . . (Job 7:16–21)
 R. Qui Lazarum. . .
 V. Qui venturus. . .

Les. II: Tedet animam meam. . . (Job 10:1–7)
 R. Credo quod. . .
 V. Quem visurus. . .
Les. III: Manus tue Domine. . . (Job 10:8–12)
 R. Heu mihi. . .
V. Anima mea. . .

(2nd Nocturn:)
 A. In loco
Ps. Dominus regit me. . . (Ps. 22)
 A. In loco pascue. . .
 A. Delicta
Ps. Ad te Domine. . . (Ps. 24)
 A. Delicta iuventutis. . .
 A. Credo vivere
Ps. Dominus illuminatio mea. . . (Ps. 26)
 A. Credo videre bona. . .
 V. In memoria eterna. . .
 R. Ab auditione mala. . .
 Pater noster
 V. Et ne nos. . .
 R. Sed libera nos. . .
Les. IV: Quantas habeo iniquitates. . . (Job 13:22–28)
 R. Ne recorderis. . .
 V. Amplius lava me. . .
Les V.: Homo natus de muliere. . . (Job 14:1–6)
 R. Domine quando. . .
 V. Commissa mea. . .
Les VI: Quis mihi hoc. . . (Job 14:13–16)
 R. Peccantem me. . .
 V. De profundis. . .

(3rd Nocturn:)
 A. Domine
Ps. Exaltabo te. . . (Ps. 29)
 A. Domine abstraxisti. . .
 A. Complaceat
Ps. Expectans expectavi. . . (Ps. 39)
 A. Complaceat tibi. . .
 A. Sitivit
Ps. Quemadmodum desiderat. . . (Ps. 41)
 A. Sitivit anima. . .
 V. Audivi vocem. . .
 R. Scribe beati. . .
 Pater noster
 V. Et ne nos. . .
 R. Sed libera nos. . .
Les. VII: Spiritus meus. . . (Job 17:1–3, 11–15)
 R. Domine secundum. . .
 V. Quoniam iniquitatem. . .
Les. VIII: Pelli meae. . . (Job 19:20–27)

 R. Momento mei. . .
 V. Et non revertetur. . .
Les. IX: Quare de vulva. . . (Job 10:18–22)
 R. Libera me. . .
 V. Dies illa dies irae. . .
 V. Tremens factus. . .
 V. Tremebunt angeli. . .
 V. Vix iusti. . .
 V. Quid ergo. . .
 V. Vox de celis. . .
 V. Creator omnium. . .
 R. Libera me. . .

LAUDS

 A. Exultabunt
Ps. Miserere mei Deus. . . (Ps. 50)
 A. Exultabunt Domino. . .
 A. Exaudi
Ps. Te decet. . . (Ps. 64)
 A. Exaudi Domine. . .
 A. Me suscepit
Ps. Deus Deus meus. . . (Ps. 62)
 A. Me suscepit dextera. . .
 A. A porta inferi
Ego dixi. . . (Canticle of Ezechias, Isaiah 38:10–20)
 A. A porta inferi erue. . .
 A. Omnis
Ps. Laudate Dominum. . . (Ps. 148)
Ps. Cantate Domino. . . (Ps. 149)
Ps. Laudate Dominum. . . (Ps. 150)
 A. Omnis spiritus. . .
 A. Credo Domine
Benedictus Dominus. . . (Canticle of Zachary, Luke 1:68–79)
 A. Credo Domine Ihesu. . .
 Pater noster
 V. In memoria eterna. . .
 R. Ab auditione mala. . .
 V. A porta inferi. . .
 R. Erue Domine. . .
 V. Credo videre bona. . .
 R. In terra. . .
Ps. De profundis. . . (Ps. 129)
 V. Requiem eternam. . .
 R. Et lux perpetua. . .
 V. Domine exaudi. . .
 R. Et clamor meus. . .
Or. Inclina Domine. . .
Or. Deus qui nos patrem. . .
Or. Deus venie largitor. . .
Or. Fidelium Deus. . .

2. Manuscript and printed Books of Hours by century and country of origin

XIII

Bohemia: nos. 11, 85.
France: nos. 1, 12.

XIV

England: no. 5.
France: nos. 48, 55, 62, 92.

XV

Belgium: nos. 34, 41, 47, 49, 58, 61, 64, 67, 72, 76, 82,
 83, 86, 97, 99, 103.
England: nos. 2, 3, 71, 86, 98.
France: nos. 6, 7, 9, 13, 14, 15, 18, 22, 23, 24, 27, 28,
 29, 30, 31, 33, 36, 37, 38, 39, 49, 50, 56, 58, 59, 60,
 63, 65, 66, 68, 70, 75, 79, 80, 81, 87, 89, 90, 93,
 94, 95, 96, 100, 101, 102, 104, 105, 106.
Italy: nos. 19, 25, 45, 74.
The Netherlands: nos. 44, 78, 88, 107.
Spain: no. 51.

XVI

Belgium: nos. 8, 17, 69, 84, 91.
France: nos. 4, 7, 9, 10, 16, 20, 21, 26, 32, 35, 39, 40,
 42, 43, 46, 52, 53, 54, 57, 63, 70, 74.
Italy: no. 77.